Sculptors' Drawings Over Six Centuries 1400-1950

Sculptors' Drawings Over Six Centuries 1400-1950

By Colin Eisler

AGRINDE PUBLICATIONS LTD., NEW YORK

The Drawing Center, a nonprofit space for the study and exhibition of drawings, 137 Greene Street, New York, New York, 10012

This gathering, *Sculptors' Drawings over Six Centuries*, held at the Drawing Center, was funded in part by a grant from the National Endowment for the Arts, a Federal agency, in Washington, D.C.

A generous grant from the Exxon Corporation made the exhibition *Sculptors' Drawings over Six Centuries* possible.

The New York Council for the Humanities, a state program of the National Endowment for the Humanities, has given partial funding for the exhibition and its accompanying programs.

Edited by
CAROL LEARSY

Designed by
BOB CIANO

Library of Congress Cataloging in Publication Data.
Eisler, Colin
Sculptors' Drawings Over Six Centuries

Bibliography: P
includes index.
Artist's Preparatory Studies—Catalogs
II Sculpture, Modern—Catalog I Title
N7433.5. E37 735 81-65434
ISBN 0-9601068-7-1 AACR2

Produced by Bob Adelman
Printed in the United States of America by Rapoport Printing Corporation in the Stonetone® process.
Bound by Sendor Bindery, New York
AGRINDE PUBLICATIONS LTD.
665 Fifth Avenue, New York, N.Y. 10022

Donatello declared drawing so essential to sculpture that he always told his pupils: The art of sculpture could be taught in one word. Draw. And that in truth is the summit and the basis of all sculpture.

Pomponius Gauricus.

Love sculpture; She gives the idea of beautiful form.

David

Intelligence draws. Only the heart can model.

Rodin

There are too many lines.

Brancusi

In memory of Charles Seymour, Jr., whose lasting lines illuminate those of many a sculptor.

Introduction

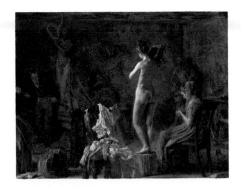

Fig. 1
Thomas Eakins, *William Rush Carving His Allegorical Figure of the Schuylkill River,* 1877, Philadelphia Museum of Art. Given by Mrs. Thomas Eakins and Mrs. Mary Williams.

To sculpt is the primary creative act—man moulded from a handful of dust. But just as in the beginning was the word, so, in art, line may come before form. Drawing can precede modeling. Lessons in drawing were the sole ventures in the visual arts allowed by Aristotle because only by such learning could one divine the harmony of human proportions.

Complete, the statue exerts a special force upon its maker. Like *Pygmalion* (42), he may want to love his image into life. By drawing after the carved stone or wrought metal, as Rodin did in his uniquely liberated style (82), the artist may free these still figures from the limitations of gravity and craft by graphic incantation. Statues can also teach of the body's beauty and proclaim the achievements of Antiquity. Silent yet eloquent messengers, Phidian "speaking models," ancient statues taught by their own example, a didactic *acte de présence.*

So often incomplete, the fragmentary state of ancient sculpture makes it all the more compelling, whether to Gozzoli (3) or to Picasso (112). Drawing a hand or leg from life or marble extends the sculptor's experience of the unfinished, the possession of loss. Michelangelo and Rodin extended such compelling suggestions of the once and future into a new allegory of art—the torso. The torso came to represent the very nature of sculpture, time's victim and victor alike. Paper provided a rapid equivalent of the emerging form—line, a passage to infinity. Gill's few strokes on the page (111), as evanescent as Ariel's messages, suggest the possibility of the future—or could it be the past?

Sculpture often starts on paper, even when artists like Nevelson (108) say it isn't so. Few workers go straight to wax, clay, plaster, or stone without setting down their initial thoughts in brush, pencil, pen, or crayon. So most sculptors first see the form that they will follow initiated on the page.

By drawing, sculptors act as critics and diarists, mystics and seers; by drawing, the sculptor releases his work in the round to weightlessness and freedom—in a daring return to paper. Forms that have found themselves in clay, bronze, or stucco, already validated by their existence in real space, then lose their "object status," provided with a graphic passport to fantasy.

"The studio of a sculptor," Hawthorne observed in his *Marble Faun,*

> is generally but a rough and dreary-looking place, with a good deal the aspect, indeed, of a stonemason's shop. Bare floors of brick or plank, and plastered walls; an old chair or two, or perhaps only a block of marble (containing, however, the possibility of ideal grace within it) to sit down upon; some hastily scrawled sketches of nude figures on the whitewash of the wall. These last are probably the sculptor's earliest glimpses of ideas that may heretofore be solidified into imperishable stone, or perhaps remain as impalpable as a dream.

The legends of the Renaissance sculptors emphasize their drawing in secret. When it became evident that they were gifted, youths were encouraged or driven to hide their skills from parental disapproval.

Mino da Fiesole and Michelangelo are described as drawing on walls; so did Bernini. Photographs and paintings of artists' studios (Fig. 1-3) show them covered with preparatory scribbling, quick notations, as though the sculptor were enclosed in a white ground, awaiting the *graffiti* of revelation. Dashed off, these mural notations are their authors' graphic letters to themselves, a linear world of figure and structure, motion and stability, drawn alternatives, to be or not to be translated into form. Long limited by the weight of stone or bronze, sculptors in their drawings revel in a heady sense of freedom. Bernini (28-30) and Canova (46),

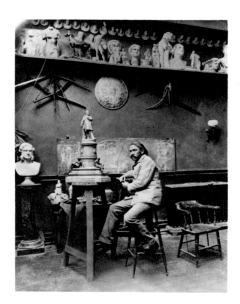

Fig. 2
John Quincy Adams Ward in his studio,
Archives of American Art, Smithsonian
Institution.

Sergel (43) and Flaxman and George Gray Bernard drew many genii-like figures, creatures of light and air, as if their studios were filled with magical vessels, ready to release figural fantasies with the stroke of a pen.

A disappearing act and art, sculptors' drawings can vanish in the course of duty, as witnessed by an eighteenth-dynasty sketch on limestone (Fig. 4). Here the preparatory lines, boldly yet exquisitely tracing those of Akhaten's princess, are destined for destruction when followed upon by the faithful chisel. Like their Egyptian predecessors, sculptors of Greece and Rome drew directly on the block to guide the masons in their initial roughing out of the form within. Ancient carvers as well as those of later times may well have kept guide books—images drawn on ivory or incised on wax tablets—close by, providing patterns and models for themselves and their patrons, showing what had and could be made. Such graphic collections survive from the late Middle Ages; most earlier indications are lost. What survive are the remnants of a massive body of drawings long of as little interest to the museum, the dealer, the collector, as they were to the artist.

Appropriately, the first medieval reference to the sculptor's use of drawing—from *The Various Arts*, written by a monk—also provides the earliest mention of paper. In the twelfth century, Theophilus told the craftsman: "When carving bone first trim a piece to the size that you want, and then spread chalk over it. Draw the figures with lead according to your wishes, and score the outlines with a sharp tracer so that they are quite clear. Then, with various chisels, cut the ground as deeply as you wish." Drawings pertaining to ancient sculpture must have shared features with more recent works stressing a clear guiding line, a supple, undulating profile to help move the image from the second to the third dimension.

Workshops and heirs cared for the master's graphic heritage only if it could be used for further sculpture or could be sold for documentary or antiquarian interest. A few master sculptors' pages were valued early on. Aretino, ever the flatterer, assured Michelangelo that he treasured two lines from the master's hand more than any monarch's jeweled gift.

Many more sculptors' drawings were destroyed, as described by a model of Gill's who recorded that

> Eric used to draw on a very large drawing block which stood on an easel; he drew many sketches all of which I thought were perfect, but nearly all of which were immediately destroyed. He never seemed to get what he wanted done until he had a great many "attempts." I could not bear to see these drawings being ripped from the great pad and being screwed up and thrown away forever.

A study by Gill in this gathering (111) may have been one saved by its model. Some sculptors, like David Hare, preserved none of their early pages, discarding them when the work was done. Nineteenth-century masters tended to keep vast quantities of notebooks and drawings in their large studios, which sometimes became their museums. Other sculptors' heirs held auctions of studio effects. On Carpeaux's (63-65) death three or four such sales took place. Many of his drawings entered public collections through one princely patron's cape.

Too often sculpture is seen in terms of black on white—as grimly patinated bronzes placed against dead white walls. But wax and terra cotta are light in color and plaster pale—and these are the sculptor's media, long used to build up form before the statue was carved or cast. Working the molten metal and carving the stone were often left to the skilled artisan. So form is often first found in light matter—the suggestion of line on paper, a plaster sketch, or one in wax or clay.

Marbles, freed from centuries of grime, are as "white on white" as any Malevitch.

Patina should be seen as a form of painting, artfully accidental polychromy, meant to suggest the benign chemical neglect of burial. Bronzes were meant to be carefully coated with protective waxes to reflect light and color, shielded from the ravages of birds and fumes. For these works, once again, drawing can anticipate their rich coloristic effect and sparkling surfaces.

The first known drawing after the antique is one in the notebook of the mason-architect Villard de Honnecourt, in the twelfth century. He wrote to his future reader: "Villard de Honnecourt greets you and begs all those who have found his work of help to pray for his soul and to remember him. For in this book you can find very good advice as to the great art of masonry and the construction of engines of woodwork and you will find the force of drawing in it, which, with the foundation of geometry, will command and instruct." His mason's knowledge of geometry is much in evidence for a study of a classical tomb (Fig. 5), in which Villard reduced the late Roman monument to a series of mathematical outlines.

Sculptors' drawings hover between reality and illusion. Sometimes there is a ghostly quality, found in sketches of the late-fifteenth-century sculptor Veit Stoss or in Daumier's trembling lines. A Renaissance study for the great German bronze reliquary for Saint Sebaldus by Vischer shares the spectral presence found much later in Giacometti's work (124).

Like architects, most sculptors must anticipate and plan the three-dimensional by beginning with the projection of their work on a single plane. Just how the page is employed as a strategic means toward form in the round is a matter of extraordinary individuality. Several views can be placed on a single page, as by Ghiberti (Fig. 8), Canova (46), Ammanati (9), Bartlett (75), or Brancusi (92). Often the artist, like Donatello (2), will juxtapose an enlarged detail alongside the image in its entirety, evaluating alternative solutions for key areas. Varying renderings of the figure on paper, drawing from a wax or clay sketch under different illuminations, permit important changes long before the project enters its final stage.

Drawing can make sculpture or its subject transparent—a solid becomes hollow, turned to empty form or pure outline. Such a process of de-materialization—the opposite of casting or building up mass—is a critical aspect of the sculptor's vision. Rarely does he or she enjoy more freedom of choice than on the page, as seen in Gertrude Vanderbilt Whitney's study for her *Titanic* memorial (89). Other drawings can provide compendia of sculptural characters, thematic deep-freezes and visual reservoirs, such as Moore's richly colored, abundant study (119).

Earlier sculptors like Foggini (36) kept notebooks with drawn records of finished sculpture. Fifteenth- and sixteenth-century sculptors kept similar books, to be handed down through the family for future use. Most moving of such gatherings are the portraits of their studios drawn by Brancusi (91) and Giacometti (Fig. 6). Here the sculptor savors and shares a sense of loving achievement. Auvera's page (38) presents a Mozartean anthology of motifs to be followed by the sculptor's many assistants, faithfully carving their master's designs.

Sometimes sculptors' pages act as flyers for graphic self-promotion. Bandinelli took justifiable pride in his drawings, prized throughout Europe for their authoritative beauty and force (7, 8). Effective agents, they circulated knowledge of his powerful art. Like Michelangelo, with whom he is so often compared, Rodin also showed a genius for self-promotion, a flair for publicity, which drew gifted writers to his studio to help fabricate a legend of agony and ecstasy almost better loved than the artist's works. Though most of Rodin's best-known drawings were made in

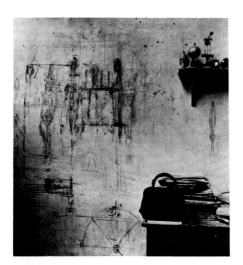

Fig. 3
Drawings on the wall of Giacometti's studio, Paris.

later life, they too acted as messengers (82), traveling more readily than marble, providing a marvelous series of graphic flourishes and figural fanfares for his monumental gifts. With his sculpture, they convey a new sense of immediacy and freedom, a simplicity and an elemental life force that anticipate much of the art of our century. Fleeting, tender, tentative signs of moods and feelings, some of these pages have nothing to do with sculpture; their fugitive transience and transparency escape the confines of matter. Such drawings could be messengers of love as well as fame. Tossed off with dazzling rapidity, some of Rodin's pages were stuffed into baskets, like peaches or bonbons, for delivery to dancers such as Fuller, Nijinsky, or Duncan, whose lovely lines had inspired his own.

Sculptors' drawings are often their forgotten language. Escaping the technical, functional, spatial limitations of the object in question, they present the vision beyond necessity. Freed from the confines of place, the need for patronage, such pages can tell more of the roots, the sources, the well-springs of creative endeavor than any other aspect of their author's work. A sheet by Chapu (69) teeming with figures for and from previous and future commissions is like a portrait of the artist's mind. Such a study is an immediate, personal response, where the hand may indeed move faster than the eye. Dreamlike, some of these first thoughts on paper resemble a late page by Bernini (30) which takes a subject already worked in sculpture, one he wanted to see again, in more pictorial fashion. Many of Canova's drawings also suggest reveries more than monuments.

First taught together, and often working on the same project, painters and sculptors learn from one another. Rich, complex cycles of reciprocity can take place. Sometimes the force of a single personality—a Donatello (2) or a Rodin (82)—can change the patterns of interaction between the media. At other times, a magisterial figure, equally endowed as sculptor and painter, such as Michelangelo (Fig. 11) or Picasso, contributes to new, mutually effective ways of seeing in all dimensions. A few artists, defined by their virtuoso draughtsmanship, can apply their graphic gifts to the sculptor's work and take over the direction of that medium. Primaticcio, LeBrun (27), and Bouchardon (40), all active in France, played just such a role. Some major painters—Leonardo da Vinci, Pollaindo, Degas, and Matisse (85)—turned to sculpture briefly but intensively at critical periods to produce works of massive significance. A few artists like Giacometti let sculpture, drawing, and painting echo one another without priority, each reflecting the others' special character, defining one another in a mutually enriching process.

At certain times there was an equilibrium between painting and sculpture, both activities represented in the oeuvre of leading artists such as Verrocchio. This was a commonplace in fifteenth-century Tuscany and provided the basis for what Berenson baptized as "tactile values." In the nineteenth century many painters turned to sculpture and enjoyed the stimulus of working in both two and three dimensions.

One way to approach the fascinating, elusive issue of the ties between painting and sculpture is to pay more attention to sculptors' drawings and to those of painters for and from sculpture, such as the pages by Tintoretto (12, 13) and Tiepolo (39). Only the stellar figures in the history of sculpture have had their drawings examined with care, but these have been viewed in distorting isolation. The larger issue of such drawings seen through time has been neglected. Drawing is the key area where painting and sculpture meet, where the extremes touch on common ground. Education of both those who paint and those who sculpt has, for five centuries, been based upon the graphic experience.

In terms of their works in the round, sculptors' most important drawings are

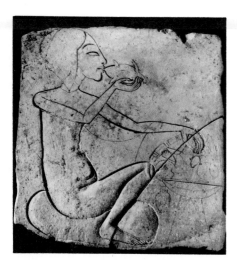

Fig. 4
Egyptian, 18th dynasty sketch on limestone,
c. 1372–1355, Egyptian Museum, Cairo.

those made in advance, renderings toward definition and clarification, pages to solve problems. But there is another category, of studies worked after the statue is finished, of second guesses and of second thoughts. These are sculptors' revisions toward the ideal, traced from the completed form. Suggesting the "If only" and "Had I but known," such sketches place the work in dynamic retrospect, providing correction without pedantry.

Not all sculptors drew or cared about drawing. Some famous masters, such as Cellini (10), preferred modeling as a first step to work on paper. Many renderings, like della Robbia's contract (4) or Greenough's *Washington* (56), were more for the patron's benefit than the sculptor's. Such pages were made when a statue of considerable expense was to be produced, often involving the work of other masters for the base or setting. Houdon's sensitive portraits were carved without preliminary draughtsmanship. His sole major drawing has nothing to do with known statuary. The same is true for Clodion, an accomplished master on paper but one who did not seem to need guidance from that source for his equally skilled sculpture. Pigalle was said to "draw with his thumb," and the American master of the statuary conversation piece, the self-taught Samuel Rogers, failed to include drawing in his curriculum, handling the pencil like a novice with chopsticks (Fig. 7).

Several sculptors, such as Dalou, drew intensely and productively but felt this was a personal, private aspect of their oeuvre, not to be seen after the sculpture was completed or compared with it in any way. Significantly, Dalou's pen study in this collection (70) was drawn after a completed work, for reproduction in a contemporary art journal. Occasionally a sculptor appears happier as draughtsman than working in the round. This is true for Bandinelli (7, 8), whose drawings belie the glacial, deliberately aggressive stance of much of his statuary.

Sculptors over six hundred years evince a common need for a speedy assertion of weight and direction which contributes to their common shorthand. Their work as engravers, incisers, or cutters also prepared the draughtsmen for definitive line, leading to a community of graphic thought over time. Beginning in the fifteenth century, sculptors' pages often show a cursive, spaceless, calligraphic quality. Artists as far apart in time as della Porta (11) and Wood (101) share an abbreviated, abstract, impulsive line open to sudden change, a quick search toward finality of form. Economy and facility are constants in the sculptor's graphic approach, from Sansovino (6) to Lachaise (113).

This selection of more than one hundred sculptors' drawings covering six hundred years, the neglected stepchildren of the graphic arts, is designed toward exploration. This gathering is meant to be open-ended rather than definitive; provocative, not conclusive. How do drawings contribute to the sculptor's training, working methods, image and self-image? Can working after sculpture teach the painter how to draw and see form? Are there many different ways in which the sculptor's drawing functions within his oeuvre? Ending with Smith (125,126) and Bourgeois (127), this collection should help us understand our recent heritage of sculptors' drawings through these masterly pages from mid-century: His lines survive, drawn against the skies, his clear gaze and hand are happily still with us.

1. Divine Design - The Sculptor's Drawing in the Renaissance

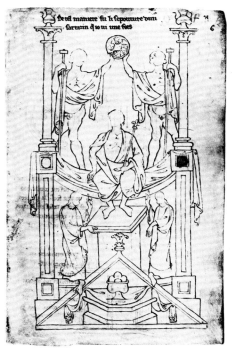

Fig. 5
Notebook of Villard d'Honnecourt,
"Saracem Tomb"
Bibliothequé Nationale, Paris.

Sculpture tends to be a poor boy's art, springing from the dust and sweat of the mason's yard and the fire and heat of the foundry. Those who came to statuary from the start were often born into that skill, proudly keeping their fathers' tools close at hand. Many masters, though, came to the working of marble and bronze from that of cut gems and precious metals, moving from the miniature to the monumental. Apprenticeship at the stonecutter's or goldsmith's shop meant training to work with line: cutting, engraving, or incising metal with decorative, often figurative, forms. Pattern books were handed down from generation to generation.

Early records of drawings for sculptors' use, from commissions of the late fourteenth century, usually list these as the work of painters. Whether the artist's skill was employed to show the sculptor's model in graphic form to the patron, or whether the painter actually designed the work to be followed by the sculptor, is not always made clear. Four different painters delivered project drawings to the sculptor Piero di Giovanni Tedesco for figures to be placed on the façade of the Cathedral of Florence. Another sculptor, Niccolò Lamberti, was given two portrait drawings of his patron Marco Datini for use in the creation of Datini's tomb.

Quercia, the great Sienese sculptor, prepared drawings for his elaborate fountain project, the *Fonte Gaia*, but the one surviving set of drawings, divided between the Victoria and Albert and the Metropolitan museums, is probably the revised project, made by a painter. Painters in the fifteenth century also prepared actual-size renderings of the sculptor's work to show what these would look like on the spot.

Drawing came into new prominence with the early Tuscan Renaissance. At the beginning of the fifteenth century great sculptors and architects emerged from goldsmiths' shops, working themselves away from intricate late Gothicism toward Classical monumentality. Brunelleschi, architect of the new age, and possibly his friend Donatello as well, came from the precious-metal-workers' craft. So did Ghiberti, long active as painter, sculptor, and supervisor of the building of the Cathedral of Florence. Implementing his skills as a goldsmith, he moved to a vibrant use of line, capturing the cruel motion of the Flagellation with whipping lines in a preparatory study for one of his Baptistry door reliefs (Fig. 8).

Design and drawing, one and the same in their Italian equivalent—*disegno*—were essential for making fine metalwork, a major source of Tuscan wealth. Remarkably many painters as well as sculptors came from the goldsmiths' workshops. Beginning with Orcagna in the fourteenth century and going right through to the end of the fifteenth with Verrocchio and Leonardo, numerous masters practiced painting and sculpture alike, moving readily from one to the other medium in stimulating exchange.

A novel approach to drawing, using very fine parallel lines or networks of hatching, probably originated with working in precious metals. This manner is found early in the century and carried on by Ghirlandaio, a goldsmith's descendant, and taught by him to the young Michelangelo (Fig. 17). Such shading is found in early engravings, and a similar reticulation of the parallel and crossed rows of chisel marks is frequently found carved on stone as the form is worked out of the marble. Often present in Michelangelo's graphic art (Fig. 11), this network, which seems to cling to, rather than define, an invisible form below, is still found in the nineteenth century, on Carpeaux's page (63c, 64).

Perhaps the major part of the young sculptor's education that was truly individual, where he could measure his own progress, was the practice of drawing. Unlike modeling in wax or clay, which called for more time and space, drawing permitted the apprentice to steal whatever free moments he had from the labors of the shop to

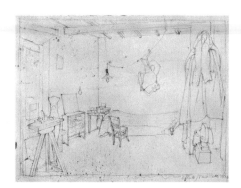

Fig. 6
Alberto Giacometti, *Atélier*, 1932,
Kupferstichkabinett, Kunstmuseum, Basel.

work on his own, at slight expense, with an enduring record of change in his notebook. More than painting, sculpture was often a collective enterprise, employing many skills, providing little chance for individual assessment. Loud and dirty, the sculptor's workshop afforded even less opportunity for discussion and instruction than the painter's. Drawing meant self-education. In addition, some of the beginner's pages, like his modeling, may have been corrected by the master sculptor. His renderings may have been life studies, drawn from fellow apprentices or after casts in the studio (3).

Disegno—the Italian for that awesome combination of drawing and design—was the critical factor in the art of the Renaissance, encompassing an ability to follow Antiquity by accomplished draughtsmanship, and the design of new images showing force, invention, grace, and skill. It was in drawing, above all, that the closest correspondence to divine design could be found. By this *writing* on the page, the first thought, the miraculous beginning, was conveyed. Heavenly inspiration was externalized by the action of the spirit on the hand. That fashionable philosophy, neo-Platonism, with its exaltation of the *idea*, brought drawing to the fore. Vasari, the sixteenth-century architect and painter who also found time to compile the great *Lives of the Artists*, owned a splendid collection of drawings kept in five or more large portfolios—the *Libro de' Disegni*, referred to with such pride in his writings. Among his most treasured pages was a two-sided drawing showing what seem to be designs for two reliefs—*Pilate Washing His Hands* and *Christ Carrying Cross* (1a-b); Vasari first believed this sheet to be the work of Donatello and then assigned it to an equally great and innovative sculptor, Nanni di Banco, about ten years Donatello's senior. A new clarity and sense of form and light, very different from most drawings of the late fourteenth century, is found on this page. The same dramatic economy of line is also present in the underdrawing of the later frescoes of Castagno (Fig. 9). But such a bold approach may well first have been limited to sculptors. Perhaps only they were able to convey this incisive vitality with such remarkable drama and immediacy. Bold, close to calligraphy but never fussy or self-involved, the sweeping graphic presentation of these narrative studies transcends the paper's physical limitations, signal hallmark of a new heroic age.

Another sheet, also owned by Vasari and listed by him as from Donatello's hand, is the only surviving drawing that today's scholars accept as his (2). *David Triumphant* is the drawing's theme, underscored by crisp, insouciant draughtsmanship, scratched and slashed across the page. The nude, classic form is made clear by a newly dramatic bravura graphism, drawn in the same hand that made the numerical indications, perhaps of scale, alongside.

Originally the sheet was twice as large, as indicated by the other side, which shows only half of the tragic combat between the Mothers of the Holy Innocents and their murderers. Here the sculptor uses a much thicker line, suggesting relief rather than sculpture in the round. According to Degenhart and Schmitt, this drawing was as hugely important for painters as it was for sculptors, shaping the graphic style of Mantegna and Giovanni Bellini. Surprisingly, Donatello specialists have ignored or rejected this drawing, usually adhering to the mistaken view that it dates from the sixteenth century or to the belief that Donatello never drew, despite Renaissance texts to the contrary. In fact, its bold approach was *revived* by the sculptors of the early sixteenth century. Drawings like this must have been among those used by Donatello's assistant Bertoldo for instruction in his "Academy," where the young Michelangelo was a student.

That major scholar of Michelangelo, de Tolnay, has shown how many of his

Fig. 7
John Rogers, *Sketch of Proposed Group "Camp Fires of The Revolution,"* from a notebook, The New York Historical Society, New York.

drawings were after Donatello's oeuvre. It may well prove that the latter included works on paper as well as sculpture, brought under the young master's eager scrutiny. Donatello's reliefs show massive skill in drawing, from the stone below the statue of Saint George at Or San Michele, to the marble panel (Fig. 10) probably meant to have been seen with Masaccio's frescoes in the Brancacci Chapel, to the late bronze reliefs at Padua. He used his chisel on marble as if it were a silverpoint on prepared paper, working with extraordinary delicacy and luminosity.

New interest in anatomy made drawing even more important in the sculptor's training (86b). Dissections were recorded on paper, and flayed musclemen were placed in studios for the instruction of painters and sculptors alike. Most of the early academies were under sculptors' supervision or founded in their memory—like those of Bertoldo and Bandinelli (Fig. 12) and the Florentine Accademia del Disegno, in honor of Michelangelo. Socrates, a sculptor before he became a philosopher, was an inspiration for such centers, shown in the act of incising his portrait as a sculptural "Know thyself" (Fig. 13). Closest among artists to the vision of Antiquity, the sculptor could approach the Classical achievement most directly. Since it was sculpture that survived, the stoneworkers of later times were in the best position to understand and learn from the ancient models. When the first book on Renaissance painting was written, Alberti's *Della Pittura*, it was dedicated to an architect, a sculptor, a mathematician, and a painter, emphasizing the relationship of works in the round and the science of numbers in the author's mind. Significantly, his self-portrait was done in relief.

Michelangelo, when he drew a design for an early *David* (Fig. 11), evoked those of Donatello (2). The same page also includes the right arm of the colossal marble image of the biblical hero he made a few years later. An inscription shows, according to Seymour, how the sculptor now saw his strength as equal to David's. The words "David with his sling and I with my bow—Michelangelo" compare the subject's weapon with the sculptor's hand drill—with which he can define and conquer all. Only by observing the drawing and the writing as well as the sculpture itself can one understand the master's complex message.

Michelangelo may have used models in wax or clay for many of his works, but his pages for the Medici Chapel figures reveal an extraordinary conjunction of dissection and the use of the living model, with bone and muscle visible beneath the skin. In highly finished preparatory drawings Michelangelo returned to the earlier working style of fifteenth-century masters like Ourrcia, in his designs for the *Man of Sorrows* in Rome. The most basic use Michelangelo made of drawings was to indicate to the stonecutters of Carrara just how the marble blocks were to be cut.

Still adhering to a conservative fifteenth-century Florentine approach is a design for a circular relief by a monastic member of the della Robbia family (4). Here the rendering was made for contractual purposes: the sculptor shows what he means to provide in return for his patron's payment. Two alternative designs were provided, so that the purchaser could select the composition he preferred. Toward the end of the fifteenth century, funerary sculpture became more massive. These gargantuan tombs for the wealthy teemed with allegorical figures, massive architectural settings, heroic portraits of the deceased, and intricate, often biographical reliefs. A finely wrought design for a Lombard tomb, possibly the work of Bambaia (5), shows the precision of an engraving, a prismatically clear, exquisite rendering made to guide the patron, indicating the location of the individual figural groups, but not yet including the large reclining image of the deceased, Gaston de Foix.

Best known of *fin-de-siècle* funerary extravaganzas is the one that never was—

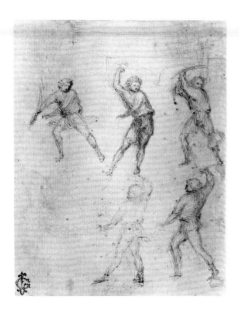

Fig. 8
Lorenzo Ghiberti, *Five Figure Studies for
"Flagellation of Christ,"* Albertina, Vienna.

Michelangelo's colossal project for Julius II. It haunted the imagination of sculptors and their patrons for centuries to come. Many drawings survive, but none showing the complete plan are from the master's hand. The mausoleum went through innumerable revisions before its final, almost pathetic reduction, with the magnificent *Moses* now at the center. Copies of the Julian project were circulated, and several of the drawings in this collection reflect its influence over the centuries. Funerary monuments by Sansovino (6), Bandinelli (8), della Porta (11a-b), and Sormani (16) go back, in part, to the magnificent disposition of figures Michelangelo first envisioned. Half albatross, half seraph, Julius' grandiose tomb was both bane and blessing for the sculpture of the future.

The new vocabulary of the colossal proved to be the sculptor's major advantage over the painter. In this sphere the carver reigned supreme. As shown by Ammanati (Fig. 14) the artist could learn best by drawing after massive monuments, deriving virtuosity, meaning, and strength from his models. In this case, the marble *Hercules*, Ammanati's statue in Padua, was nowhere near as large as his drawing made it appear. Ammanati is also thought to be the author of a beautiful study page from Vasari's collection, showing a *Leda* and a *Pietà* (9).

A huge *Fountain of Hercules* commissioned from Vincenzo de' Rossi was to have been one of Florence's major monuments, a many-tiered ensemble of the weighty Labors of the city's patron hero. This extravagant project was never completed, though some of its figure groups, symbols of Justice, were installed in the largest hall built in the century, the city's Council Chamber, which Michelangelo and Leonardo had vied to decorate. Only de' Rossi's drawing remains to show just how his muscle-bound marbles would have looked (15). Splendid pages like these were already prized by sixteenth-century collectors. Borghini juxtaposed fifteenth- and sixteenth-century sculptors' drawings in his albums, noting how the genius of the first anticipated that of the second. Other collectors, such as Vecchietti, included drawings by Leonardo, Michelangelo, and Cellini with models in clay and wax and statues in bronze, so that works in the round could be admired in the same museum-like chamber that housed the sculptor's thoughts on paper.

Bandinelli's (7, 8) *Memoirs* elucidate the important role of draughtsmanship in his life and work. Addressing his son, he wrote, "I principally applied myself to drawing, in which I was outstanding in the judgment of Michelangelo, of our princes, and of the best people. Their Excellencies [the Grand Duke and Duchess of Tuscany] have a great many of my drawings, others were sent to Germany and to France, and others scattered throughout Italy, some of which I have sold for as much as two hundred *scudi*. I leave you almost a chestful of them, which you should guard like jewels. Never let them go, for the time will come when they shall be highly treasured and God bless you."

Italian carvers, bringing with them their drawings and sandstone, traveled north. An unusually fine, unpublished example of their work is found in the design for the tomb of an Italian resident in France, one of the exiled Pazzi (14). Here the mannered elegance of the athletic figures above the tomb is close to the art of Rosso Fiorentino, the Florentine painter who also designed the great reliefs framing his works in the Gallery of François I^er at Fontainebleau. Michelangelo's works traveled north as well, in sculpture and on paper.

At the same time, a new cult of the statue developed. The love-inspiring power of statuary, as in the story of Pygmalion's passion for his statue Galatea (42), became part of the literature of the times. Even the drawings of the marbles of Leda and other mortals beloved by the gods were endowed with the miraculous properties enjoyed

Fig. 9
Andrea Castagno, *The Crucifixion*, detail,
Sinopia, S. Appollonia, Cenacolo, Florence

by their models in the round.

In the mid-sixteenth century, when drawing—*disegno*—had become almost an obsession, the Accademia del Disegno was founded in Florence as an enduring tribute to Michelangelo's genius. The common denominator of painting, sculpture, and architecture, *disegno* was to be the central subject of instruction at this and all future academies. Drawing to and from sculpture and after engravings (only later was the live model introduced) was the focus of these schools.

Through drawing, sculpture was finally accepted as Art. Too rooted in the material and the materialistic to inspire the soul, sculpture had been excluded from the elevated company of those arts lifting the spirit heavenward. But in the late fifteenth century, when Gauricus defined the role of *graphike* in Donatello's art, drawing began to elevate the sculptor's craft, until at last he was perceived as master of the eighth Liberal Art.

Despite the surly self-confidence and snobbery of Michelangelo, the aggressive bluster of Bandinelli, the pugnacious paranoia of Cellini, design, that divine agent of initial creative revelation, began to validate the sculptors' claims to social status as well as genius. Writing of the importance of drawing, Cellini (10) noted that when the artist was satisfied with the large model of his work, he should take charcoal and draw the figure on the marble block with great care. "The best method ever was that used by the great Michelangelo; after having drawn the principal view on the block, one begins to remove the marble from that side as if one were making a relief and in this way, step by step, brings to light the whole figure." Some of Cellini's contemporaries believed in an incubation period for their drawings. Rustici, Leonardo's follower, thought "that it was necessary first to reflect, then make sketches, then designs, to leave them for weeks and months without seeing them and then to select the best and execute them."

Responding to the historic rivalry between painting and sculpture, the late-Renaissance sculptor stressed the importance of producing images with beautiful aspects from eight different views, increasing by seven the painter's best efforts. Such ambitions contributed to an emphasis on drawing and modeling alike. These new criteria developed an enormous emphasis on preparatory draughtsmanship among later sculptors such as Bouchardon (40), who executed hundreds of studies toward a single finished work.

New impetus for drawing also came from the Italian literature on the pursuit of grace and decorative skill, known as *maniera*. All the arts were to be engaged in the making of elegantly elaborated figures, the *maniera serpentinata*, defined by its sinuous, spiraling line. Goldsmith, who was painter and sculptor alike, used rhythmic, undulating forms, achieving the sophisticated, ingenious integration of their arts and crafts through design. Drawing made possible this virtuoso resolution of authority and refinement.

Sculpture, on the small as well as the colossal scale, was making an impact in important ways in the sixteenth century. Little wax figures and reliefs by such gifted sculptors as Andrea Sansovino (6) were made for the painters' use. Theaters with diminutive wax actors on experimental stages were employed by painters to work out complex compositions. This practice, used by Michelangelo, Titian, and Tintoretto (12, 13) was carried on in later centuries by masters like El Greco, Eakins (Cats. 68a-d), and Benton. Often the painters made these figures themselves, working as sculptors and then drawing after their models.

The monuments of the late Renaissance and of Antiquity were the great drawing teachers of the time. Michelangelo's Medici Tombs, reduced in size, came to

Venice with other of his works for use in Tintoretto's studio, and many studies were made by flickering candlelight. This practice began in the fifteenth century, but was far more highly developed in Bandinelli's Academy (Fig. 12), where a statue's shadows, cast against the wall like the figures in Plato's cave, taught students the secrets of beauty of line. Such drawings assimilated a new world of form, an innovational canon of proportions, a novel presentation of expression and musculature. Understanding through imitation, long the central practice of the Academy, was achieved by drawing alone.

Though very few pages related to the work of the Venetian sculptor Alessandro Vittoria survive, he was a keen judge of the genre, owning a splendid collection of works on paper, outstanding for many drawings by Parmigianino. In later times painters often turned to sculpture, but for a sculptor to paint was far more rare. Veronese, the silvery master of Venetian pictorialism, began as a sculptor. Only the clean graphism of his inked lines, building brisk armatures on paper, provides a clue to that early experience.

The same severe, handsomely Classical lines that define the Pazzi tomb and its rendering (14) are seen once again in an English monument dating from the early seventeenth century (18a). Designed by a Flemish sculptor working in England, the project brings together an authoritative use of Renaissance formulae with a local quality of the additive and the applied, of ornament laid onto the surface without a sense of continuity or transition. This turning away from conventional unity toward lively, unorthodox ornament is carried further still in a German drawing for a commemorative wall monument (17). Here sudden spurts of decoration become the fringes of a new seventeenth-century style—the Baroque.

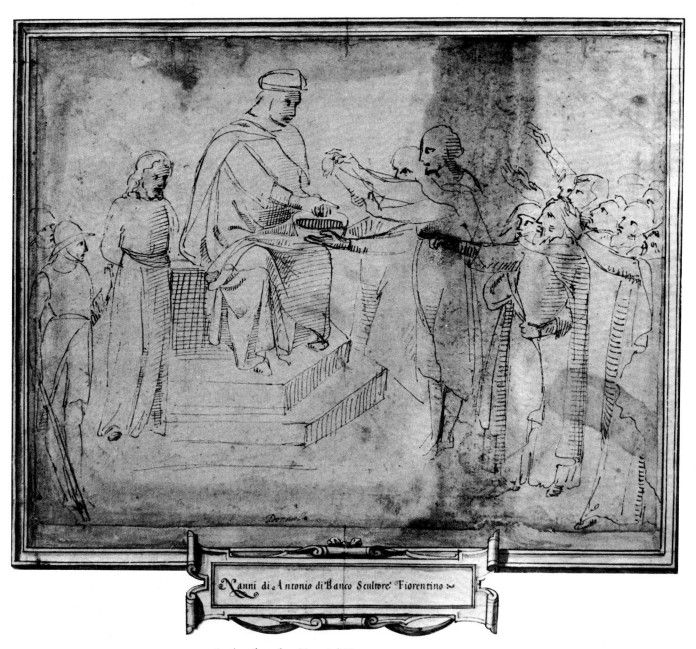

Nanni di Antonio di Banco Scultore Fiorentino

1. Attributed to Nanni di Banco:
Pilate Washing his Hands (recto), early 15th century.

2. Donatello: *David Triumphant* (verso).
Musée des Beaux-Arts, Rennes.

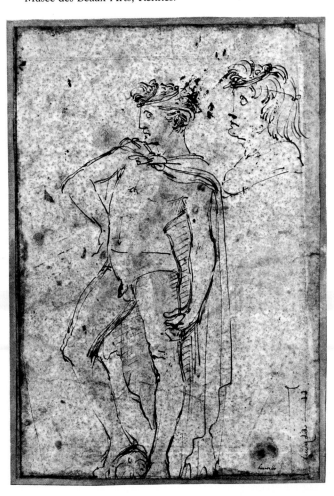

Attributed to Nanni di Banco:
Christ carrying Cross (verso), early 15th century.
Trustees of the
Chatsworth Settlement, Bakewell.

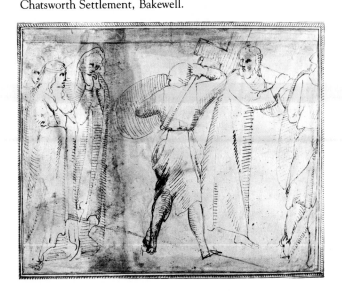

2. Donatello: *Massacre of the Innocents* (recto).

3. School of Benozzo Gozzoli: *Classical Torso*, c. 1475. The Cooper-Hewitt Museum, Smithsonian Institution, New York.

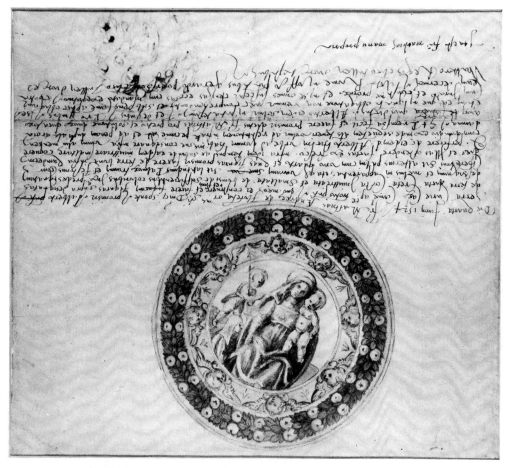

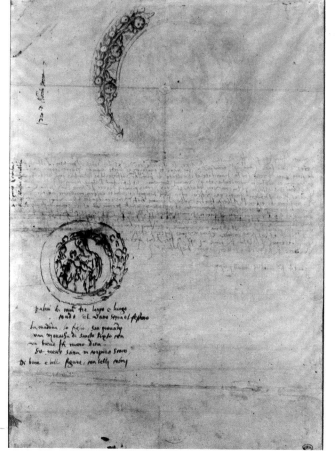

4. Marco della Robbia: *Designs for a Tondo of the Virgin and Child with Young Saint John and Nun,* (recto and verso), 1524. Visitors of the Ashmolean Museum, Oxford.

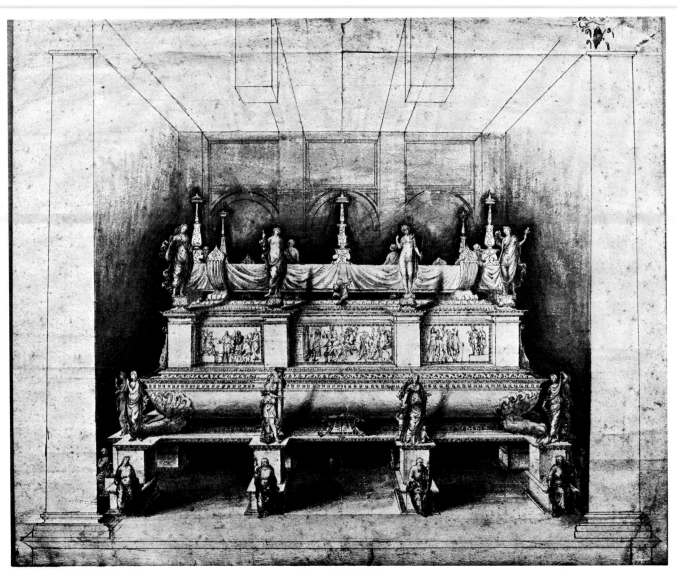

5. Attributed to Bambaia:
Design for Tomb commonly described as the Tomb of Gaston de Foix, c. 1515. Victoria and Albert Museum, London.

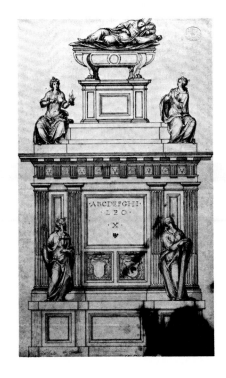

6. Andrea Sansovino:
Design for Tomb of Pope Leo X, (?) c. 1521. Victoria and Albert Museum, London.

8. Baccio Bandinelli:
Design for Tomb of Pope Clement VII, c. 1536.
Museum of Art, Rhode Island School of Design, Providence.

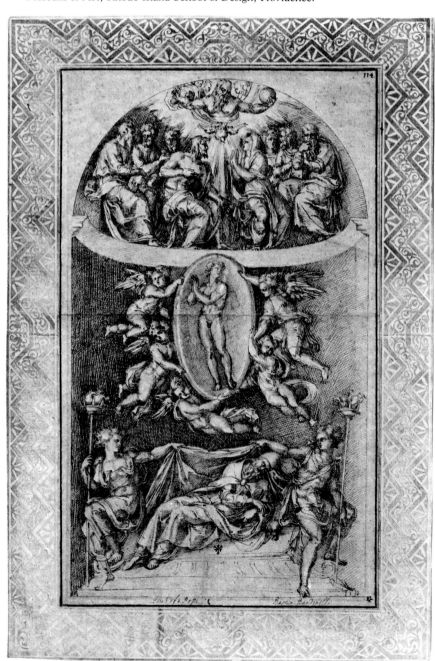

7. Baccio Bandinelli:
*Design for base
of the Doria Monument,* c. 1529-30.
The Cooper-Hewitt Museum,
Smithsonian Institution, New York.

Attributed to Ammanati:
Leda and the Swan,
Victoria and Albert Museum, London.

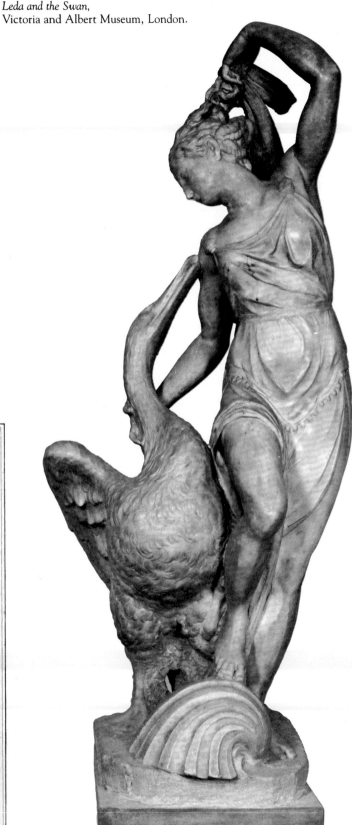

9. Attributed to Bartolomeo Ammanati:
Study sheet with Leda and the Swan,
a Pietà. Museum of Fine Arts,
Boston. Francis Bartlett Fund.

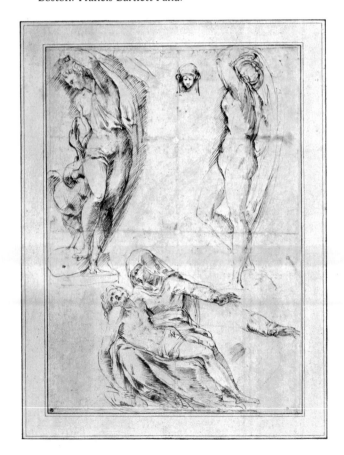

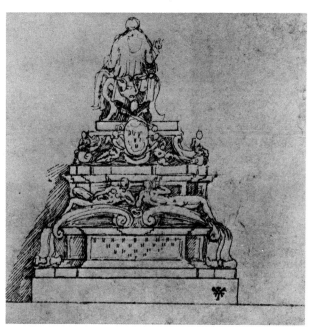

10. Benvenuto Cellini:
*Drawing of a Satyr for
the Porte Dorée, Fontainebleau*, c. 1543.
Ian Woodner Family Collection, New York.

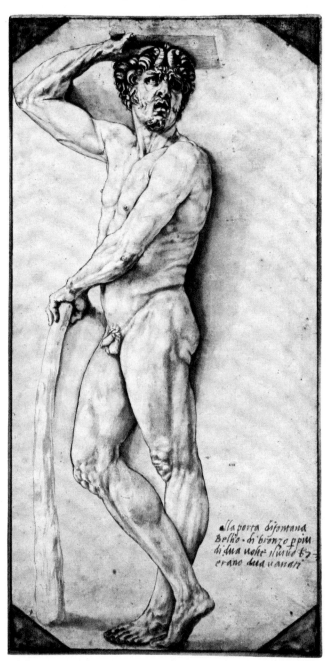

della Porta: *Tomb of Pope Paul III*, Saint Peter's, Rome.

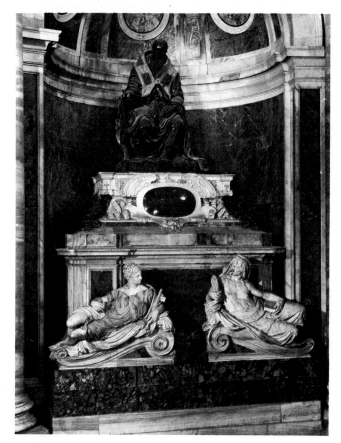

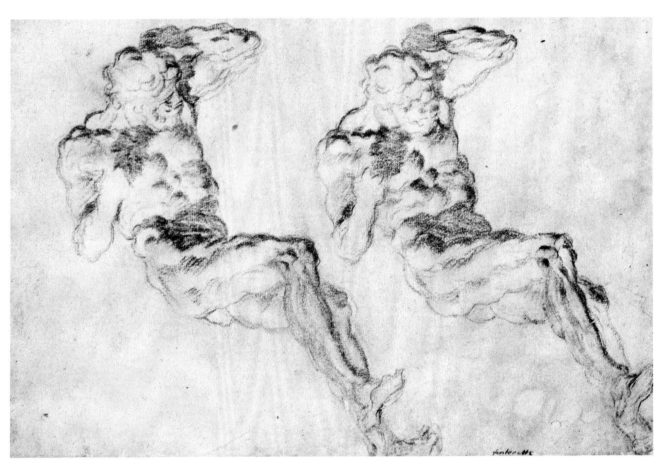

12. Jacopo Tintoretto:
Drawing after Jacopo Sansovino's "Atlas",
c. 1559 (recto and verso).
William H. Schab Gallery, Inc.,
New York.

Jacopo Sansovino, *Atlas,* Pushkin Museum, Moscow.

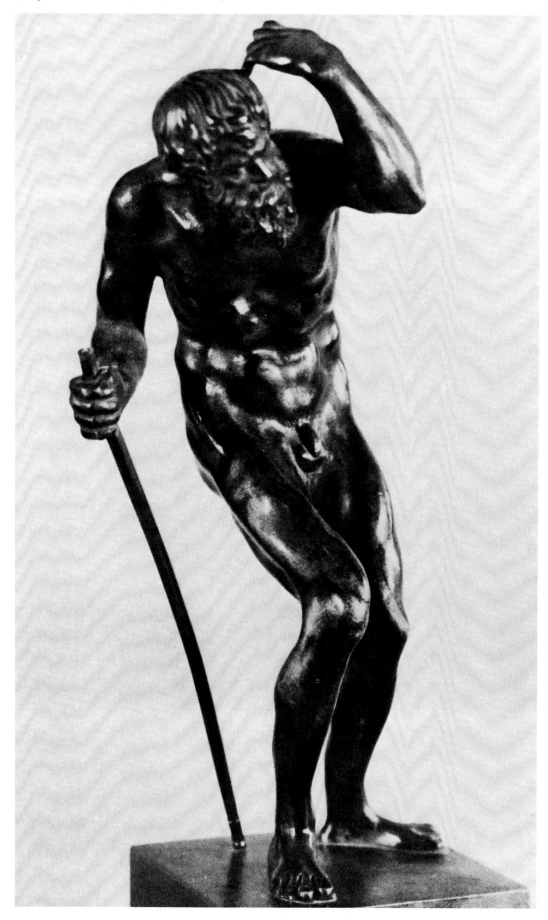

15. Vincenzo de' Rossi: *Design for the Fountain of the Twelve Labors of Hercules,* c. 1560. Cooper–Hewitt Museum, Smithsonian Institution, New York.

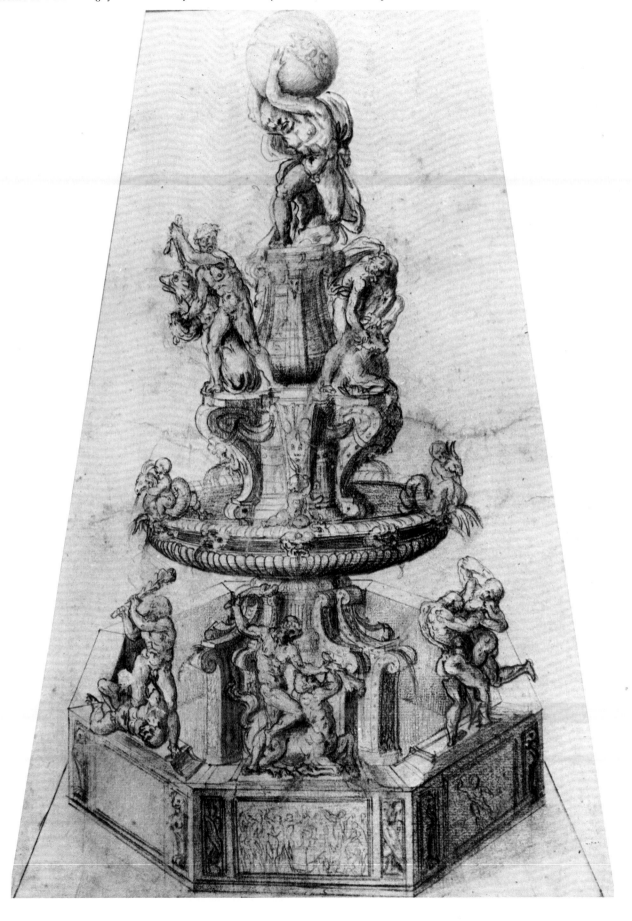

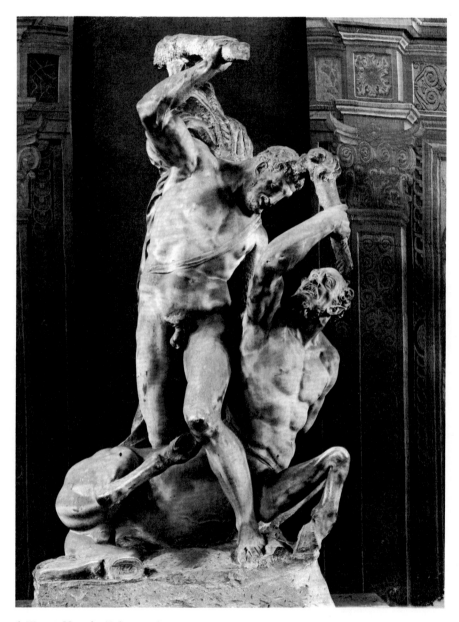

de' Rossi: *Hercules Fighting with a centaur,* c. 1584. Palazzo Vecchio, Florence.

16. Leonardo Sormani:
Design for Tomb of Pope Pius IV, 1577–1582.
Victoria and Albert Museum, London.

14. Italian Master active in France, c. 1550:
Tomb for Francesco(?) Pazzi,
Pennsylvania Academy of The Fine Arts, Philadelphia.

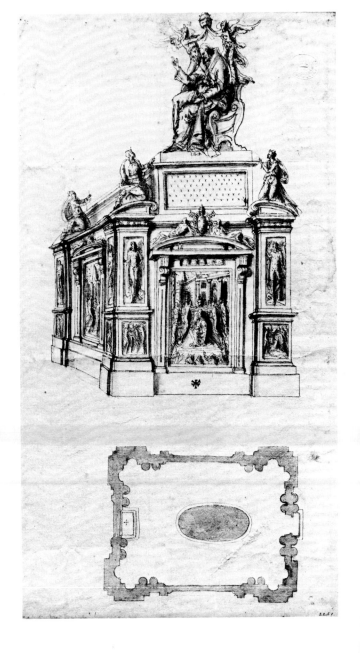

18b. Sebastian Colte: *Study for the Tomb of Sir George Savile,* c. 1627. University of Delaware, Library, Newark.

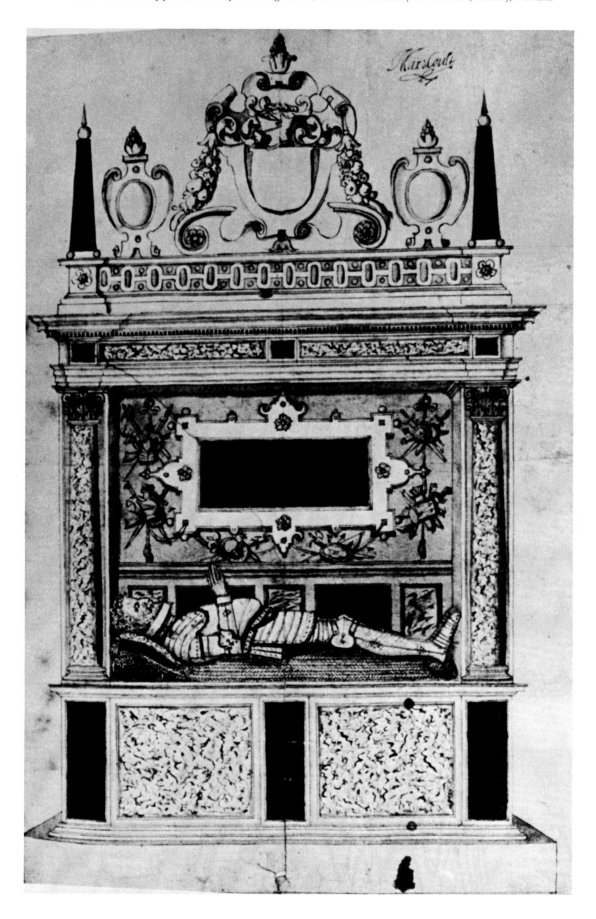

2. Drawn to Drama - Rendering Baroque Sculpture

Fig. 10
Donatello, *Christ giving keys to St. Peter*, bas-relief, Victoria and Albert Museum, London.

Baroque art, with its operatic approach, often suggests a synesthesia of all the arts. Suddenly sculpture, that most earthbound of all forms, was challenged to assume the extremes of vibrant, fleeting, theatrical effects. Moving to ever more ambitious illusion, the sculptor seemed called upon to produce not only the Commendatore's commemorative statue but life-like automata of *Don Giovanni's* entire cast. The greatest of the Italian Baroque sculptors, Bernini (28-30) and Algardi (19), both sometimes turned to painting as a source of inspiration, and both were brilliant draughtsmen, Bernini among the most prolific of his age. Algardi had his origins in painting as a student at the Bolognese Academy of Ludovico Carracci; Bernini, a sculptor's son, admired the art of Ludovico's cousin and pupil, the painter Annibale Carracci.

Conquest of motion and emotion, enlivened by light and a sense of the presence of color, were Bernini's greatest concerns and triumphs. No other master approached the audacity of his sculpture. Bernini's pencil was the basis of this unique artistry, the baton with which he conducted his symphonic effects. Few sculptors drew as rapidly, as dramatically, or as constantly. "Cavalier Bernini was most singular in the arts," his biographer Baldinucci wrote, "because he possessed in high measure skill in drawing. . . . infinite numbers of his drawings of the human body are found in almost all the famous galleries in Italy and elsewhere, showing a boldness of touch that is really a miracle." His studio walls were covered with charcoal for whatever project was under way. Rapid sketches in pen, on generous-sized pages, brought the work closer to view, as did the many smaller sheets with variants of the same composition in chalk or pen. After dashing off these initial explorations, Bernini liked to set them aside, returning to them weeks or months later to be seen and judged afresh. Then he would return to the drawing board, making surprisingly looping, calligraphic renderings in boldly abbreviated fashion. These terse, wire-like forms led to a final draft. Only then was he ready to make the finished version for presentation to his patron (29). Still more drawings usually followed, incorporating new requirements and directives. Like Michelangelo, Bernini was a hugely gifted architect, his success as a sculptor springing from and contributing to a builder's sense of space and plan.

Drawing after Hadrian's beloved *Antinous* brought the young Bernini to sculptural solutions. He called the statue his oracle, one that spoke to him whenever he drew the short-lived youth's contours. Despite his criticizing French art as too arid, too much drawing based on casts rather than nature, Bernini as *Principe* of the Roman Academy of Saint Luke (an unprecedented honor at twenty-three), stressed that "Before drawing from Nature it is necessary to fill the mind with noble ideas from the antique." He was a master of chalk studies from the nude model, usually in a Classical pose, but he never lost the sculptor's early discipline of retracing Antiquity, walking four miles daily to sketch Rome's ancient monuments.

Papers littered Bernini's studio. Happily a few hundred of the thousands of splendid drawings that sprang so effortlessly from his hand still survive. Among the very finest is his portrait of his great patron, Scipione Borghese (Fig. 15). Before carving the bust (Fig. 16) Bernini engaged his sitter in conversation to obtain the liveliest possible likeness on paper and in clay, making many sketches and models. But all these were banished when work on the roughed-out marble began, a section at a time. Nothing was to come between artist and model. "I don't want to copy from myself," Bernini said, "but to create an original work."

Stone and water seem poles apart, but statuary placed where water begins and ends—at springs and urban water sources—promises a constant flow of this sub-

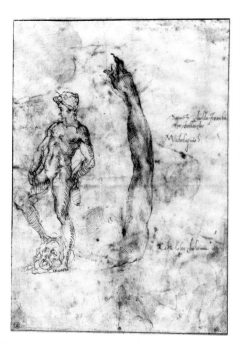

Fig. 11
Michelangelo, *Study for "David"*, Louvre, Cabinet des Dessins, Paris.

stance that is essential to life but often in short supply. This symbol of water's presence, the fountain, is one of sculpture's major contributions, even though many such statues now rest in the dry-dock of the museum.

Drawings for such projects show just how the water was to flow with the marble or bronze or travertine. Nymphs and river gods, virtues and heroes, placed at the source, personified the vital, eternal spring. Bernini, with his Baroque genius for drama, added tritons blowing conchs and great shells, often supported by dolphins. Most splendid of all these designs is *Neptune*, god of the seas, proclaiming his watery domain (28). Here the sculptor's technique with black chalk conveys a sense of mist, just as a later Italian drawing of a winged triton wading in a pond uses watercolor to provide an aqueous sensation (32). Prud'hon, returning to a Classical formula, shows a seated river god in a drawing that the painter, a great master of marble flesh, submitted for a Parisian monument project (50).

Going back to the great marble fountains of sixteenth-century Tuscany, to the designs of Ammanati (9), Giambologna and Tribolo, Derwent Wood (101) chose the great saucer-like basin of ancient times, brimming with water, using Steinbergian swoops of calligraphy to show just how the fluid would flow (101 verso).

Such emphasis on spontaneity was not to the French formal taste. It was Bernini who introduced the word "caricature" to Versailles, doodling acerbic spoofs of his sitters on paper whenever the immortalization of their too, too flabby flesh into marble was more than he could manage. Like the early sculptors, Bernini "drew" on wet clay, making quick incisions on his terra-cotta models (a practice shown in Fig. 19), describing by line alone the changes that were to be made in the final work. Deeply devout, Bernini's first thoughts, his *pensieri*, were drawn in moments of divine frenzy—*furor poeticus*—in an ecstatic state of revelation and creativity. He described this critical moment as one in which he was but a tool of divine grace.

Although the aging Bernini employed the painter Il Gaulli to project his vision into the second dimension, several Baroque sculptors worked directly in both media. Others devoted more of their energy to painting but designed much sculpture as well, such as Ciro Ferri (24).

Two drawings by Algardi and Bernini show them freed from the technical limitations of sculpture, in projects that may have been meant for paintings or prints. Bernini's *Penitent Saint Jerome* (30) presents a favorite theme of the Counter-Reformation, one that the artist had sculpted a decade before for a niche in the Chigi Chapel, in the Siena Cathedral. But this study and two that pre-date it are far more dramatic than the statue, showing the saint in a state of penitential abandon. Like many sculptors' drawings of the nineteenth and twentieth centuries, Bernini's is a fantasy, a vision beyond translation into stone or bronze. Algardi's work (19) points to a graphic context—possibly a book illustration or a decoration for a festivity, like Cornacchini's angelic *Fame* (37).

Less exuberant than Bernini, Algardi, in his own harmonious classicism, was a major figure for future generations of sculptors. Monnot (31), among others, turned to Algardi's handsome art as more dependable than Bernini's. Bracci (35), another sculptor active in Rome, found Algardi a useful source even though he retained a keen appreciation of Bernini's achievements.

Spain, which kept the traditional balance between the arts, saw such gifted sculptors as Cano (22) and his follower Herrera y Barnuevo (23) move back and forth between painting and sculpture. Sometimes both were combined in designs for festivities, as in Herrera's sea-goddess (23). Rubens, primarily a painter, also designed much temporary sculpture for triumphal entries as well as creating archi-

tectural decoration and producing small-scale works in precious media like ivory. His dramatic art, along with the paintings of Cortona, was adapted by many sculptors of the seventeenth century.

In the north, drawing toward sculpture was put on an increasingly formal footing through the founding in 1648 of the Académie Royale de la Peinture et de la Sculpture. Like its sixteenth-century Florentine model, the Académie was established to elevate artists from the restrictions of the guild to a loftier intellectual plateau, closer to court than to craft. Only drawing classes were conducted within the Académie's amphitheatre, with more immediate technical matters learnt by practice in the studios of sculptors on the faculty.

Before confronting the live model, the student began by copying ears, noses, lips, and limbs from prints—the *modèles de dessin*. After that, the novice drew from similarly fragmented casts, then traced the statue in its entirety (Fig. 17). Successful completion of such studies permitted the future painters and sculptors of the *école du modèle* to confront anatomy and perspective by drawing. So when the future sculptor finally got to the essence of art—man—his living model was seen through the "corrective" veil of the Classical ideal.

Academic procedures were ever more standardized in the centuries to come, when drawing was first to be done by contour (*dessin du trait*) and then enriched with shading (*dessin ombré*). High relief was obtained by hatching and by *estompe*, simply smudging the pencil or charcoal by rubbing it with pointed paper (50), as prescribed in the eighteenth and nineteenth centuries.

In Donatello's day and in subsequent inventories, his reliefs were described as paintings, as *tavole*, clearly enjoying as much prestige as the greatest pictures of the time, if not more. But toward the end of the Baroque era sculptors began to be taught from painting. Gifted students from Tuscany were sent to Rome to study under Ferri's direction at the newly established Florentine academy, founded in 1673, at the Villa Madama. There sculptors such as Soldani were taught to master composition by copying paintings like Poussin's *Crucifixion* in relief.

Another student at the same academy, Foggini, also worked in an intensely dramatic style for some of his subjects, like the *David Victorious* (36), one of a series of twelve religious bronzes ordered from the leading sculptors of Florence. Foggini increases the "pictorial" aspects of the composition by stressing the prostrate body of Goliath, stretched along the ground, with David "riding" his dead giant, holding the severed head. A similar sense of drama pervades von der Auvera's work-sheet (38). Here Rococo motifs are assembled for his assistants' guidance, to adorn the theatre-like little churches of Franconia, where priest and parishioner alike are caught up in a *son et lumière* of glittering gold and white, with the heavens opening above in paradisiacal pastel shades.

While a pictorial sculptor—Bernini—dominated Italian statuary in the late seventeenth century, the reverse was true for France. There the king's painter, Charles LeBrun (27) directed the lion's share of commissions beginning in 1664. These were given out with prodigality at Versailles and elsewhere. Too intelligent to expect a gifted master to follow his every detail, LeBrun contented himself with establishing the general outlines, theme, and composition of the work and then selected a sculptor for what he, and not LeBrun, could do. Possibly the force of LeBrun's graphic guidance may explain the extraordinary scarcity of drawings from such gifted masters as Girardon, Coysevox, or Coustou.

Other painters were pressed into service to furnish designs for sculpture. Those of Poussin are, unsurprisingly, for the most part restrained Classical forms, a series of

Fig. 12
Bandinelli's *Academy at the Belvedere*, Rome, 1531.

herms at Versailles. Rejecting the purist approach of the French Academy, Pierre Puget presents a more Romantic, Italianate style than that of his fellow country-men. First trained at Marseilles, young Puget worked on the ornate carved decora-tions of ships, like many sculptors of that period, and his drawing shows us their waterfront workshops (25). He then went to Italy for a decade, steeping himself in Cortona's and Rubens' painting and in the sculpture of Michelangelo. Despite his personal, expressive art, Puget won a major commission for Versailles, *The Meeting of Alexander and Diogenes*. Completed in 1689, the large relief was never installed, possibly because of Puget's audacious interest in the ugly, as seen in his preparatory study for the soldier closest to Diogenes (26).

The South German sculpture of von der Auvera anticipates the light-hearted, delicious art of Tiepolo, who went north in the next generation to paint in the very same palace where Auvera had worked for so many years. Zephyr, the wind god, would present a challenge to any sculptor, and perhaps only a painter like Tiepolo would have thought to include him in a statuary group with Flora (39), which he designed for a villa's park in the Veneto. As was sometimes true of Bernini's most magnificent concepts, such as his *Neptune Fountain* (28), Tiepolo's project proved far beyond the limits and skills of the local sculptors. The art of the sculptor and that of the painter can present a chicken-and-egg conundrum. Infinitely varying in the ways that it participates in stylistic change, sculpture can act as the warp, or the weft, as well as the weaver. Drawings for sculpture may prove so intricate as to be elusive in their workings. But here, Tiepolo's page would have been inconceivable without Bernini's art in stone and on paper.

Years after Italy and Germany had let sculpture and its drawing assume a more personal, relaxed quality, France still clung to the heroic tradition, typified by such monument-mania as Evrard Titon du Tillet's *Parnasse François* in honor of Louis XIV, a never-made ensemble, a massive folly of fifteen over-life-sized statues, symbol of sculpture's commemorative role. Only worked stone or its *simulacrum* could freeze the passing of time. For this reason, many painters had used *trompe l'oeil* renderings of illusionistic sculpture ever since the Middle Ages. Artists became sculptors by painting symbolic carvings into their canvases. These images came to convey new shrewd sentiments such as "The Triumph of Time over Love," or showed how passion spent could still be profitably exploited by a bored king's resourceful mistress in allegories of Friendship.

The practice and skill of drawing, as much as modeling and carving, came to define the work of the major French sculptor during the mid-eighteenth century. A painter's son, Bouchardon drew toward sculpture in an even more complex way than Bernini, whose works, with those of Raphael and Domenichino, Bouchardon had studied so closely as a *Prix de Rome* winner. For an equestrian statue of Louis XV, to which he devoted the last decade of his life, Bouchardon prepared about four hundred pages. He also drew for guide books in draughtsmanship, such as his *Livre de diverses figures d'Académies dessinées d'après la nature* (173) (40) and *L'Anatomie nécessaire pour l'usage de dessin* (1744).

Bouchardon's first drawings from the model were done freely, followed, once the basic form had been arrived at, by studies in contour alone, or with modeling of a portion of the work. Then a small clay or plaster sketch (*maquette*) was prepared from the drawing. Now Bouchardon went back to the draughting board, posing the model as rendered in the round, examining the living source and drawing after the figure once again as a "control." What resulted from this repeat performance were very elaborate indications of chiaroscuro, modeling, and musculature. He would

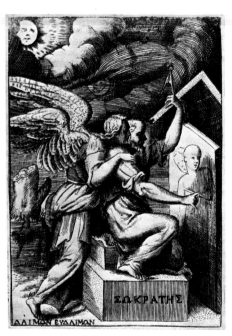

Fig. 13
Socrates as Sculptor, 1555, engraving by
Bonasone.

draw his figure from different vantage points, "in the round," stopping every two feet or so as he walked around the model to record the pose and the special effects of light upon the body. Returning to Cellini's comparison between painting and sculpture, the French sculptor Varazone agreed that the superiority of his medium lay in its eight views, seven more than the painter could produce. But here Bouchardon employed the second dimension as a key to the third; his studies on paper were of critical importance for the next stage, when a terra-cotta model was prepared in order to make the cast. Finally, the professional stonecutter, that highly skilled craftsman, would perform all but the final, finishing touches, copying the model with pointers. Then the marble returned to Bouchardon, who, working with sandpaper and polishing agents, re-created the very same highlights on the stone's surface previously indicated with such skill in his sanguine studies.

Sanguine, used so brilliantly by Bouchardon, is a hard red chalk especially effective for sculptors' drawings. Jombert, whose *Méthode pour apprendre le Dessin* (Paris, 1840) was a popular text, warned his readers, "Beyond a certain point, continuing to draw on white paper would lead to a dry and narrow manner that could only be avoided through experiencing the warmth of colored papers and the facility of black and white chalk media. Only those not destined to paint, such as the sculptor Bouchardon, remained exclusively attached to red chalk; for others, too much of it was a danger and a waste of time." Colored paper, used widely during the Renaissance, was very effective for drawing for and from sculpture, as in Tintoretto's many studies on blue or buff paper (12, 13). The warmth of the page, contrasted with the rich tonality of chalks, creates a sense of space and light.

Great spenders, the kings of France sometimes made money as well. They saw to it that Boucher's small figure drawings were converted into the highly profitable porcelain figures from the royal manufactures at Sèvres. Toward such sound commercial goals, Louis XV founded a school frankly dedicated to the decorative arts—the Ecole Gratuite de Dessin, which opened with fifteen hundred students. Established in 1767, it was under the direction of the Pompadour's favorite flower painter, Bachelier, who was also in charge of porcelain painting at Sèvres. Known affectionately as the Petite Ecole in the mid-nineteenth century, the school still survives as the Ecole Nationale des Arts Decoratifs.

Like the Academy, the Ecole had teaching by drawing as its *raison d'être*, but the study of ornament, of animals and flowers, with instruction in architecture and geometry made it a very different place. Oriented to a practical, no-nonsense curriculum, to the commercial "How" rather than the theoretical "Why" of the Academy, the Ecole's scholarship and dynamic, direct instruction made it a haven for talented poor boys who had to earn while they learned. Many of them were to do decorative plaster work, learning such crafts at the Petite Ecole. Significantly, Falconet, the gifted master who was director of sculpture at Sèvres, felt that both the wonders of Antiquity and the necessity of drawing were vastly exaggerated, opposing Langier's fashionable contemporary view that "perfection of design is the whole merit of sculpture." His *Reflections on Sculpture* (1761) argued for the importance of the nude, for working directly, without excessive use of drawing, which, in Falconet's view, tended to make figures too elaborate for sculpture.

The growing freedom in French art, after the rigorous methods of Bouchardon and the new austerity of neo-Classicism, can be found in Pajou's work. His *modus operandi* was far less involved than his predecessors'. Beginning with drawing, Pajou went on to the terra-cotta model and ended with the finished work. Perhaps his greatest image is his funerary monument to Maréchal Fouquet, Duc de Belle Isle

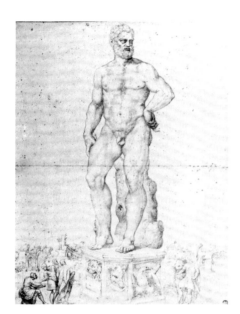

Fig. 14
Ammanati's Paduan *Hercules* drawn by the sculptor, Louvre, Cabinet des Dessins, Paris.

(41). Like the duke, whose only son predeceased him, the drawing was without issue, too expensive to be realized. With a new Romantic quality, combining drama and intimacy, Pajou shows the other side of Death's door, where the duke is reunited with his wife and son. For all its abundant Classical references and coloristic restraint, there is a quality of pathos here that anticipates much later sculpture. Pajou's large, splendid page was proudly exhibited at the Salon of 1761.

Though accident prevented the duke's tomb from "coming to life" in stone, a new vogue for purely illusionistic painted funerary monuments followed at the century's end. Such pictorial epitaphs, first used by frugal Florence in the Renaissance, returned once again in the flat "sculpture" of the Napoleonic period. Thousands of wall paintings of intricately vaulted and richly carved mausolea, usually done in fresco in stone-like tints of grey, proved popular monuments to the dear departed (52), the work of painters who thought like sculptors.

Pygmalion's passion for his beautiful statue, favorite myth of sculptors, was drawn by Pajou in a sketch for the Salle de l'Opéra at Versailles, a cascade of lines more than equal to their subject—the personification of genius as the spirit of playful and precocious babes (42). Such uninhibited gaiety was soon to be a thing of the past, thanks to an inhibited gay theorist, Winckelmann. His rigorous, humorless view of the Glory that was Greece (all he really knew was the Grandeur that was Rome) was to hold sway throughout the West for much of the late eighteenth and nineteenth centuries. "Quiet simplicity and noble grandeur" called for a deliberate, restrained art, with a new emphasis on stability and severity.

Color and movement were banished, and there was a return to the profile, in an effort to fuse beauty of contour with clarity. Though not a deliberate revival of the neo-Platonic concepts of idea and design that so influenced sculptors of the Renaissance, Winckelmann's emphasis upon outline gave new impetus to the importance of drawing in an abstract, intellectual, "de-materialized" style much like that of Renaissance draughtsmen working to and from sculpture. Sergel (43), Flaxman (47-49), Canova (46), Thorvaldsen (51), and their followers in Europe and America, though each came to terms with the Classical heritage on his own, were profoundly influenced by Winckelmann's writing and illustration.

19. Alessandro Algardi:
Allegorical Scene.
The Art Institute of Chicago,
Lenora Hall Gurley Memorial Collection.

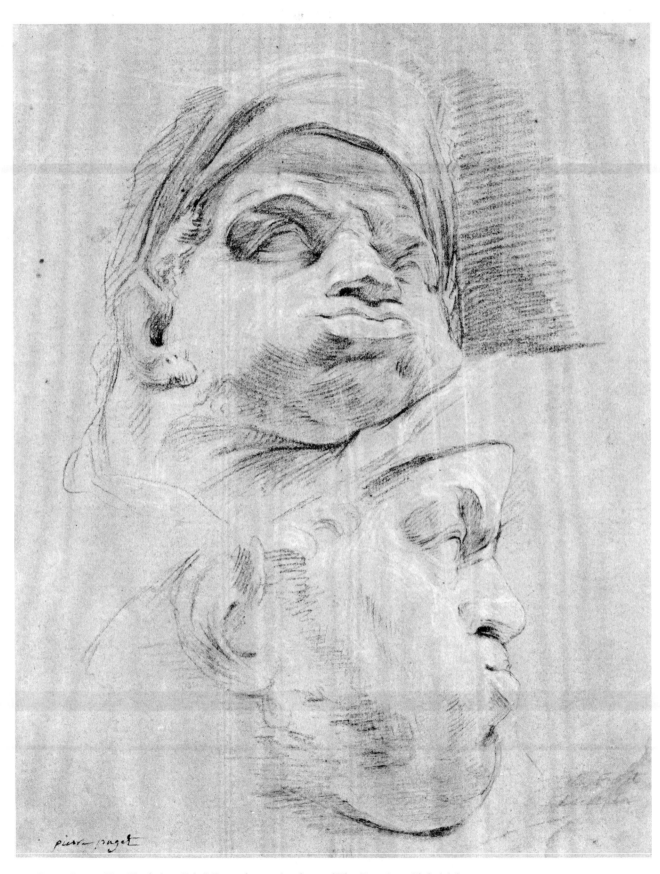

26. **Pierre Puget:** *Two Heads for a Relief.* Pennsylvania Academy of The Fine Arts, Philadelphia.

Puget: *Alexander and Diogenes,* 1670-89, Louvre, Paris.

20. Jacques Sarrazin:
Standing Figure—Study for "Autumn", 1630–32.
The Cooper–Hewitt Museum,
Smithsonian Institution, New York.
Engraving after lost *Autumn* by Sarrazin.

22. Alonso Cano: *Studies for the Annunciation* (recto)
Courtauld Institute Galleries, London.

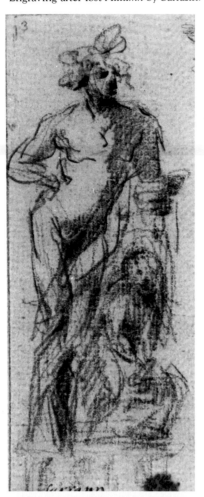

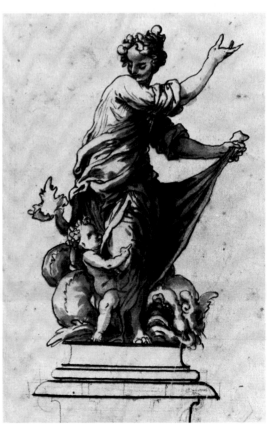

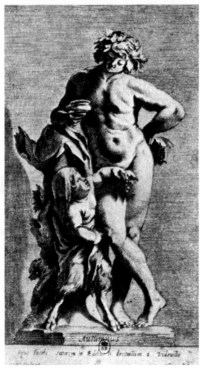

23. Sebastian de Herrera y Barnuevo:
Study for a Sculptural Group on a Pedestal
Courtauld Institute Galleries, London.

28. Gian Lorenzo Bernini:
Design for Neptune Fountain.
Lent by Her Majesty Queen Elizabeth II, Royal Library, Windsor Castle

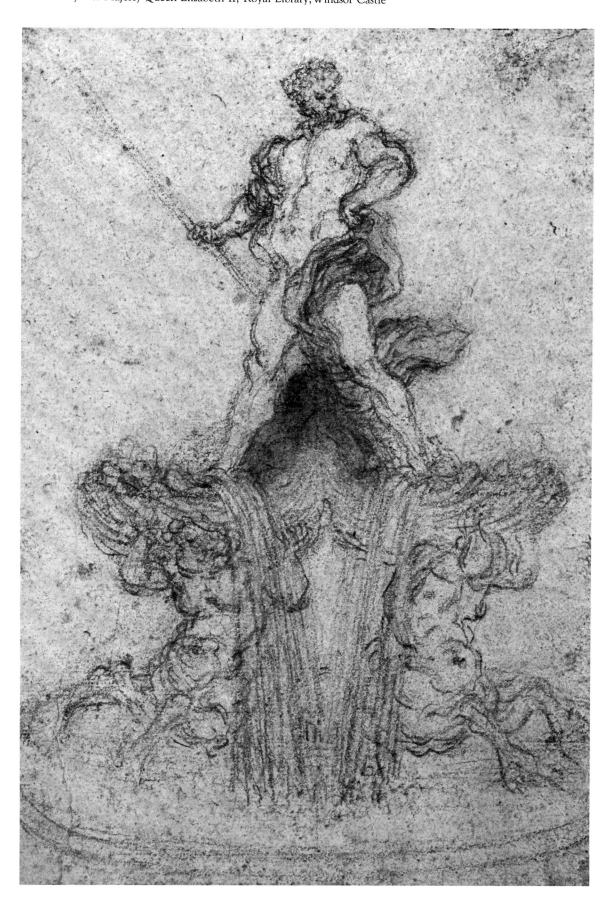

29. Gianlorenzo Bernini:
Design for Tomb of Pope Alexander VII,
c. 1671–78.
Pennsylvania Academy of The Fine Arts, Philadelphia.

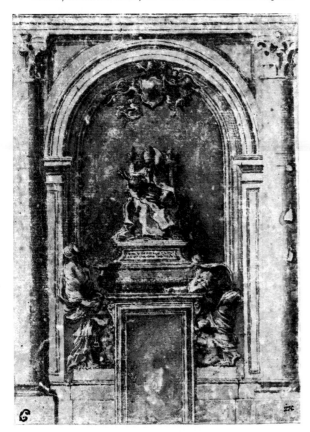

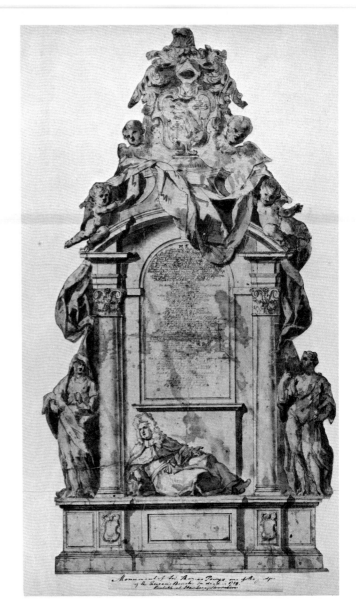

34. Robert Hartshorne:
Study for Tomb of Sir Thomas Powys, 1720.
Avery Library, Columbia University, New York.

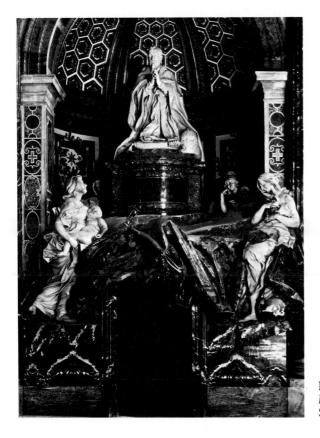

Bernini:
Design for Tomb of Pope Alexander VII,
St. Peter's, Rome.

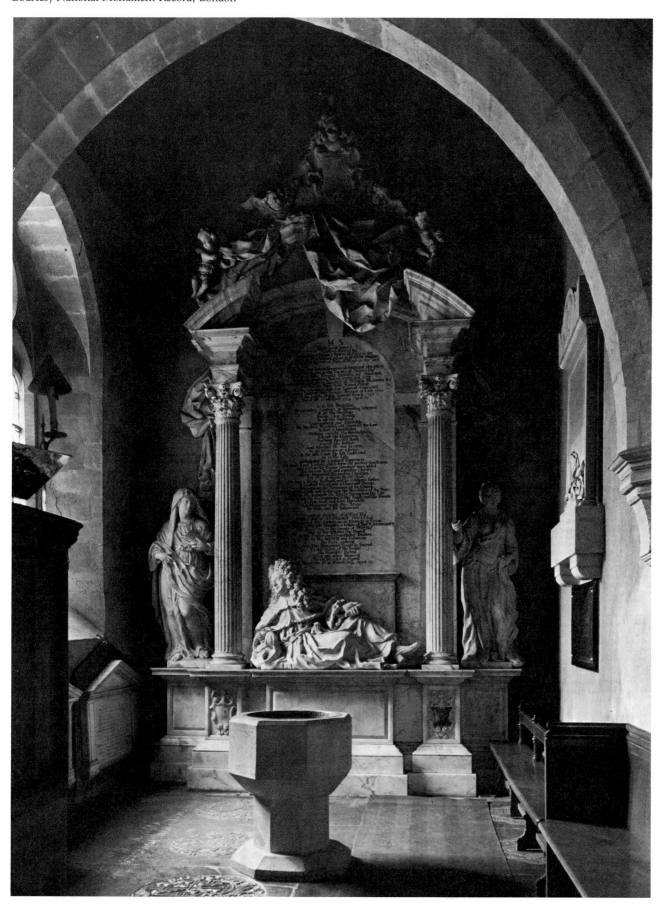

36. Giovanni Battista Foggini: *Drawing for the Group—David and Goliath,* c. 1723.
Avery Library, Columbia University, New York.

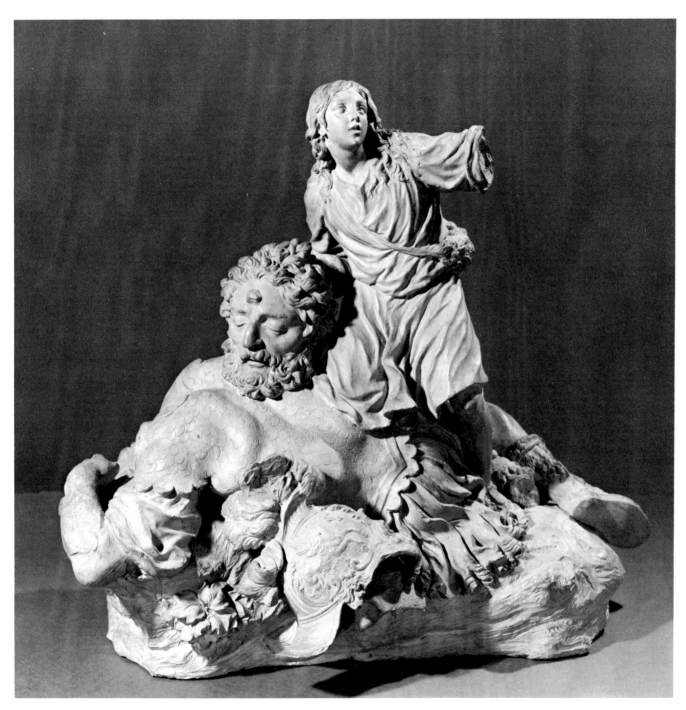

Foggini: Bozzetto,
David and Goliath, The Cleveland Museum of Art, Cleveland.
Gift of Harold T. Clark in Memory of Mrs. William B. Sanders.

38. Johann Wolfgang von der Auvera:
A sheet of studies.
Martin von Wagner Museum, University, Würzburg

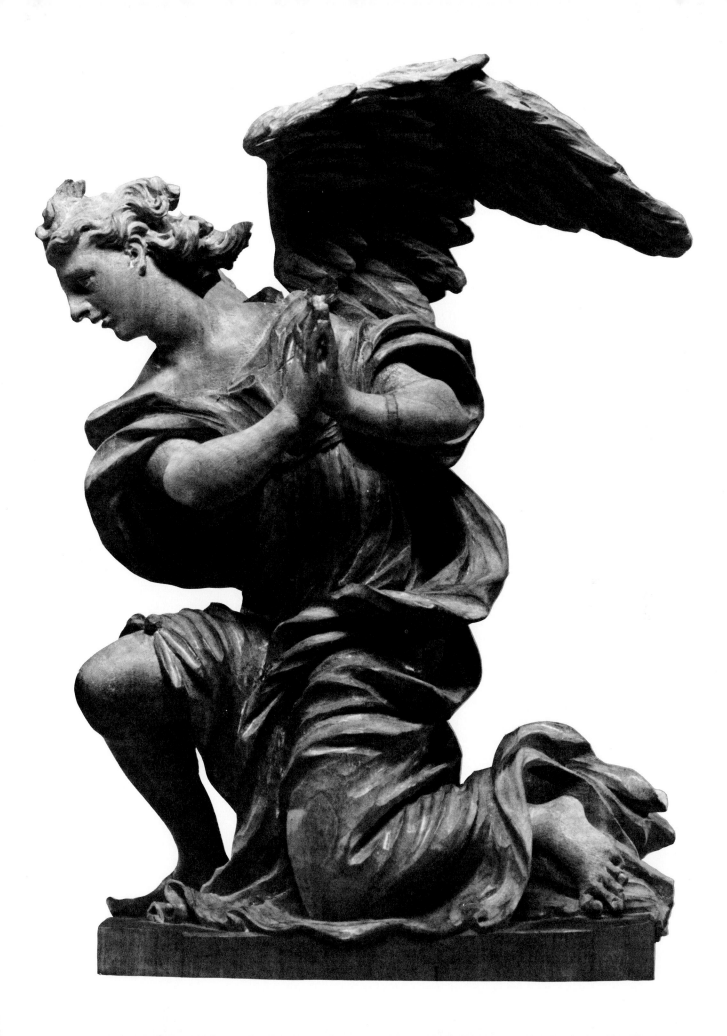

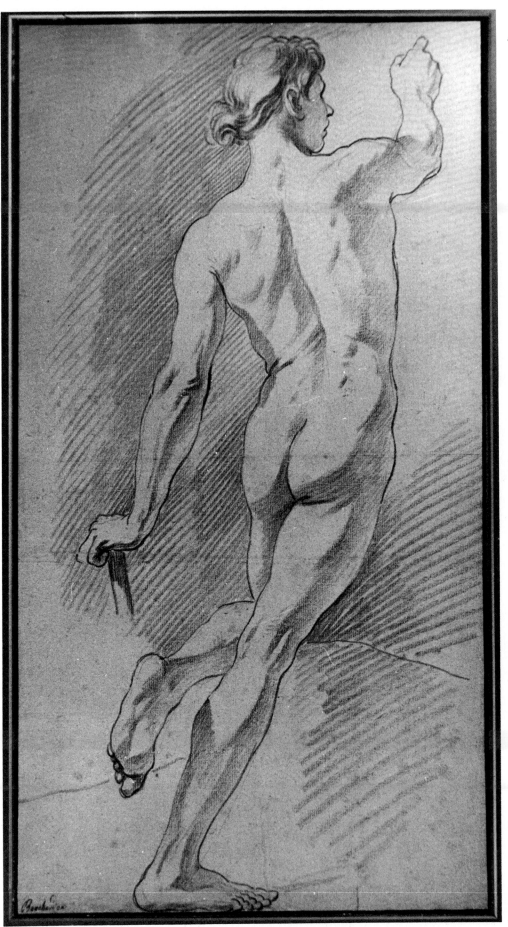

40. Edmé Bouchardon:
Academy—Standing Male Nude,
c. 1737. Private Collection,
New York.

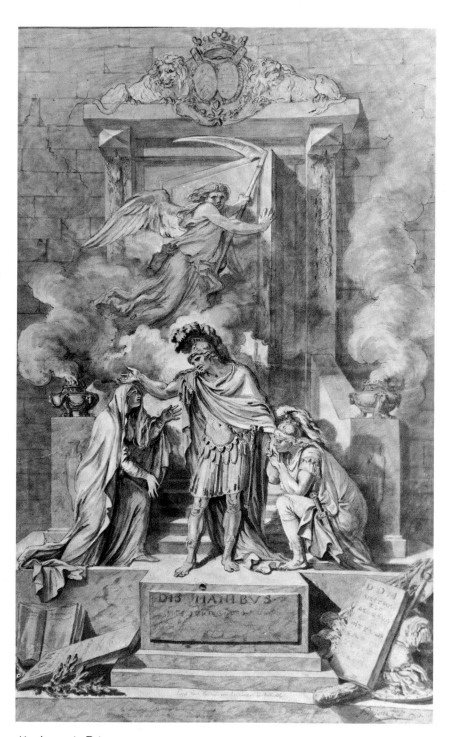

42. Augustin Pajou:
Study for two reliefs for the
Opéra at Versailles, c. 1768–70.
Arthur M. Sackler Foundation, New York.

41. Augustin Pajou:
Project for the Funerary Monument of
Maréchal de Belle-Isle, 1761.
The Cooper–Hewitt Museum,
Smithsonian Institution, New York.

43. Johann Tobias Sergel:
Study for "Tobias with the
Fish and the Demon Asmodeus", c. 1769.
Nationalmuseum, Stockholm.

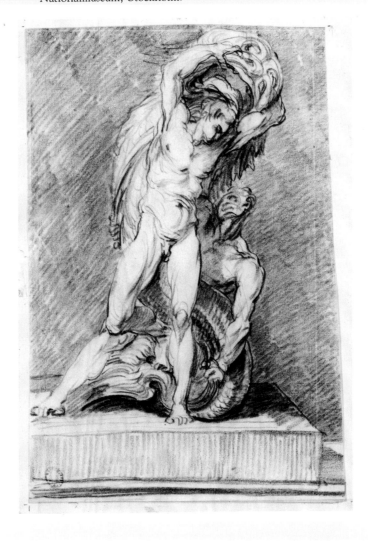

Sergel:
Tobias with the fish,
Nationalmuseum, Stockholm.

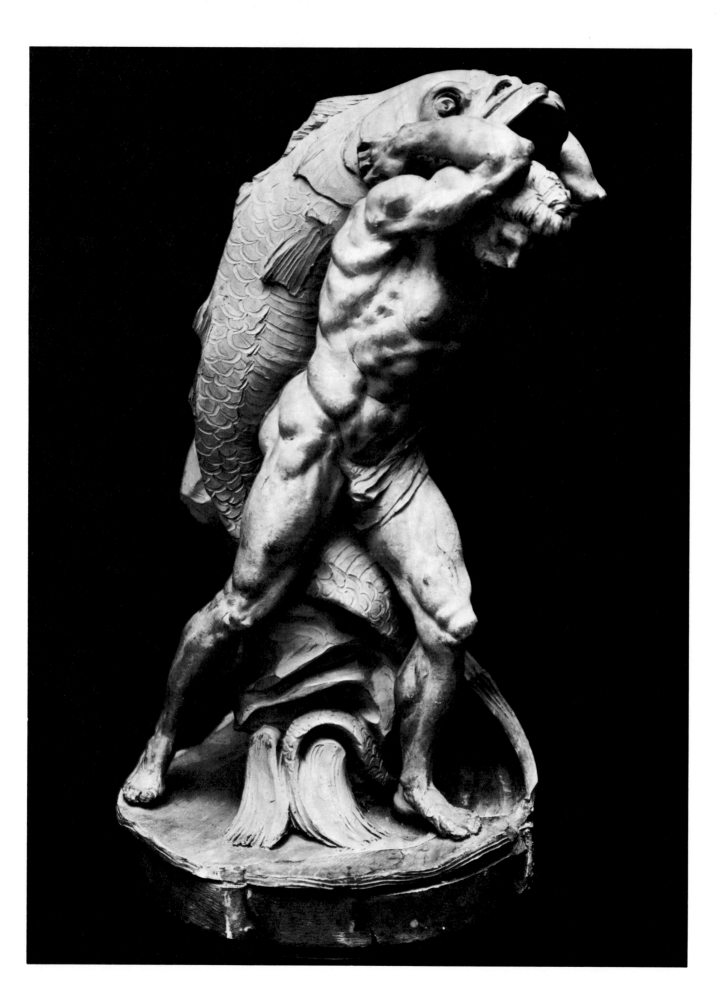

3. Graphic Exploration Between Classical and Romantic Models

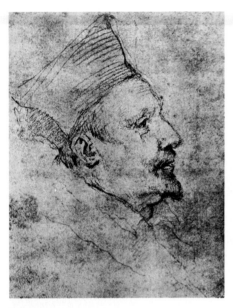

Fig. 15
Bernini, *Scipione Borghese*, c. 1632, Pierpont Morgan Library, New York.

Surprisingly, it was England that contributed in a major way to Winckelmann's radical reordering of sculptural priorities. Since the Middle Ages, England had made few contributions to the monumental arts, more often importing sculptors from the Continent, such as Torrigiano and Colte (18). Gifted native sons like Hartshorne (34) contented themselves with conforming to mainstream styles like Verbruggen's (33). Later, Nollekens (45) also followed established Continental lines. But with the work of Flaxman austerity and simplicity re-entered English sculpture, an economical art with several sources.

First came the renewed interest in Antiquity, intensified by the writings of Winckelmann (translated by Fuseli) and the finds at Pompeii and elsewhere, which had already greatly influenced Romney's paintings and drawings. Second was the ingenuity of the great potter Josiah Wedgwood, who popularized the new discoveries with his handsome ceramics, and brought Flaxman into his employ as designer. The sculptor's severe yet affectionate style in funerary monuments (48, 49) as well as his projected colossus of a *Britannia* (47) are harbingers of nineteenth-century taste, of the bourgeois Classicism of the Biedermeier period and the audacity of Bartholdi's *Statue of Liberty*. Such statuary shows a new concern for stasis, for the austerity of relief, and respect for contour.

Far more important than his works for Wedgwood was the fruit of Flaxman's Italian journey (financed by the potter), the series of drawings made there. These pages, seen by the whole Western world, conveyed Flaxman's all-in-a-line depictions of the *Odyssey* and the *Iliad*, Aeschylus, Hesiod, Dante (Fig. 18), and Bunyan. More than illustrations, these rich cycles of sculptors' drawings, like those of the fifteenth and sixteenth centuries, needed no text to convey the heroism and the beauty of biblical and classical images. A sculptor on paper, Flaxman brought a new sense of the abstract and the sublime to the coming century.

Flaxman's graphic break with the recent past can be seen by comparing his drawings with those of the gifted sculptor Sergel, the Swedish master fifteen years his senior. Studies for Sergel's *Tobias*, 1769-70 (43), still reflect the tradition of Bernini. Prepared about three years after he came to Rome, his biblical subject is drawn with warmth and color, suggesting the terra-cotta sketch to come. By the 1790's Sergel had also evolved a radically simplified style, charged with the strangely touching aridity of even the liveliest neo-Classicism, like that of Giani's *Severoli Memorial Tablets* (53). Piranesi's stormy, melancholic Classicism and Fuseli's bizarre pictorial revision of Michelangelo contributed to a shifting perspective in the darkening and revolutionary close of the Enlightened Age.

Equally personal in his approach to Antiquity is the sculptor Canova. Two years Flaxman's junior, the Venetian sculptor, like many others, began as a mason. Travels to Naples and Pompeii soon changed young Canova's style from one that had affinities with mid-century French art to a more neo-Classical style. His massive papal monuments led to international fame and major commissions in Vienna and Paris, where he produced gargantuan images of Napoleon, among many others, becoming Europe's most famous sculptor. Canova's draughtsmanship is far lighter in spirit than much of his statuary. Many of his pages have the qualities of reverie found in Sergel's drawings, and his study for the *Hercules and Lycas* (46) is almost cinematic in its quick transcription of movement, fusing the dramatic sense of connection with one of sudden, spinning release. Like Bernini and Bouchardon, Canova viewed drawing as a lifelong exercise. Beginning every day at the drawing board, he kept a full-time model for such critical practice. But drawing was far more than an academic discipline for Canova. It provided a complex fusion of escape

and exploration, both visionary and functional.

The Dane Bertel Thorvaldsen also gained international acclaim, the only Protestant ever to make a major papal tomb. His early study for a Bacchus (51), shows the immensely gifted young sculptor keenly and equally aware of the images of Antiquity and those of the Renaissance. Presenting two alternative poses for the wine god's head, this drawing, like Sergel's early *Tobias* (43), conveys much of the animation of earlier eighteenth-century art. To their contemporaries, Canova and Thorvaldsen had the stature of Michelangelo. Like the Florentine residence of the last of the Buonarroti, Canova's studio and Thorvaldsen's house became shrines of art, lasting tributes to their genius.

Far from such authoritative evocations of Antiquity in Europe is a primitive personification of *Columbia* (54). She may be the work of one of the first American sculptors, the Philadelphia woodcarver William Rush, who had founded an artist's society in 1795 under the aegis of that goddess of Democracy. Though major examples of Houdon's art and, later, that of Canova were to be found in America, the few early academies stressed painting over sculpture, as this simple sanguine drawing, along with Rush's naïve sculpture, shows.

Ingres, son of an ornamental sculptor, who first taught him drawing, was a lifelong student of statuary, scarcely needing his teacher David's injunction to "Love sculpture—she gives the idea of beautiful form." Bartolini, a fellow student in David's studio, shared his friend Ingres's love for Flaxman's works and for the art of the fifteenth century. Meanwhile, other sculptors were returning to the early statuary of Tuscany and Lombardy, copying the delicate, precise ornament and lapidary subtlety of Quattrocento portraiture. Bartolini's *Carità Educatrice*, 1824, with its elongated, slightly archaizing forms and smoothly simplified features, shares this revival, as does his preparatory drawing for it (55). Here the Italian master's slashing lines recall the pen strokes of the fifteenth and sixteenth centuries. Steeped though he was in the neo-Classical, Bartolini made an important break with its increasingly monotonous idealism and sterile perfection.

Many American sculptors, such as Horatio Greenough, came to Bartolini's Florentine studio in the 1820's and '30's. There, Ingres's portrait of the sculptor, so very like Bronzino's of a Renaissance stonecutter, may have hung on the wall. Greenough returned to America in 1826 with the clay model for his Zeus-like *Washington*, destined for the Capitol. Though ridiculed for its somewhat awkward nudity, the marble remains a major monument in the history of American sculpture, and its authority is evident in a highly finished rendering (56).

Like most of the larger marbles of the century, Greenough's *Washington* was carved in Europe, by the skilled stonecutters of Carrara. As Hiram Powers, who had made the famous *Greek Slave*, wrote in 1859, without such prodigious, skilled, and cheap labor "a sculptor can do but little—and there is not a workman of this description that I would trust and employ in all America. If I do go home, I must leave my *hands* behind me." Thus, drawing and sketches had become more important than ever, as the sculptor was called upon to make no more than a model, to be enlarged and carved by others.

The Pleiades, Henry Kirke Brown's drawing for a lost relief (60), shows how strongly Flaxman's influence was still felt in the mid-nineteenth century, especially in America, where sculptors learnt more from books and prints than from the few available works in the round. German sculpture too was known, since so many Americans went to study in Munich, Dusseldorf, and Dresden. Hahnel's handsome study (59) for a frieze in Dresden's Old Court Theatre influenced the way

American students saw the art of Antiquity as well as that of the present.

Somewhat stodgy, the establishment style of the 1840's is epitomized by the stalwart Roman matron who stands for Serious Comedy in Pradier's *Molière Fountain* (58). Baudelaire noted three years after the Ingres-like lady's completion that Pradier's virtual monarchy over the art showed sculpture's pitiful state; he characterized Pradier's as a "cold and academic talent."

A more original master, Pradier's pupil, Etex, was the author of one of the best-loved books on drawing printed in the nineteenth century. His *Cours élémentaire de dessin* urged the reader never to be without "a notebook or sheet of paper, so as to catch the varied compositional lines of nature by observation of real life, on the street, in the fields, or when walking along a river." Writing in 1851, Etex urges the sculptor to take part in the surrounding world, to move away from the chilly confines of classical marble for the active space of daily life, advice evidently followed by Carpeaux, as shown by his carnets in the 1860's.

Most American sculptors had to go to Europe to work from the nude. The strange state of the arts in the States is best described by the teaching of anatomy in Massachusetts in 1861. When the sculptor and doctor William Rimmer began his lectures in art anatomy, "It was the first living element in art education Boston had ever possessed," Truman H. Bartlett recalled. "He drew in chalk upon a blackboard every bone and muscle with which the artist needed to be acquainted; first as an independent fact, and then in relation to the formation of the complete figure. Each member of the body was next drawn, to illustrate its principal physical movements, actions, and purposes; and finally the entire figure was similarly illustrated." Note the blackboard in Kirke Brown's studio (Fig. 2). A sculptor of great power, Rimmer's anatomical "drawings were made . . . not only as illustrative of facts . . . but every figure was a complete composition. His students were supposed to copy everything down that he drew on the board and he would then go among them, criticizing their work and using them as living models as an illustration of the type of character under consideration." Worked in the hardest of stones, Rimmer's statuary and draughtsmanship (62), was certainly by far the most individual and powerful in mid-nineteenth-century America, stemming from Michelangelo and later masters like Fuseli and Blake.

Studies of animal as well as human anatomy had long been important for modelers and carvers. Horses rather than dogs were ever a sculptor's best friend, getting their sitters off the ground and onto monumentality. Workers in the round from Leonardo da Vinci to Bouchardon prepared hundreds of measured drawings for their major equestrian projects. Other beasts also received some measure of graphic attention; but it was only in the early nineteenth century, following the painter's lead, that sculptors began once more to accord animals the consideration given them in Antiquity. Never since then had the animal kingdom been quite so closely watched and so richly found.

"The lion is dead! Come at a gallop! It is time for us to set to work!" So wrote Delacroix to his friend Barye in 1828, when they were both drawing at the Jardin des Plantes' zoo. The new genre of the animalier, made popular through Barye's bronzes, led to generations of sculptors' zoological drawings. Rodin, recalling instruction from Barye, described him as "The master of masters, who clung to nature with the force and tenacity of a god and dominated all . . . he was himself and himself alone. One thinks of him and the Assyrians together." A man of few words, Barye's credo was: "Observe nature, what other professor do you need?"

Toward the mid-nineteenth century, endlessly pictorial, illusionistic effects were

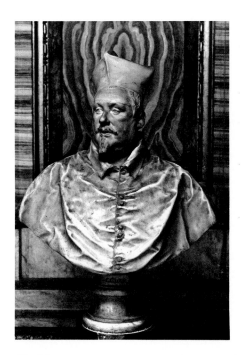

Fig. 16
Bernini, *Scipione Borghese*, Galleria Borghese, Rome.

played back by the new "multiple" techniques of bronze casting which recorded every detail of the modeled wax or clay. As sculpture rivaled painting in its infinitely detailed rendering, massive numbers of drawings were now prepared. The creative process for later-nineteenth-century bronze and marble, with its emphasis upon flickering light and its suggestion of rapid, balletic movement and hugely elaborate illusionism, presented new areas for exploration in two dimensions. Staggering numbers of little notebooks, *carnets* such as those of Barye (57), Carpeaux (63-65), and Chapu (69), were copiously filled. Meanwhile, their sculpture was often multiplied, issued in many bronze editions of varying size and quality, using new mechanical means.

Such artful mass-production in bronze and terra cotta was most skillfully developed by the enterprising Carrier-Belleuse. Though his works were issued in quantity, careful attention was paid to individual finishing. Carrier-Belleuse's playful *Nude* (66) is in sharp contrast to Pradier's grimly serious *Comedy*. His carefree eroticism is much in the spirit of later-eighteenth-century French masters like Clodion; Baudelaire, among others, took pleasure in this insouciant Rococo revival. Mid-nineteenth-century France, happily vulgar, with more money than taste, encouraged a sudden efflorescence of sculpture in all shapes and sizes, what Mirolli so well characterized as "Monuments for the Middle Class."

Emulating the French use of sculptors for the development of their profitable decorative arts, the English hired Carrier-Belleuse and Dalou from Paris for the porcelain works at Stoke-on-Trent, to design and promote English goods for the international market. English masters like Chantrey had already enjoyed commercial success earlier in the century, building monuments to commemorate the empire. Now sculpture as an industrial art boomed.

Among the most gifted sculptor-draughtsmen at mid-century was Alfred Stevens, who first won recognition at the World's Fair of 1851. Like so many later artists, he began as a painter and then turned to sculpture, studying with Thorvaldsen in Rome. Stevens rivaled the Renaissance masters, able to unite the gifts of Raphael and Michelangelo in his derivative but beautiful art (61).

When Carrier-Belleuse returned to France he ran a large workshop which enrolled many talented young sculptors. His neo-Rococo style, with its endless decorative applicability, made him a logical choice as instructor at the frankly commercial Petite Ecole. The school had a gifted faculty and student body, including Barye, Garnier, Carpeaux, and Rodin.

Of the combined drawing and modeling which took place in the crowded rooms of the Petite Ecole, the American sculptor Saint-Gaudens wrote in 1868, "We worked in a stuffy, overcrowded, absolutely unventilated theatre, with two rows of students, perhaps twenty-five in each row, seated in a semi-circle before the model, who stood against the wall. Behind those who drew were about fifteen sculptors... Here I modeled my first figures from the nude, and laid an excellent foundation for the future." However, Jacquot, one of his teachers, "maintained that you must draw freely and with no fear of the paper, while Laemelin's advice was that you should draw lightly, carefully and firmly, and not with sloppiness as do those who prefer to work with vigor. The result of this weekly divergence of views upon the boys can be imagined."

Before the long overdue reforms of the Ecole des Beaux-Arts, the Petite Ecole was the place where technical questions were tackled. Its strong-minded director, Horace Lecoq de Boisbaudran, author of *L'Education de la Mémoire Pittoresque*, Lecoq wanted students to concentrate upon the visual experience in a newly

Fig. 17
School of Drawing from Diderot *Encyclopèdie.*

intensive fashion. He urged sculptors to draw after the figure in motion, a practice that Rodin was always to use in later life (82).

Another sculptor associated with the Petite Ecole was Carpeaux, whose new, almost impressionist sensitivity to light and motion liberated the look of sculpture and its preparatory drawings. Both he and Degas drew after the dancers at the Opéra. Compared with the work of Carrier-Belleuse (66) and Falguière (77), Carpeaux's sculpture was more ambitious, sensitive, and observing. Beginning in the dramatic, literary tradition of the *Ugolino* (63a-c) Carpeaux soon found a style that won favor with the Second Empire. Close to the grand tradition, to the draughtsmanship of Michelangelo and the triumphs of French seventeenth-century Classicism, Carpeaux, in his thousands of drawings, worked toward sculpture with unrivaled pictorial freedom. His studies for *The Dance* for the Opéra façade, a work that horrified bourgeois sensibilities in 1869 by its frank nudity, show an almost expressionist sense of the moment (65a-b), anticipating Rodin's. Such intense preparation, very different from Bouchardon's glacially correct procedures, may be what occasioned criticism like Blanc's, that the Carpeaux *Dance* "seems as if it were done with a brush rather than a chisel. It is wrong to think that what is possible for a painter can be done by a sculptor."

Electing a safer path than Carpeaux's, the gifted Falguière allowed himself an exploration of the darker side of life only on paper or canvas. An extraordinary page from his hand (77) shows a composition for a picture as violent as Daumier's *Rue Transonain*, surrounded for convention's sake by studies for the usual flurry of petite but hugely profitable bronze nymphs.

An American counterpart to Falguière, his student, the talented sculptor Mac-Monnies, elected an almost always decorative, chronically light-hearted approach. Even his battle monuments have a festive air to them. His rendering of a memorial to a Civil War hero (81) would never suggest, in its briskly celebratory style, that the sculptor had gone to great lengths to study photographs of General McClellan so that his portrait would be accurate in every detail. Carpeaux, Rodin, and Falguière also employed the camera as a supplement to drawing and sketching, the first probably for his portraiture.

Though notable examples of his draughtsmanship survive, Dalou, Carrier-Belleuse's fellow "commercial traveler" to England, supposedly staged great potlatches in which all drawings for his sculpture were destroyed upon a project's completion. There is something strangely contradictory in Dalou's attitude toward drawing, since he himself was as fine a draughtsman as he was a sculptor, and stressed the great value of drawing as a teacher. The page in this collection (70) is one he prepared specifically for reproduction, after a completed work, using the same technique that Rodin would employ for the same purpose.

The delicate balance of light and shade made by the Renaissance masters in shallow relief is found in the work of Augustus Saint-Gaudens, who, with Whistler, was one of the few American artists to achieve an international reputation. Drawing played a large role in Saint-Gaudens' oeuvre. Sadly, many such works were burned in a studio fire. His sensitive graphic abbreviations, clues and cues toward sculpture, are in the tradition of the drawings of early sculptors such as the Vischer of Nürnberg, a style found again in the twentieth century in some of Giacometti's works. Paradoxically these pages seem the antithesis of sculpture. Flickering and trembling apparitions, the images seem drawn by a seismograph or a hygrometer, the lines, as they rise and fall, merely implying, in the most fugitive fashion, a ghost of the form to come. Like so many earlier masters, Saint-Gaudens

worked closely with painters and architects, with his friends John LaFarge (72) and the architect Stanford White. All three may well have felt, deservedly, in such pooling of energies and skill, a return to a golden age of artistic achievement.

Their contemporary Daniel Chester French, more academic in his approach, turned, for his inspiration for the *Minute Man* (67), to the Apollo Belvedere, the same famous antiquity that had already helped John Quincy Adams Ward arrive at the pose for his *George Washington* (76).

American painters who were close to French academic studio practitioners such as Meissonier sometimes returned to traditional working methods, making little model figures for their compositions. Eakins' *William Rush Carving his Allegorical Figure of the Schuylkill River* (Fig. 1) required the designing of at least six such small figures (68a-d). Arguing for the crucial importance of the nude model for artists' training, Eakins had selected this scene to support the reform of the Pennsylvania Academy founded by Rush (54) in 1805. Rush's use of the nude model had scandalized Philadelphians then just as Eakins' insistence on the right of women students to learn from the male nude shocked them in the 1880's. In Eakins' painting, Rush's studio wall is shown covered with notations which Eakins may have copied from the sculptor's drawings, later lost. Eakins used preparatory studies in the round from time to time for his own canvases, a practice that contemporaries such as Degas also counted upon for many of their paintings where an unusually difficult pose or motion was involved.

In fact, drawing, modeling, and carving enjoyed unusually active roles in the later nineteenth century. Gerome, Leighton, Klinger, Degas, Gauguin, and many others found an alternation of media stimulating. For some, like Degas, their sculpture worked as a guide and source for their major canvases; others brought painting to sculpture, producing elaborately polychromed statuary or figures made of vari-colored stones and metals. Occasionally a very gifted painter such as Meunier abandoned that art in favor of sculpture, the beneficiary of his many magnificent preparatory studies on paper.

Friendships between painters and sculptors brought significant extensions and exchanges from one medium to the other. This was true for Donatello and Masaccio, Ingres and Bartolini, LaFarge and Saint-Gaudens, Rodin and Carriere. Such reciprocity was particularly important for German art, in the link between the highly gifted later-nineteenth-century sculptor and theorist Hildebrant and the equally forceful Hans Von Marees, an outstanding painter of the period.

Hildebrant felt drawing was the beginning of the sculptor's thought, as line moved from the page, to the relief, to the work in the round. He stressed how Greek and Egyptian reliefs (Fig. 4) and statuary alike started with extensive linear indications, laying out the carving to follow. His new emphasis on the purist and the planimetric, a far cry from mid-nineteenth-century anecdotal concerns, suggests the bold Classical simplicity of Canova, Schardow, and Thorvaldsen. Austere pages and monumental restraint lead the way. Also striving for a new lucidity, for a clarification of surface far from the intricately descriptive yet mindless surface of so much sculpture of the day, is the art of the Belgian master Minne. His pages (80), with their powerful emphasis upon pure contour and elongated, expressive form, augur much of the art of the twentieth century.

46. Antonio Canova:
Study for Hercules and Lycas, 1795.
Michael Hall, New York.

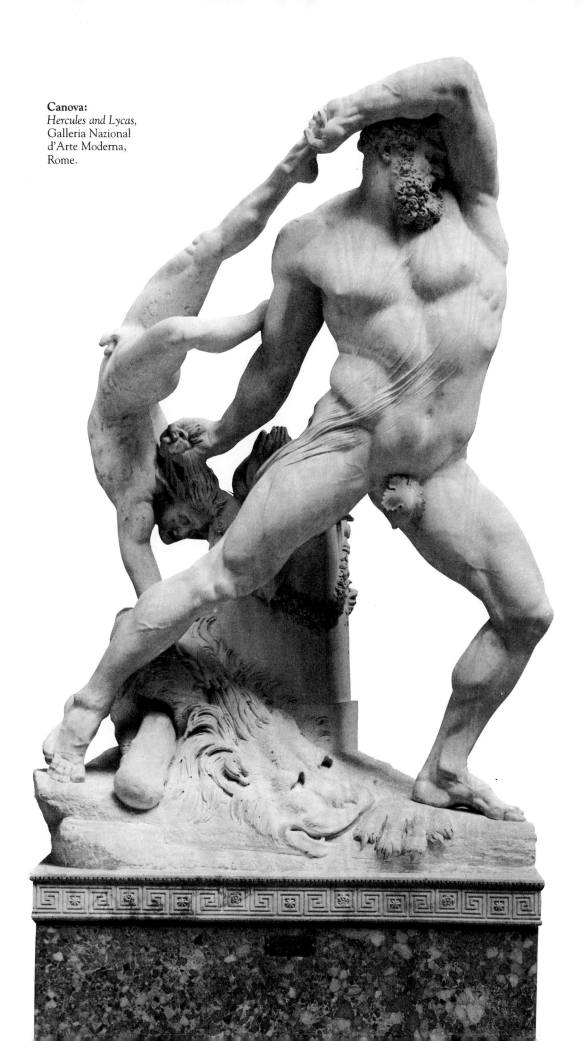

Canova:
Hercules and Lycas,
Galleria Nazional
d'Arte Moderna,
Rome.

47. John Flaxman:

Study for "Brittania, By Divine Providence Triumphant," 1799. Victoria and Albert Museum, London.

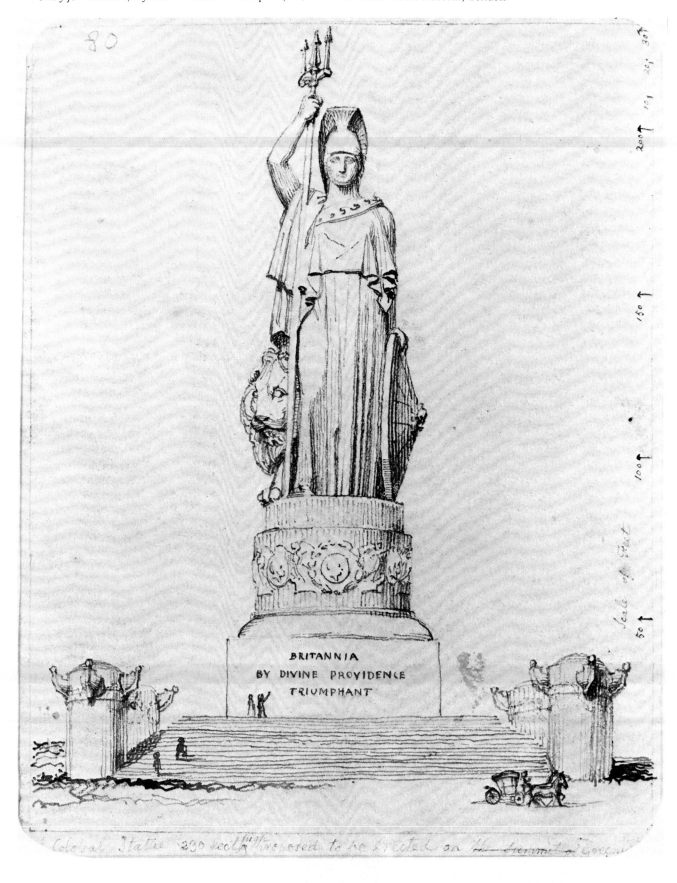

BRITANNIA
BY DIVINE PROVIDENCE
TRIUMPHANT

Flaxman: *Bozzetto* for *Britannia, By Divine Providence Triumphant*, Copyright University College, London.

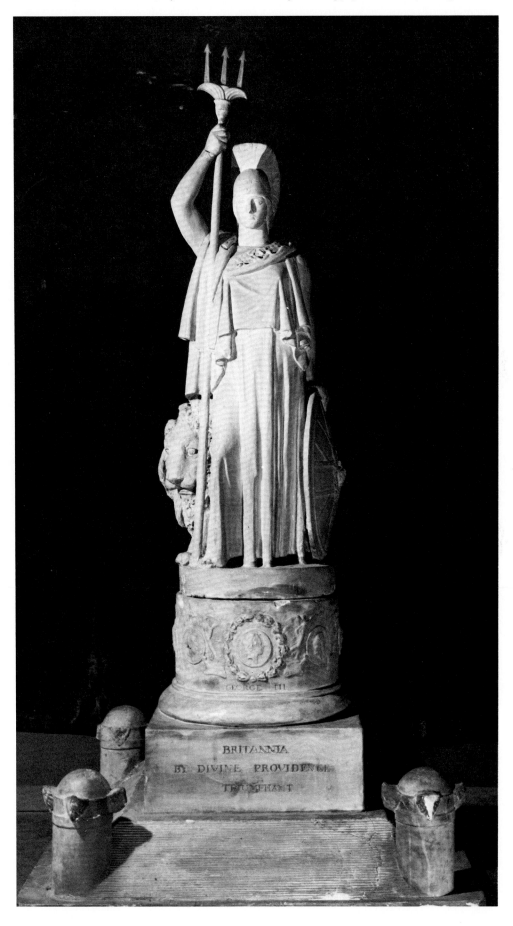

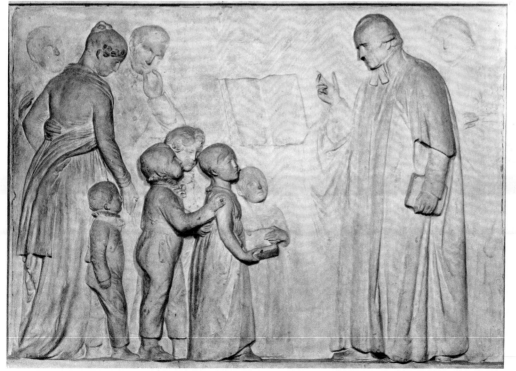

49. John Flaxman:
*Study for Monument to the
Rev. John Clowes,* c. 1820.
Yale Center for British Art,
Paul Mellon Collection,
New Haven.
Flaxman:
*Monument to the
Reverend John Clowes,
St. John's, Manchester,*
now destroyed.
Copyright
University College,
London.

50. Pierre Paul Prud'hon: *Study for "River Rhine",* c. 1801. David Daniels, New York.

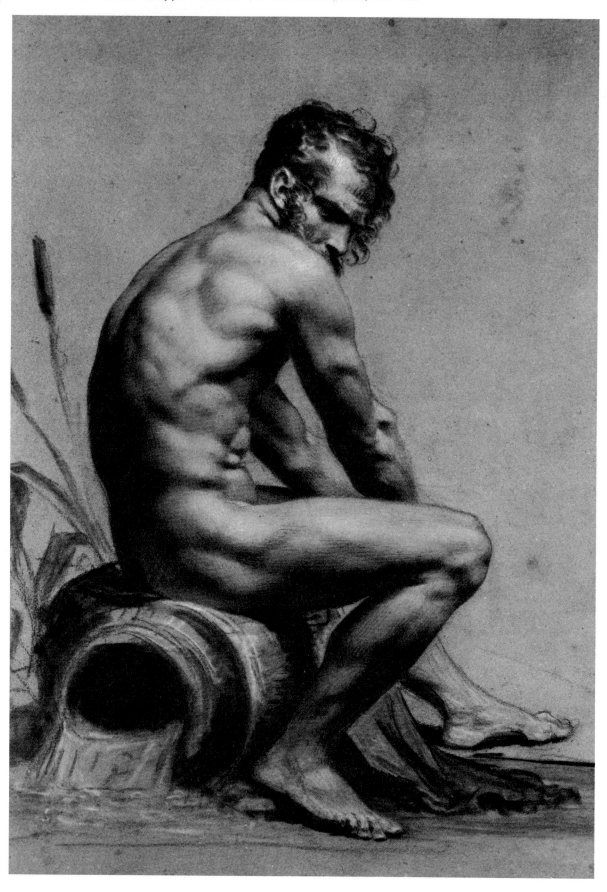

Thorvaldsen:
Bacchus,
Thorvaldsens Museum,
Copenhagen.

51. Bertel Thorvaldsen:
Study for a statue of "Bacchus",
(recto), 1804.
Thorvaldsens Museum, Copenhagen.

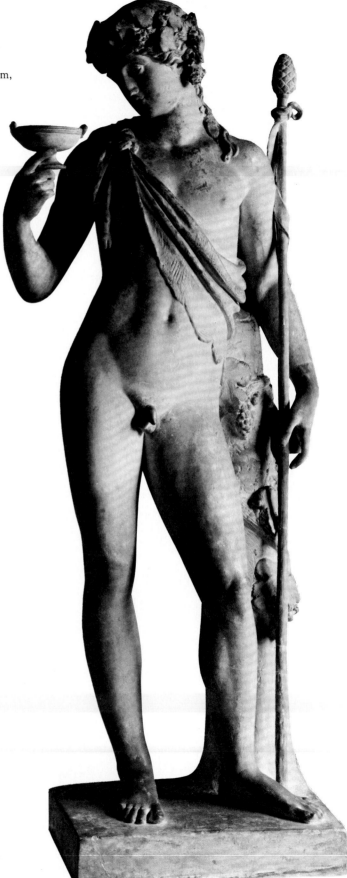

Bartolini:
Carità Educatrice,
Galleria Palatina,
Palazzo Pitti.

55. Lorenzo Bartolini:
Study for Carità Educatrice, 1817–24.
Private Collection.

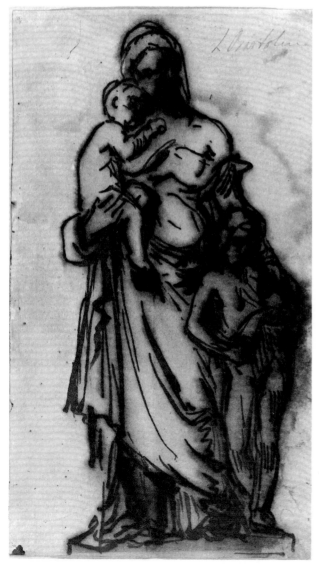

56b. Horatio Greenough: *Drawing of model of "Washington" for Capital,* 1834. National Archives, Washington, D.C.

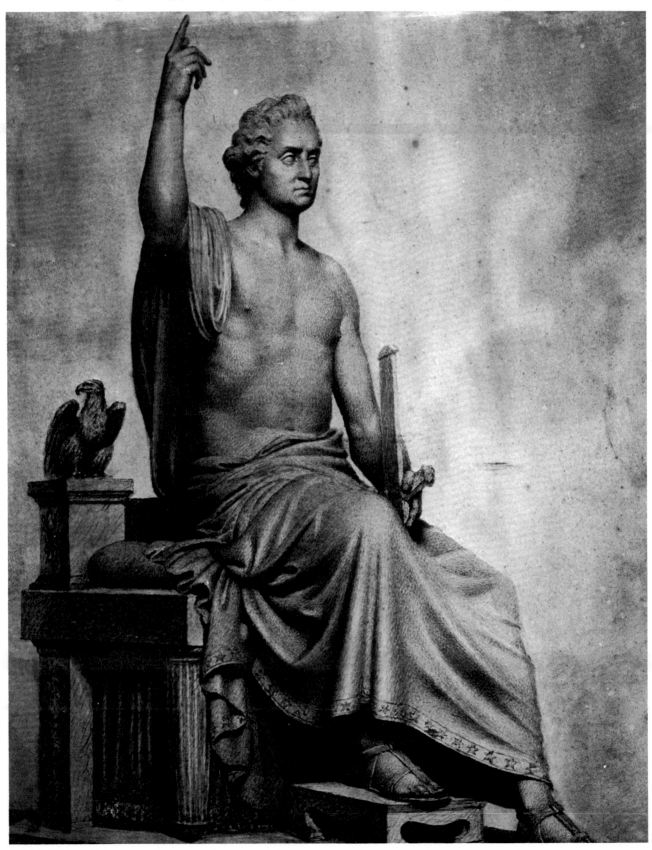

Greenough: *Washington*, Museum of History and Technology, Smithsonian Institution, Washington, D.C.

57.a. Antoine-Louis Barye:
Four sketches of snakes.
Walters Art Gallery, Baltimore.

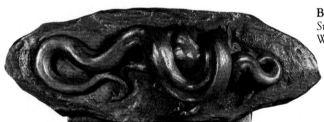

Barye:
Snake Killing Rabbit.
Walters Art Gallery, Baltimore.

57.b. Antoine-Louis Barye:
Studies of Measurements of Dead Elephant.
Walters Art Gallery, Baltimore.

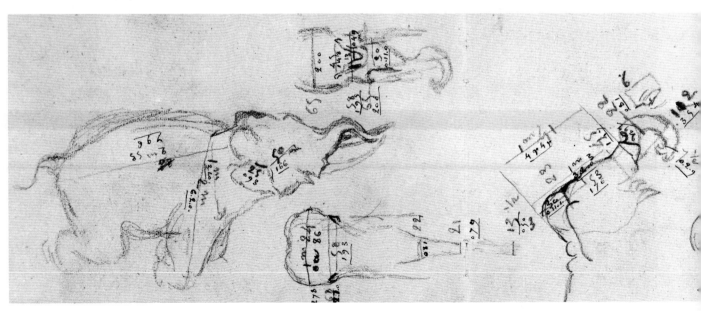

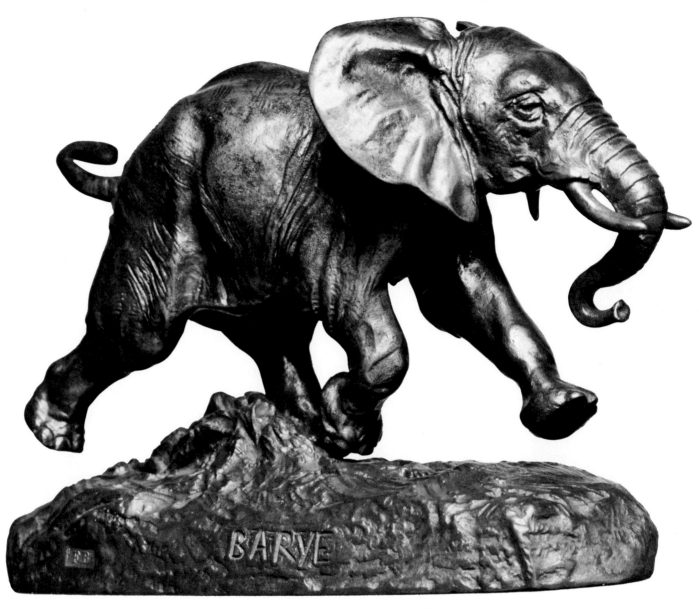

Barye:
African Elephant Running,
Walters Art Gallery, Baltimore.

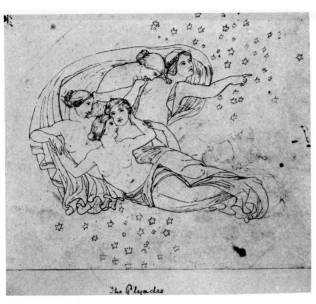

60. Henry Kirke Brown:
"The Pleiades",
Sketchbook M, c. 1845.
Library of Congress.
Washington, D.C.

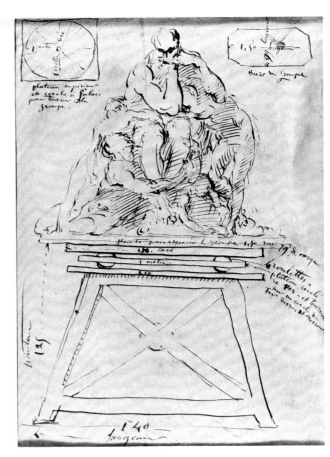

63.c. Jean-Baptiste Carpeaux:
*Study for the modeling stand
of the Ugolino Group,* c. 1860.
The Metropolitan Museum of Art,
New York.
Gift of Daniel Wildenstein, 1975.

62. William Rimmer: *Tri-Mountain,*
c. 1863-64. Boston Medical Library,
The Francis A. Countway Library of
Medicine, Boston.

Carpeaux: *Ugolino and his sons,* The Metropolitan Museum of Art, New York. Purchase 1967.
Funds given by The Josephine Bay Paul and C. Michael Paul Foundation, Inc. and Charles Ulrick and Josephine Bay
Foundation, Inc. and Fletcher Fund

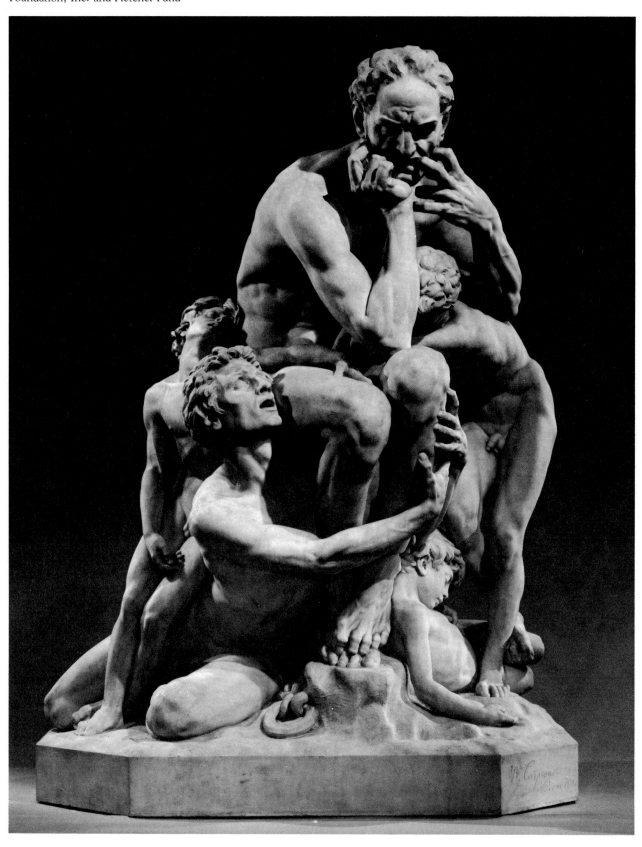

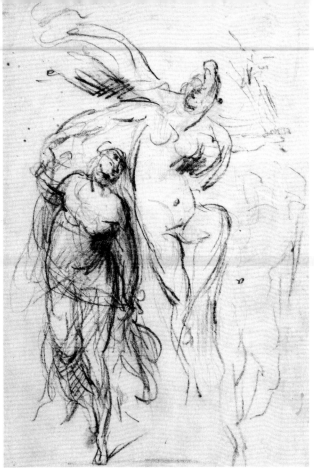

65.b. Jean-Baptiste Carpeaux:
a, b. Studies for "La Danse."
The Art Institute of Chicago, Worcester Sketch Fund.

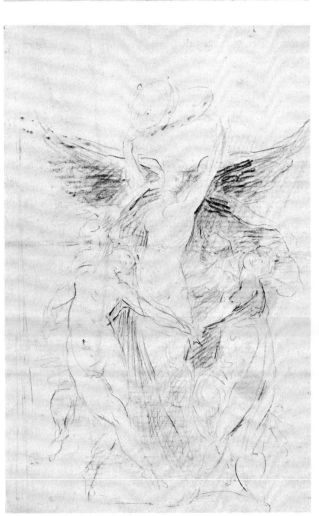

Carpeaux:
La Danse, l'Opéra, Paris

66. Albert-Ernest Carrier-Belleuse: *Nude Female in Niche.*
Michael Hall, New York.

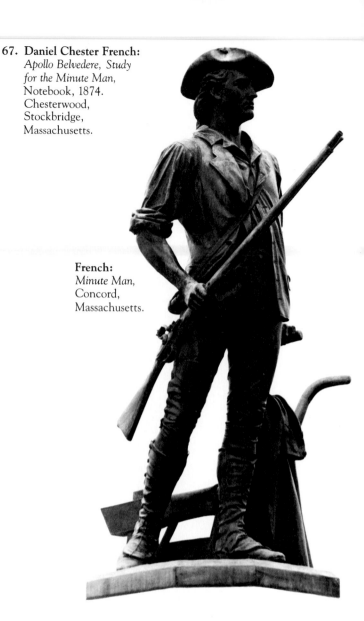

67. Daniel Chester French:
*Apollo Belvedere, Study
for the Minute Man,*
Notebook, 1874.
Chesterwood,
Stockbridge,
Massachusetts.

French:
Minute Man,
Concord,
Massachusetts.

70. Jules Dalou:
*Fisherwomen of Boulogne
at Church,* 1876.
Arthur M. Sackler Foundation.
New York.

Abbema: *Portrait of Sarah Bernhardt*, Collection Ellen Burstyn.

74. Louie Abbema:
Sarah Bernhardt,
from a sketchbook,
c. 1871–75.
Michael Hall,
New York.

Bartlett:
The Bohemian Bear Tamer,
1887, The Metropolitan Museum of Art, New York.
Gift of an Association of Gentlemen, 1891.

75. Paul Wayland Bartlett:
The Bohemian Bear Tamer, c. 1887, Library of Congress.

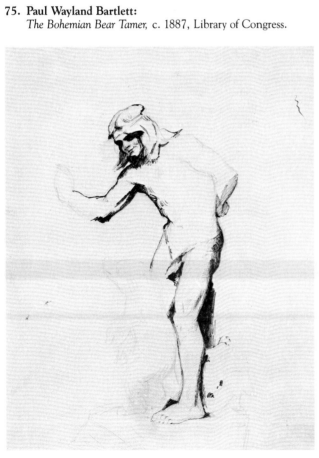

78a. Augustus Saint-Gaudens:
Study with two figures for Violet Sargent Portrait Relief, 1890. The Cooper–Hewitt Museum, Smithsonian Institution.

Saint-Gaudens:
Violet Sargent Portrait Relief, The Art Institute of Chicago.

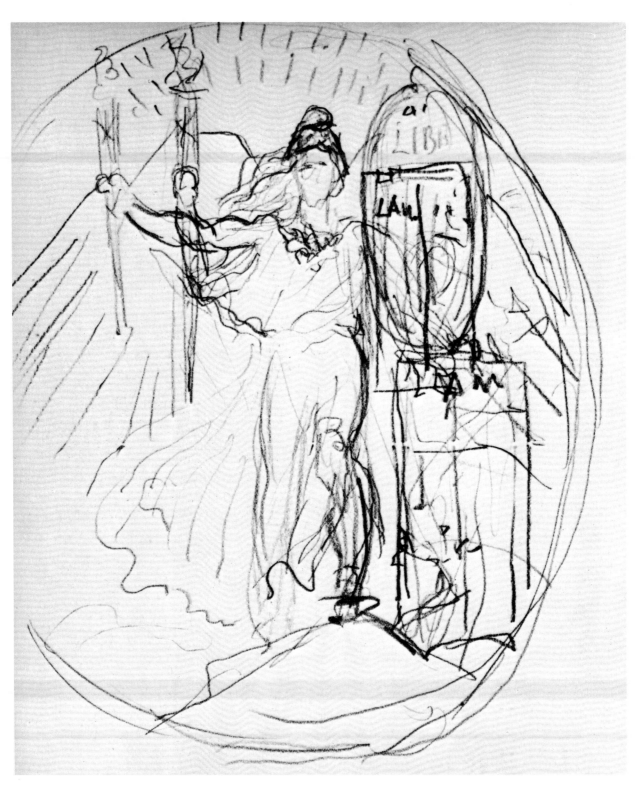

79. Augustus Saint-Gaudens:
"Striding Liberty", Study for U.S. Twenty Dollar Gold Piece of 1907, c. 1905,
Dartmouth College, Hanover.

Saint-Gaudens: *Double Eagle* (obverse), enlarged,
American Numismatic Society, New York.

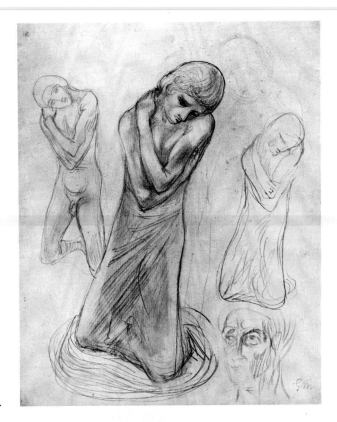

80. Georges Minne:
Le Petit agenouillé, 1896,
Albert Alhadeff, Boulder.

Minne:
Le Petit agenouillé,
Museum of Fine Arts,
Ghent.

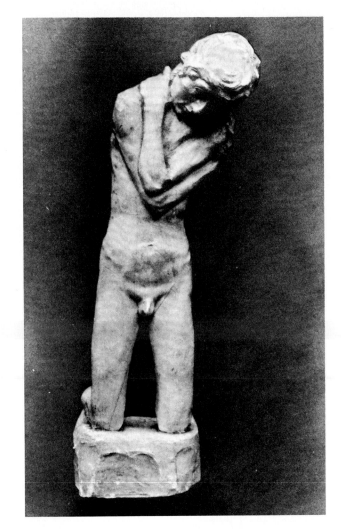

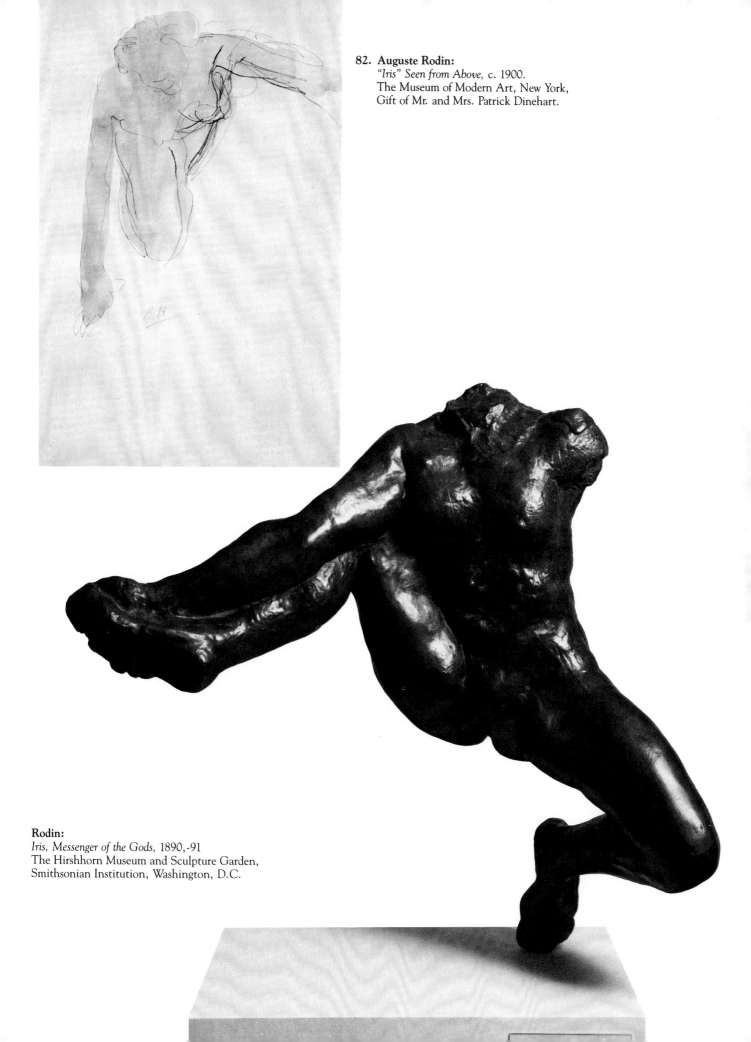

82. Auguste Rodin:
"Iris" Seen from Above, c. 1900.
The Museum of Modern Art, New York,
Gift of Mr. and Mrs. Patrick Dinehart.

Rodin:
Iris, Messenger of the Gods, 1890,-91
The Hirshhorn Museum and Sculpture Garden,
Smithsonian Institution, Washington, D.C.

4. Structured to Extremes - Austerity and Fantasy, 1900-1950

Fig. 18
John Flaxman, *Ugolino* from Dante's *Inferno*.

Sculptors' drawings at the end of the nineteenth century once again contributed to a radical re-evaluation of the lines of artistic expression. The sixty-year-old Rodin had become the patriarchal, monumental image-maker of the West. Priest, prophet, and satyr, the master advanced a graphic manner of amazing daring (82), going even further than his sculpture in its sensual abandon. Like all great artists Rodin always knew where to find essential resources. His magnificent obsession with the nude required balance, which he found in the rigor of architecture. The Gates of Hell draw upon the medieval cathedral and the Renaissance portal, the worlds of Reims, Dante, and Ghiberti. Rodin immersed himself in architectural studies on paper by tracing his French Gothic heritage with extraordinary intensity. By re-drawing the achievements of the medieval sculptor-mason he provided the works of his last maturity with the same essential sense of structure and context afforded Michelangelo and Bernini by their building disciplines. Rodin also turned to the camera as an invaluable diagnostic short-cut, drawing over photographs of his work in progress to guide him to completion.

Most evanescent of all sculptors' drawings are those of Medardo Rosso. Hovering on the brink between being and nothingness, his pale, reluctant lines capture a vestige of light and shade, barely visible symbols of his white, waxen sepulchres. Like so many sculptors he placed no value on these drawings, often using scraps snatched from café tables, destined to be discarded or to disintegrate because of the poor quality of the paper.

Paradoxically, just when sculptors and painters were freeing themselves from academic restraints, from the programmed rigors which confined drawing to conventional lines, draughtsmanship re-emerged, more important than ever. Malvina Hoffman's estate, which has kept the sculptor's huge graphic output intact, offers valuable documentation for such extensive use of drawing—studies of anatomy (86b), figures in motion, and records of and for works in progress (87). Pages were pinned on the studio walls (Fig. 19) immediately below the reliefs for which they were made, ready for constant consultation, as the sculptor would go from the model to the drawing to the work in clay, plaster, or stone. Her autobiography describes an encounter with Rodin, when, as a student, Hoffman first came to his studio. Examining her first studies after his works, the sculptor asked Hoffman whether she thought these were drawings. Upon her affirmative reply, he answered witheringly, "They are sketches. Michelangelo *never* made sketches, everything he drew was a study, a real drawing. See that you never make any more sketches. Beware of the weakness of your American artists—their damned facility." Drawing was to be a sign of understanding and a way of exploration—no slick, shallow transcription of what the uninformed eye glimpsed.

Little notebooks, the *carnets* so popular among European sculptors, were also used in America for speedily drawn figures shown in sequence like those in books printed for children, where, with a flick of the wrist, printed images turned into cinematic "projections" (86a). Quickly sketched in lead or pen, these small pages are filled with figure studies or varying solutions for commissions. Gertrude Vanderbilt Whitney's notations for a monument to those lost with the *Titanic* show an immediacy and originality absent in the finished work. Like a missal or diary, the little book (89) combines the sculptor's art with her spiritual resolutions, written on pages after those drawn in memory of the dead.

Rodin still relied upon professional stonecutters to translate his sketches into marble. But a turn toward simpler surfaces brought the revival of direct carving and a new sense of craft, exemplified by Maillol's art. His formula for monumentality

was almost fool-proof, the mastery of the heroic female nude. Beginning as a painter and then turning to tapestry, papermaking, and other skills, Maillol followed the arts-and-crafts currents of the *fin-de-siècle*, his works evoking the clarity of Puvis de Chavannes. Such studies as the *Reclining Nude* (102) show his gifts for Classical statement. Describing the role of drawing in his art, Maillol once said: "Right now I am drawing: I always learn a little from it. For a sculptor it is necessary above all to draw, you understand. He must make many drawings, and the day that he understands something about one of them, he makes a statue out of it."

It was through sculptors' drawing, that the twentieth century revived concern for the clearest statement of form, for the unbroken contour. Brancusi's works on paper present the classic example of such seeking and finding of definitive images. His exhaustive academic training had included rigorous anatomical studies in the Renaissance tradition. But after proving himself master of the illusionistic surface, Brancusi turned against the seductions of Rodin's style. Rodin's *Iris* (82) and Brancusi's *Nude* (90) show two completely different, irreconcilable ways of seeing, the first still descriptive, locked in narrative, the second beyond time, absolute.

"There are too many lines," Brancusi protested as he sought the quintessential, closely defined form. *Hands* (92) shows how the sculptor worked toward the most basic resolution, finding, by the limb's varied *mise-en-page*, his way toward the worked marble. Most scholars know only that *The First Step*, now lost (as is its' photograph), used drawing in its genesis, and Geist, for example, wrote that all other pages from the master's hand were prepared after sculpture, but this is hard to believe. Only in Brancusi's depiction of his studio (91) is the retrospective unarguable. A graphic gathering-in of his labors, this drawing represents a *catalogue raisonnée* in the profoundest sense. The word "invention" could be applied to this study, in its Latin meaning of "to come upon," a loving confrontation of achievement rendered in the momentary tranquility of the workplace.

Matisse, whose finest paintings share the absolute quality of Brancusi's art, often turned to sculpture concentratedly. The greatest of such campaigns is the one for his most monumental series, the *Backs*. A drawing from the model (85) initiated this cycle without intimating its momentous role. Matisse's working of the great slab-like reliefs moved them back and away from the illumined, genre quality of the page's first pose to a basic statement of the nature of life primeval, worked within the monumental confines of the massive rectangular. He never returned to sculpture on so large a scale, or of such an elemental and essential nature, as in the *Backs*, the series that proved to be Matisse's opening and closing salvo.

At twenty-one, in 1902, during his second year in Paris, Picasso (112) began modeling. These small figures express the melancholy of the young master's Blue Period canvases. Throughout his life, there are sustained periods of sculptural activity. Undoubtedly the most ingenious and resourceful sculptor of the century, Picasso has a sculptural parallel, postscript, or initiation for nearly every pictorial discovery. Sculpture and painting become so intimately related in reliefs and other forms that they are inseparable. Drawing, the basis of these achievements, is seen most forcefully at an early stage in Picasso's page *Head of a Woman*, the bust he completed in 1909. Cubist constructions such as *The Guitar* were also carefully planned on paper before being extended into the third dimension.

His most rigorous and intellectually profound discovery—Cubism—was made possible through an analysis of form springing from the sculptor's vision. Picasso's leaps toward new forms of pictorial representation—ever more bravura performances in pursuit of reality—seem almost always anchored in the third dimension.

Never a believer in the abstract, the Catalan concretized his inventions and observations. Plastic reference is the *leitmotiv* for his greatest work, the tightrope upon which so much of Picasso's boundless invention depends.

Just as this essential sense of the tangible informs Picasso's most complex and original art, so does a world of sculptural reference permeate his most Classical imagery throughout the Twenties, and in the forty etchings on the theme of *The Sculptor's Studio* (1933-34). Here the painter clearly identifies himself with the image of the sculptor in Antiquity as the creator incarnate.

In the late Twenties and early Thirties Picasso turned very directly to the Classical achievement. His Renaissance concerns led to his revival of the *Paragone*, the comparison of the arts implicit in his many depictions of painters' and sculptors' studios. Equally powerful in both painting and sculpture, Picasso could afford an ironic view of the academic debates that were so popular in Michelangelo's time. A witty comparison of conservative arts is afforded by Picasso's sketch of 1933 where Venus' torso—symbol of sculpture—is reflected on a very unusual easel. The latter is reduced to a neo-Classical hat-rack, supporting the helmet of a homely Trojan "hero" who is engaged in defiling Venus' mirrored image.

Picasso's *Construction in Wire* (1928-29) was laid out in lively calligraphy before being worked in metal, pointing to the growing influence of a technique he was learning from Gonzales. Numerous essays in imaginary sculpture, many of them restricted to paper, are found throughout his later drawings. Beginning around 1950 Picasso's cut and folded metal sculptures called for paper "*maquettes*" of similarly cut and folded pages to guide an assistant in cutting the metal.

Early followers, like Archipenko, made somewhat superficial, decorative adaptations of Picasso's works, applying Cubist *formulae* and devices such as *collage* to sculpture (96). Here the work on paper acted as a guide in the preparation of the final form. Writing of his own use of drawings, the Russian sculptor observed: "There are periods when avalanches of ideas and feelings must be fixed in a moment, before they dissolve in the course of life. Such rapid sketches in a matter of minutes must be brought before the eye in their multiple variation. Indeed there are no rules, no conventions in the process . . ."

Another Eastern artist, the Lithuanian Lipchitz, made surprisingly adroit works in the Cubist idiom—many of which show a welcome sense of humor. His *Girl with Braided Hair* (97) drawn in 1914, shows how other masters could take on the new language of Braque and Picasso and make it their own.

Many sculptors found the new "esthetic fundamentalism" of abstraction appealing but were reluctant to abandon the body image. So they achieved the best of all possible worlds; they combined the two. Some nineteenth-century masters had already contributed to such a style, most notably the Belgian Minne (80), who stripped his marble of any chit-chat and directed it toward bold, essential statements like the moving *Prodigal Son*, followed by German expressionists like Barlach. Maillol had also worked in the same direction using a classical, rather than Minne's somewhat medieval, vocabulary. The same deductionism is found in Gill, who had spent time in Maillol's studio (102).

Gifted young sculptors from Italy and Germany, Modigliani and Lehmbruck, though both inspired by Parisian developments, kept classicism in mind and sight. The work of Brancusi influenced much of their art. Lehmbruck's *Nude* (94) shows interest in Brancusi's draughtsmanship (90-92) and his sculpture. Similarly, Modigliani's *Caryatid* (93) is clearly determined by Brancusi's direct carving and monumentality—although the influence of primitive art and of Picasso are also visible.

Two sculptors, one active in New York, the other in London, show the extraordinary divergency of styles that prevailed around the time of the First World War, even among artists concerned with identical subject matter. Gaudier-Brzeska, active in the *avant-garde* movement in London, drew his grappling male figures (95) designed for a relief, in a boldly primitive manner, while Young's *Fighter* (107) shows how much longer American art was rooted in the descriptive and the anecdotal, in the tradition of the academic bronze. Gaudier-Brzeska's figures recall an elemental, Darwinian state, closer to Cain than to the boxing ring.

But reverberations of the new art did reach America. Her leading Beaux-Arts sculptor, Bartlett (75), singled out drawings made in France as particularly pernicious influences. Writing in 1913, he regretted that young sculptors who had gone to Paris were no longer receiving the basic training in draughtsmanship they so much needed. No longer drawing after casts or models, they were "lured into circles... where mental aberration is deliberately cultivated; where intellectual impotence passes for genius, and theories take the place of talent. It is learned that they have frequented studios in which drawing is done with closed eyes, in order to give a better expression to the soul."

Bartlett seems to have anticipated the automatic drawings made by Arp in the years before he turned to the biomorphic sculpture for which he is best known. Surrealist sculpture, which Bartlett would have hated, might at least have pleased him in one respect: it left few if any drawings. Eschewing graphic forethought, the artist was meant to assemble his work in an instant act, unpremeditated, like a crime of passion. David Hare, a prominent Surrealist sculptor, was one of the few who drew, but he threw such traces away as soon as his work was done.

Soon even the Beaux-Arts approach was being stripped of inessentials, as seen in the art of Derwent Wood, whose drawings (101) and sculpture typify the new "radical chic" of the Twenties, dispensing with Edwardian frills and realizing a style oddly reminiscent of that of sixteenth-century Tuscany. This elegant manner soon turned into Art Deco, and as found in Méstrović's *Dancer* (100) for a wall panel. Its modest, decorative goal makes this page a welcome exception among the Yugoslav's pretentious art. Like the European masters, many American sculptors were aware of the drive toward the abstract, though few of them embraced it; they stayed within an academic style, adding a sleek gloss of modernism for good measure. One of the earliest and best of these was Manship (115), whose accomplished decorative art was firmly grounded in the Classical and Renaissance traditions.

In the Academies of the *avant-garde* in Germany and Russia between the First World War and the 1930s, the intellectual incisiveness of Cubism continued to make itself felt, now applied to Constructivism and other movements. The new sculptor-architect-designers who directed instruction at these centers usually came from a Beaux-Arts training which they had rejected, only to replace it with a new orthodoxy. Casts were hammered to bits and drawing from the model discouraged. In a possibly unwitting return to primary, Pythagorean and Platonic principles, sculpture was now, more than ever before, subject to the mystery of measure, the use of perfect abstract shapes and lines. To represent the human was indeed to err.

These new movements' concepts of sculpture, its role and form, were radically different from those of the past. Statuary, that most solid of arts, was now tied to de-materialization. In their *Realist Manifesto*, Gabo and Pevsner wrote that they sought to deny volume as a spatial form of expression. "In sculpture we eliminate a physical sense of mass as a plastic element." This made the ties between drawing and sculpture stronger than ever, as, more and more, sculpture became a concep-

Fig. 19
Hoffman's studio, *Bacchanale*, 1915–1924,
Malvina Hoffman Properties, New York.

tual art. The viewer was to be weaned from his "prejudice that mass and contour are indivisible." Such words recall images of sculptors' drawings from the past, from Donatello to Canova, Flaxman to Maillol. Sculpture on paper of all periods could serve to illustrate this seemingly radical twentieth-century *Manifesto*. Gabo and Pevsner simply state more firmly that the idea of sculpture as structure permits its presentation on paper to be the equivalent of its realization in the third dimension.

Constructivists' drawings sometimes resemble visionary architecture, which, as long as it stays on paper, can enjoy unlimited scope, pristine in its absolute isolation from a working context. The sculptor as fantasy builder is also seen in Storr's powerful drawings and bronzes. His Futurist-inspired skyscrapers on paper (106) and in the round communicate the same sense of modern drama as an architectural rendering by Sant'Elia.

Vision in Motion, both the title and the key concept of Moholy-Nagy's view of art, applies as well to earlier masters like Bernini and Rodin, of whom Moholy wrote with such sensitivity. He characterized the spiral figure of the sixteenth century, the *figura serpentinata*, which underlay Michelangelo's *Samson and the Philistines* (13), as "not only an attempt toward vision in motion but also toward a more emphasized use of light as a medium of plastic organization." His own sculpture in rotating metal was designed to create a play of light that would extend the sculptor's dreams of the past. He prepared several drawings (105) as the work was in progress to anticipate the way its manipulation of light would function.

An American painter and sculptor, Burgoyne Diller, drawn to the purity and clarity of Dutch neo-Plastic works by Van Tongerloo and of the paintings of Mondrian, translated the latter's principles into reliefs, making several preparatory drawings (116) in the process of his creative adaptation. This austere art of the Thirties anticipates the minimalist currents of later decades.

Two powerful European sculptors, Nadelman (88) and Lachaise (113), the latter starting out by working in Manship's studio, brought an erotic, expansive sense of forceful female beauty into American art. MacMonnies' prancing nymphets with their arch, coy ways look distinctly fly-by-night alongside these masters' sleekly monumental nude bronze goddesses. Lachaise drew through the nights, outlining thousands of pages of great buxom bodies defined by a thick, suggestive pencil line. Imperious fertility figures, these unique fusions of sexuality and dignity, which owe just a little to Maillol (102), are as suave in metal as on paper. Lachaise's new Venuses and Nadelman's forms changed the shape of the American nude. Other sculptors, such as Robus (114), produced works of deliberately commercial, streamlined appearance, anticipating Pop's crass message with their mass-produced look and brassy late-Deco commercialism. Above all, these sculptors shared authoritative draughtsmanship. The way in which they elaborated their sculpture, curve upon curve, in the round, followed their lines as first set on paper.

Noguchi, though at first identified with Lachaise and Nadelman, added a technical perfection and a special sense of texture and calligraphy from his Oriental heritage and training. Close to Brancusi and to Lachaise, he has had an eclectic career that includes working both with architects and for the dance. His splendid scroll (110), shows a sense of line and life equally indebted to East and West.

The art of the *animalier*, so popular in the later nineteenth century, diminished in the twentieth. But masters like Pompon and Bugatti in France and Manship (115) in America showed how even the wildest creatures could be made to conform to the chic, suave profiles called for by the rich *moderne* classes. What could be more Deco than a Pompon polar bear or penguin? Nakian's witty drawing of a

bull (104), its elegant lines reminiscent of those of Lachaise, has an almost Minoan gaiety, but in no other way does this work anticipate the sculptor's great, late mythological statuary. Not all *animaliers* chose the commercial route. Sculptors like Flannagan, with a long memory for Celtic as well as pre-Columbian art, found in the animal world basic statements of life's experience as succinct as a hieroglyph. His *Triumph of the Egg* (118) is an eloquent symbol of the Jungle Book of Life, as strong in the drawing as it is in stone. Nevelson's surprising twentieth-century sphinx (108), part Picasso, part dry-cleaner's hanger, shares a Calder-like wit. Her page shows the artist's interest in primitive art, so tediously evident in her early sculpture, before she abandoned drawing for assemblage.

With Picasso's mastery of the art of welded iron, a new excitement and sense of dramatic expression entered Western sculpture. His teacher in technique, Gonzales, was also a powerful sculptor whose incisive draughtsmanship is seen in a finished drawing (1938) after his statue of a *Woman Combing Her Hair* (117). Gonzales had two different graphic approaches, one toward the statue and the other from the finished work. After completing his image in welded iron he would translate it back to paper, often in a more innovational and advanced form than the statue provided. *Woman Combing Her Hair* belongs to the second drawing, or re-drawing, after a sculptural phase. In many ways it is a more powerfully plastic statement than the welded form from which it was taken. Such drawings, possibly more than their models, contributed to Smith's oeuvre, both on the page and in space (126). The critic, Clement Greenberg, characterized Smith's works as "drawing in the air" and the artist himself described his sculptures as drawings.

Giacometti's studio walls, like those of earlier sculptors, provided him with great blank pages for the first harsh intimations of the work to come (Fig. 3). Among the most haunting of Giacometti's drawings are the two portraits of his studio prepared in 1932 (Fig. 6). How appropriate that in this most surreal phase, the sculptor should be sleeping as well as working in his studio, as if to dream the forms to life in art. *Woman with Her Throat Cut* hangs immediately over the bed near the same suspended light shown with Picasso's *Torso* (112). Giacometti's coat, hung over the door, ironically symbolizes the sculptor's presence.

One of a family of painters, Giacometti first mastered their art. "What I believe," he said to James Lord, "is that whether it is a question of sculpture or painting, it is in fact only drawing that counts. One must cling solely, exclusively to drawing. If one could master drawing all the rest would be possible." Whether in metal or on paper, most of Giacometti's figures are seen as if at a vast distance, so far away that they seem to fade into a critical yet ambiguous metamorphosis. Does man become line, or is line becoming man? This same sense of removal verging upon alienation is found in his *City Square* (124). Both the lines on paper and those of the metal figures on their base are drawn in just the same way. Nothing is lost in translation from one medium to the other.

Expressionism is also found in Lipchitz' later art in the 1930's. By now the sculptor had long abandoned the wry wit of his Cubism for a portentous neo-Baroque style, which turgidly strove to express the tragic spirit of the times. Rife with mythology, Lipchitz' work aspired to an ancient monumentality, which was successfully realized decades later by hands other than his own.

A courageous classicism, analogous to Lipchitz' ambitious goals, arose in Europe after the Second World War in the sculpture of Marino Marini. Like so many workers in the round, he had started as a painter. Marini always believed that his oeuvre was rooted in drawing, and he stressed his dependence on the page. Marini

Fig. 20
Drawings in David Smith's living room.
Artist's Photo.

revived Greco-Roman *formulae*, most notably, and repeatedly, that of the equestrian figure. He freed these forms from a Fascist stranglehold. His own horsemen (123) ride to the end, to death and defeat, as well as to triumph, their bodies sometimes forming the sign of the cross.

Another European sculptor who found classical rebirth in the Second World War was Henry Moore. Long attracted to archaic and primitive sources, he rendered his perceptions of the London Blitz in graphic records of the air-raid shelters. These intricately worked visual descriptions of stoicism and survival became a reservoir for future statuary, a thematic *musée imaginaire* to be realized on a heroic scale after Britain's victory. In 1937, Moore wrote: "My drawings are done mainly as a help towards making sculpture—as a means of generating ideas for sculpture, tapping oneself for the initial idea; and as a way of sorting out ideas and developing them. Also, sculpture compared with drawing is a slow means of expression, and I find drawing a useful outlet for ideas which there is not time enough to realize as sculpture. And I use drawing as a method of study and observation of natural forms (drawings from life, drawings of bones, shells, etc.). And I sometimes draw just for its own enjoyment." His shelter drawing (119), made a few years later, validates these words.

As triumphs of technical ingenuity, much of Calder's sculpture profits from two endowments: His father was a leading Beaux-Arts sculptor, and young Calder was first trained as an engineer. Responding to the witty, innovational art of Paris in the 1920's, Calder created an art in which line spiraled from the page into space. First known for his mechanized wire circus, he then went on to produce abstract, multi-sectioned hanging forms—mobiles—where an engineer's skills were called for. Calder also made stabiles of great size. For the circus and the stabiles many drawings were made. One drawing for a stabile (120) shows a family in an austere setting facing the totemic spiral. Calder developed the abstract image into a statue with the prophetically genetic name of *Helix*.

Another American sculptor exercising Yankee ingenuity in the production of works in wire is Lippold. His *Juggler in the Sun* (122) brings together a complex assemblage whose circus references suggest those of early Calder. But both title and figure recall also the *jongleurs* of medieval faith. Lippold's later works, with their dependence upon tense wires, call for exquisite mathematical drawings very like those of LeWitt. Such sculpture in golden line, completely defined by numerical paper charting, suggests Pythagorean goals.

Totally opposed to the exquisitely limited precision of Lippold's art is the all-embracing oeuvre of his contemporary, David Smith, whose voracious passion for drawing is in the great sculptors' tradition. Beginning as a painter, predictably in Picasso's splendid thrall, Smith was a prodigious master of the page. His achievements are a happy combination of devotional graphic exercise and a celebration of his creative strength and insight. He did not depend on such pages for his sculpture. Writing a friend, Smith noted, "I just want to put in a word to you for drawing because I think drawing has all the immediacy and flexibility and a quicker realization than anything else you can do. And I wanted to show you these drawings because from here my work comes. Not specifically. If I know all about it in drawing, then I don't have to use a drawing to make a sculpture . . ." That last line is extremely important, as it shows how the work on paper is often more an evocation of the work to come than a cartoon or model.

As with so many medieval sculptors, Smith's training included the anonymous labor of the factory. Working his way toward sculpture in the round, he first

confined his use of line and relief within the restrictions of emblematic medals. Here drawing helped pave the way for a transition from painting to sculpture. Rarely a formal process, Smith's constant pursuit of drawing and of sculpture played the mutually enriching, enlivening role of that same combination during the Tuscan Renaissance. His notebooks show the most precise development of ideas toward sculpture (125). Smith was also deeply interested in photography, like Rodin and Brancusi, and, like the latter, he was an active cameraman himself. He inscribed a picture that he had taken of his floor covered with drawings with the message: "Sometimes I draw for days. I like it and it's balance with the labor of sculpture to average a drawing for every day I *live* some form of sculpture" (Fig. 20). Canova or Bernini may well have thought the same thing.

Living a visual world of deferred rewards, of patience and process, the sculptor needs the affirmation of direction and completion afforded by the promise of his page. He must see his visions on paper.

A great colorist, Smith revived the practice of polychromy, long forgotten and abandoned. A few drawings like the one included here (126) gave him a chance to work toward the statue's color as well as form. "My sculpture grew from painting," said Smith, and daily his drawing let this growth continue. Smith described making about four hundred drawings for a single statue— almost the same number prepared by Bouchardon for his equestrian *Louis XV*.

Sculptors of the past believed in making a drawing and setting it aside for weeks or months so that they could reappraise it objectively. Bourgeois, working today, has followed a similar process, sometimes putting away a sketch for years and years before the statue is fully realized. Her beautiful study of a curtain-like wall (127) points to the new interest in soft forms, to the yielding media of Oldenburg and Hesse. Curtains reveal and conclude. The Bourgeois drawing allows a graphic vista into the future, so evident in her marble *Cumul I* carved almost thirty years later. There a textile shade shelters the vulnerable egg-like forms clouded within. Her curtain also rings down this survey of sculptors' drawings.

84. Emile Antoine Bourdelle:
Leda and the Swan, c. 1913.
The Art Museum, Princeton Platt Collection.

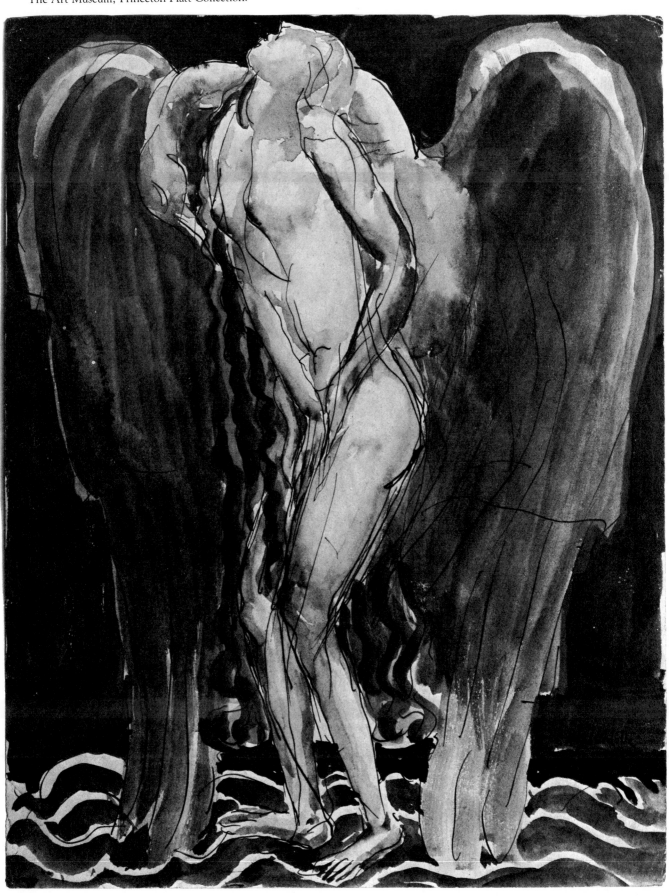

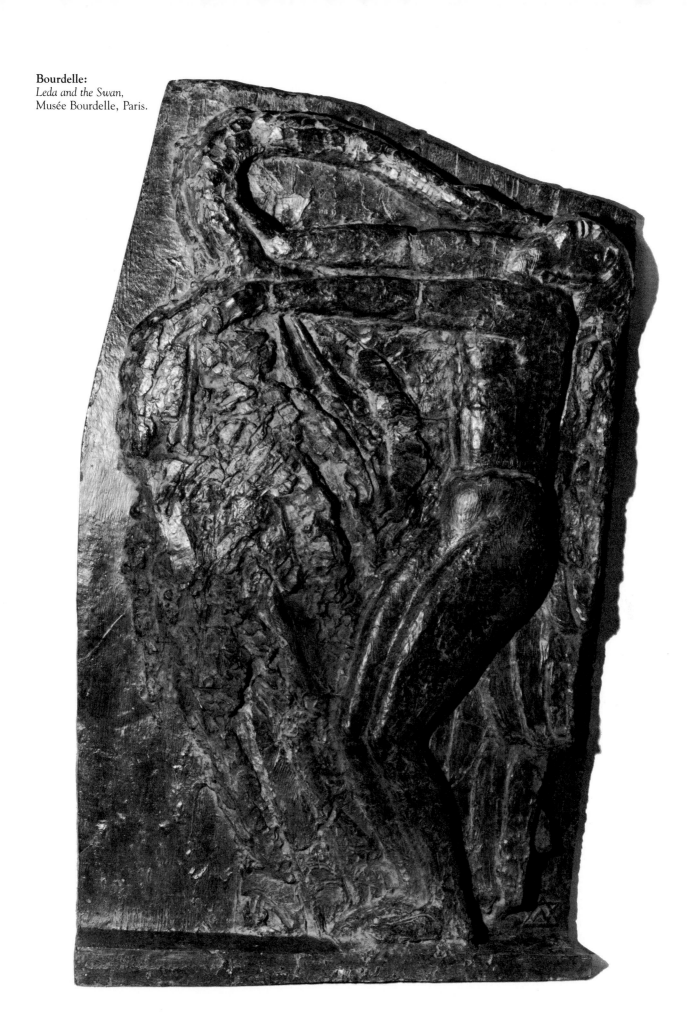

85. Henri Matisse: *Standing Nude seen from the Back,* c. 1905-07. The National Gallery of Canada, Ottawa, acquired 1974.

Matisse: *The Back I,* The Museum of Modern Art, New York Mrs. Simon Guggenheim Fund, given 1952.

86.a. Malvina Hoffman: *Dance Sketchbook "Gavotte,"* 1914–1915,
©Malvina Hoffman Properties, New York.

Hoffman: *Gavotte,* wax,
Photo by Cecil Beaton, ©Malvina Hoffman Properties, New York.

87. Malvina Hoffman: *Nude Study for "Gavotte"* 1915,
©Malvina Hoffman Properties, New York.
Hoffman: *Gavotte,* ©Malvina Hoffman Properties,
New York.

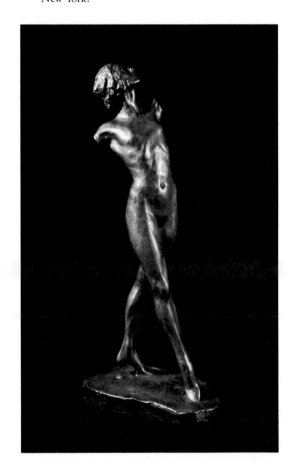

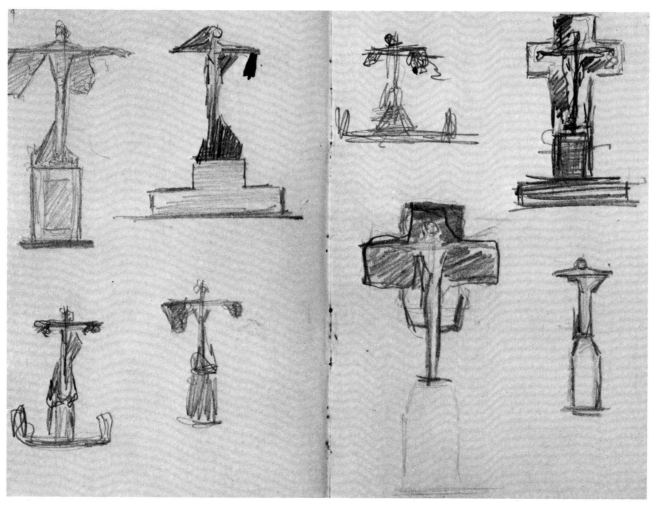

89. Gertrude Vanderbilt Whitney:
Studies for "Titanic Memorial,"
sketchbook, c. 1912,
Archives of American Art,
Washington, D.C.

Whitney:
Titanic Memorial,
Potomac Park, Washington, D.C.
Photo by S.C. Burden.

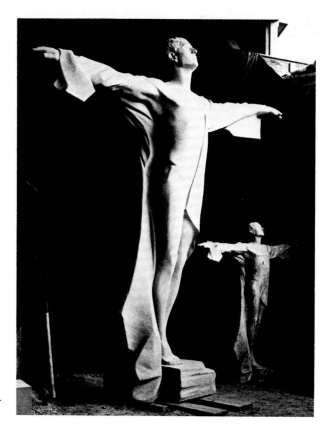

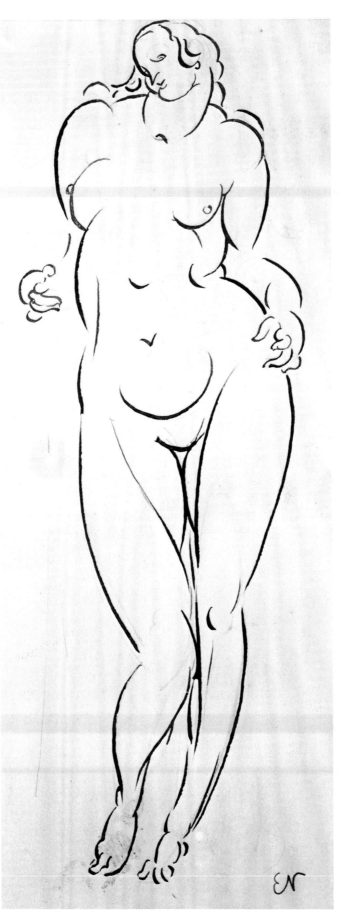

88. Elie Nadelman:
Standing Female Nude,
c. 1906–7.
Robert Schoelkopf
Gallery, New York.

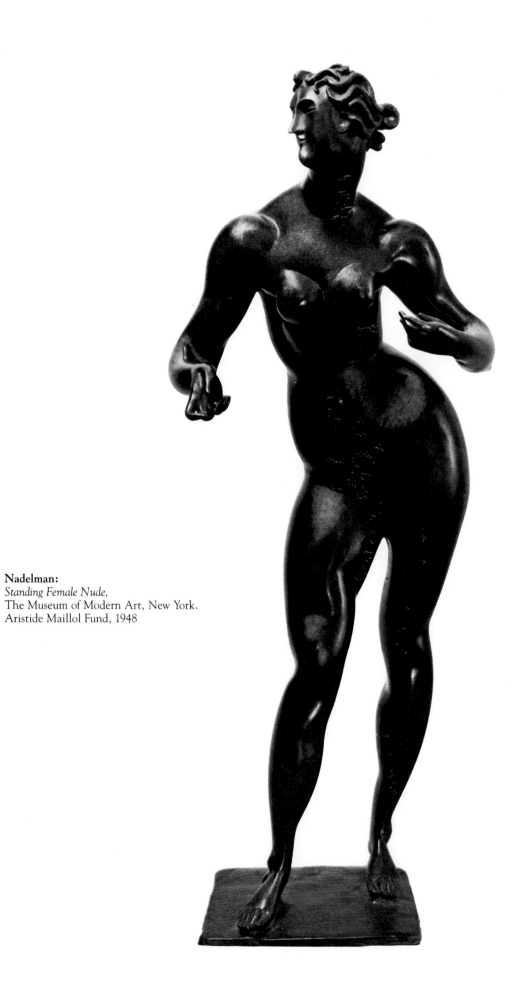

Nadelman:
Standing Female Nude,
The Museum of Modern Art, New York.
Aristide Maillol Fund, 1948

90. Constantin Brancusi:
Nude, c. 1920–24.
Solomon R. Guggenheim Museum,
New York. Photo: Robert E. Mates

Lehmbruck:
Female Figure,
Duisberg, Germany.

94. Wilhelm Lehmbruck:
Standing Figure, n.d.
The Museum of Modern Art, New York;
Gift of Edwin M. Otterbourg.

Brancusi:
Hand of Mademoiselle Pogany, 1920
Fogg Art Museum, Harvard University,
Cambridge.
Gift of Mr. and Mrs. Max Wasserman.

92. Constantin Brancusi:
 Hands (the Arm).
 Private Collection.

93. Amedeo Modigliani:
Caryatid, c. 1910–12.
San Diego Museum of Art.
Bequest of Pliny F. Munger.

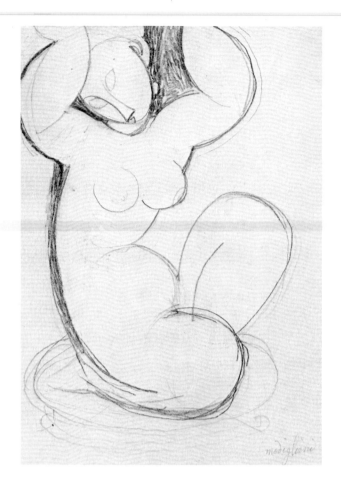

Modigliani:
Caryatid,
The Museum of Modern Art,
New York.
Mrs. Simon Guggenheim
Fund, 1951.

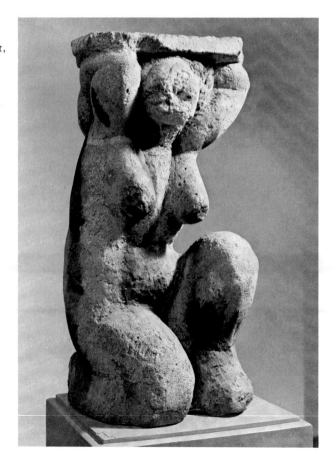

95. Henri Gaudier-Brzeska: *Two Figures Entwined.*
Museum of Fine Arts, Boston, Gift of the Kettle's Yard Collection.

Gaudier-Brzeska: *The Wrestlers,*
Museum of Fine Arts, Boston, Otis Norcross Fund.

96. Alexander Archipenko: *Figure in Movement,* 1913.
Museum of Modern Art, New York;
Gift of the Perls Galleries, New York.

Archipenko:
Médrano II, 1913
Solomon R. Guggenheim Museum,
New York. Photo: Robert E. Mates

97. Jacques Lipchitz:
Girl with Braided Hair, 1914.
The Museum of Modern Art, New York;
Mr. and Mrs. Milton J. Petrie Fund.

Lipchitz:
Girl with Braided Hair, 1914.

102. Aristide Maillol:
Reclining Nude.
The Art Institute of Chicago,
Gift of Robert Allerton.

Maillol:
La Montagne,
Perls Galleries, New York.

103. George Kolbe:
 Nude Bending Over Sideways, c. 1920.
 The Art Institute of Chicago;
 Gift of Robert Allerton.

105. Laszlo Moholy-Nagy:
Untitled, c. 1923.
The Museum of Modern Art,
New York
Gift in Honor of Paul J. Sachs.

Moholy-Nagy:
Light-Space Modulator,
Busch-Reisinger Museum,
Harvard University,
Cambridge.
Gift, Sibyl Moholy-Nagy.

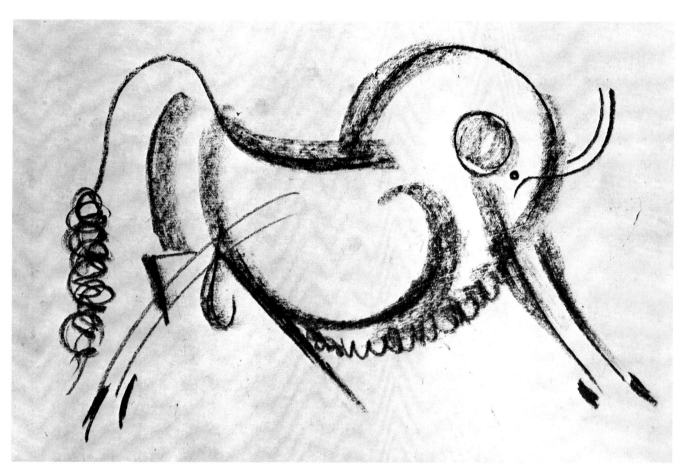

104. Reuben Nakian:
Animal Study No. 2, c. 1921.
Collection of Whitney Museum
of American Art, New York. 1931. 31. 560

109. William Zorach:
Two Figures, 1929.
Collection of
Whitney Museum
of American Art,
New York. Gift of
the Artist's Children
in honor of
John I. H. Baur,
Acq. 74. 69.

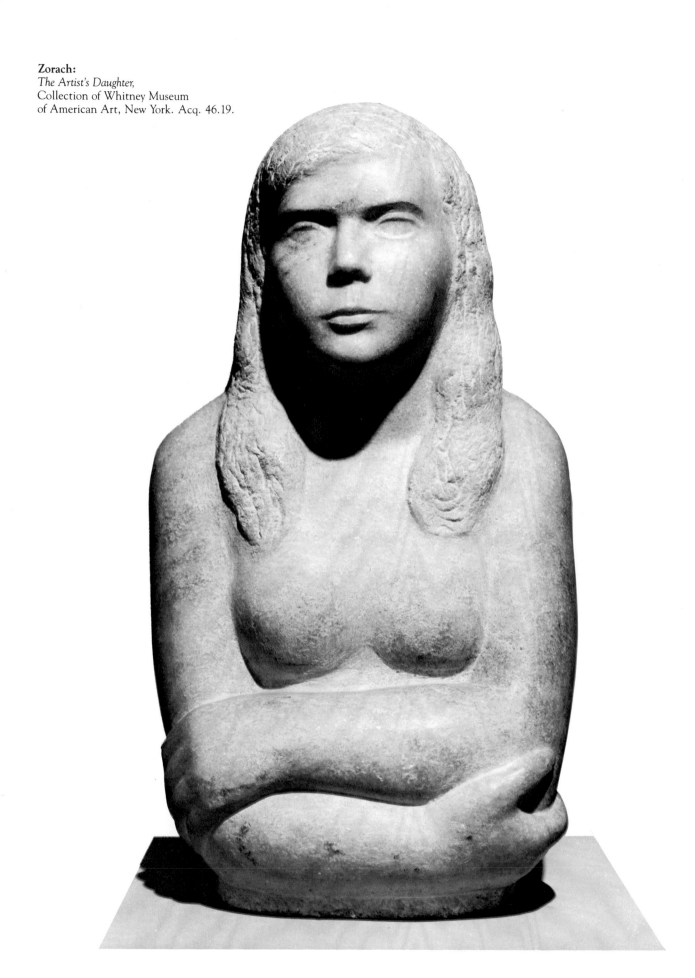

Isamu Noguchi

112. Pablo Picasso:
Still Life with Torso, 1933.
E. V. Thaw & Co, Inc. New York.

110. Isamu Noguchi:
Reclining Baby, 1930.
Mrs. Jacob M. Kaplan, New York

113. Gaston Lachaise:
Nude No. 1, n.d.
Collection Whitney Museum of
American Art, New York Purchase Acq. #32.1

114. Hugo Robus:
One and Another, c. 1934. Forum Gallery, New York.

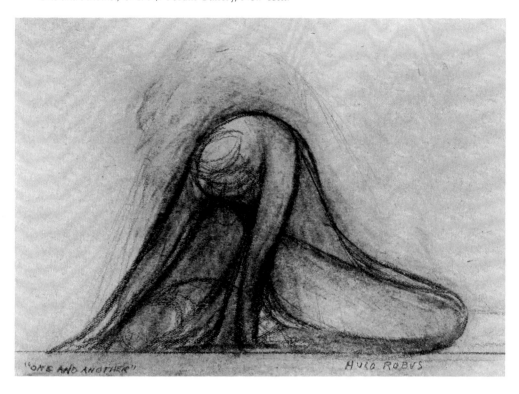

Robus: *One and Another*, Sara Roby Foundation, New York.

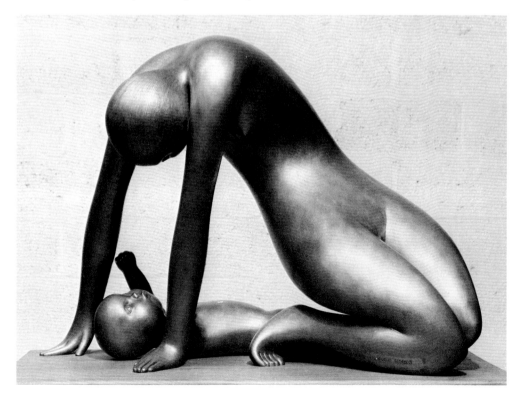

115.b. Paul Manship: *Study of Two Baboons,* n.d.
Minnesota Museum of Art,
Saint Paul, Minnesota.

115.b. Paul Manship:
Study of Two Baboons, n.d.
Minnesota Museum of Art,
Saint Paul, Minnesota.

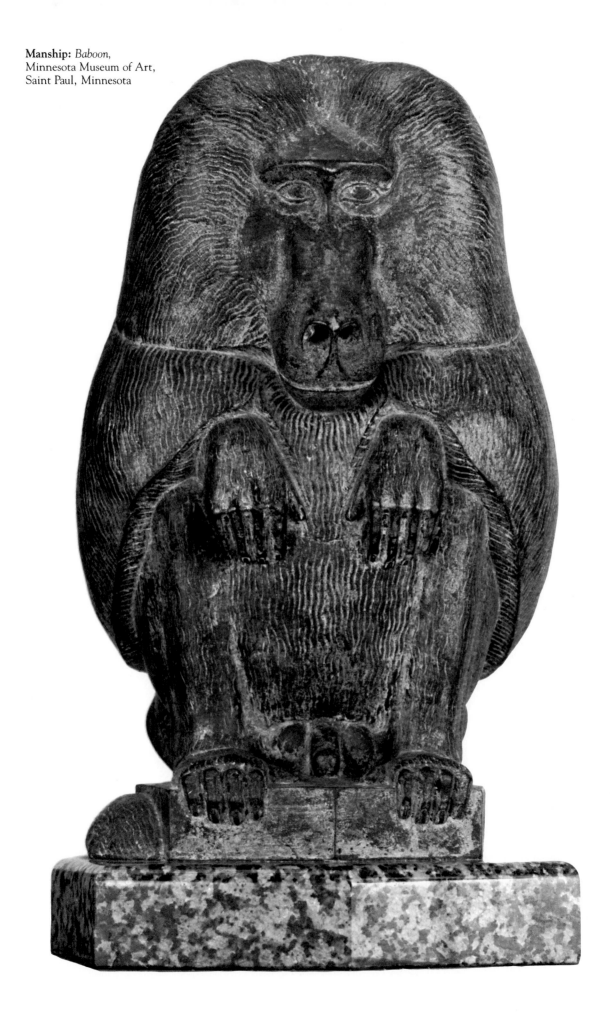

Manship: *Baboon,*
Minnesota Museum of Art,
Saint Paul, Minnesota

118. John B. Flannagan: *Study for "Triumph of the Egg,"* 1937. Museum of Art of Ogunquit, Maine.

Flannagan: *Triumph of the Egg I,* 1937, The Museum of Modern Art, New York, Purchase, 1938.

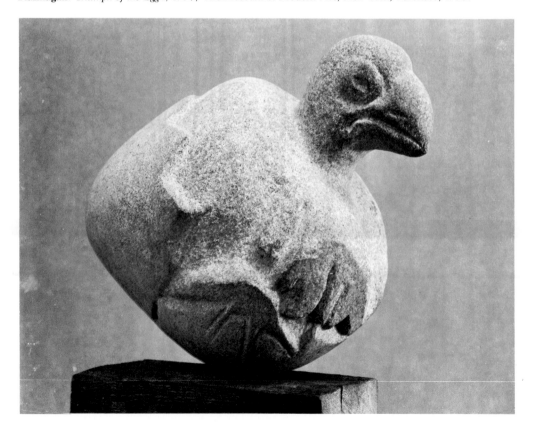

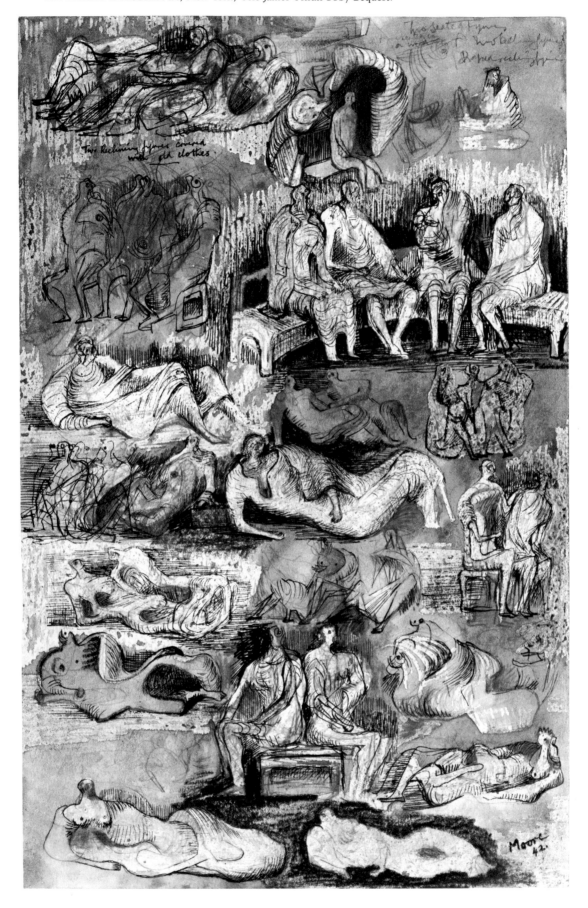

120. Alexander Calder:
Family with Sculptures, 1944. Perls Galleries, New York.

Calder:
Double Helix, Mobile Sculpture in Three Pieces.
Perls Galleries, New York.

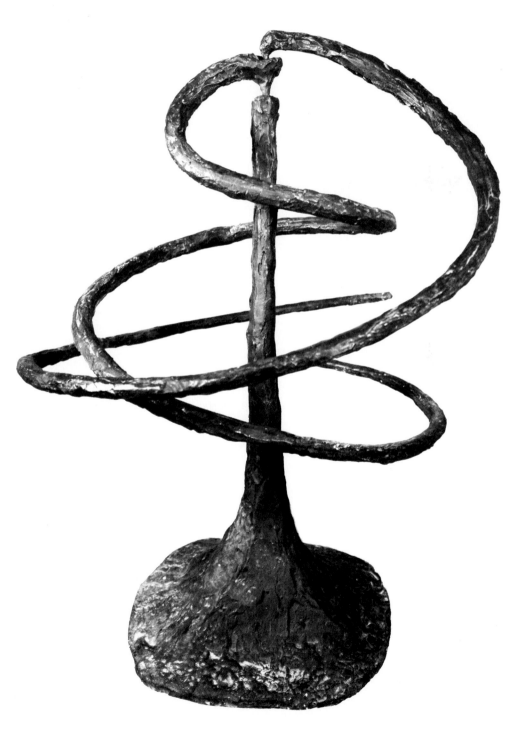

122. Richard Lippold:
Study for Juggler in the Sun, 1949.
Museum of Modern Art, New York,
Gift of Miss Mildred Constantine.

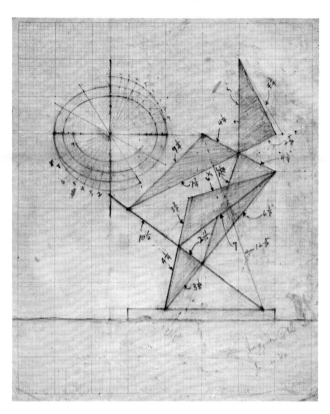

121. Theodore Roszak:
Study for Raven, 1946.
Collection Whitney Museum
of American Art, New York.
Gift of Mrs. Theodore Roszak, Acq. #79.8.

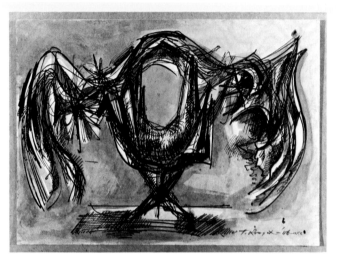

Lippold:
Juggler in the Sun,
Collection of Mr. and Mrs. William A.M. Burden, New York.

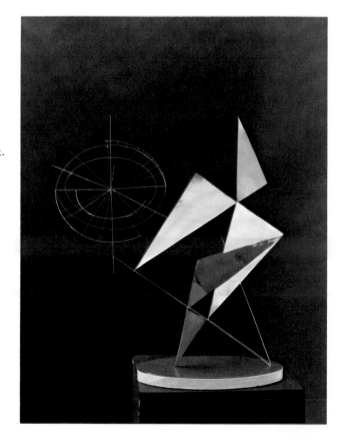

124. Alberto Giacometti:
The City Square, 1949
The Museum of Modern Art, New York;
Gift of Alexander Liberman
in Memory of Réné d'Harnoncourt.

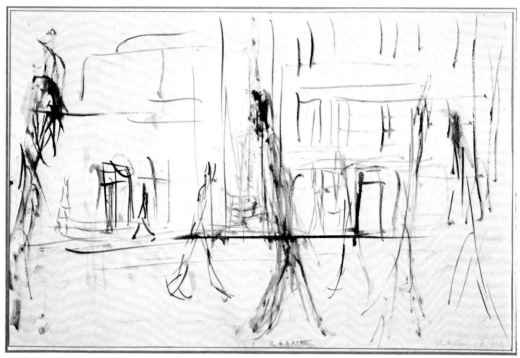

Giacometti:
The City Square (La Place),
The Museum of Modern Art,
New York, Purchase, 1949.

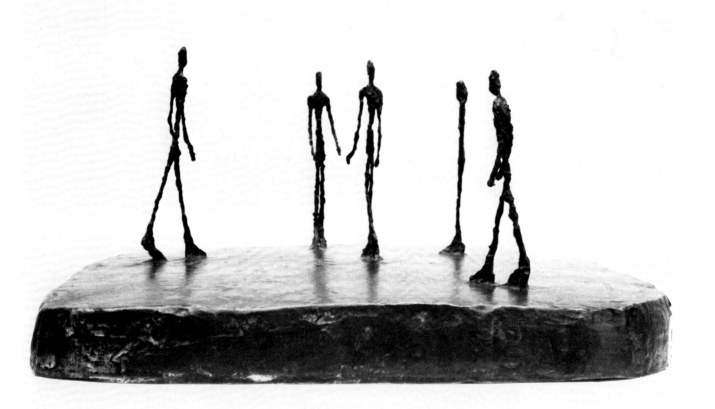

125. David Smith, *Twenty-four Greek Ys,* c. 1950,
From Sketchbook, Archives of American Art,
Washington, D.C.

Smith: *Twenty-four Greek Ys,* The Museum of Modern Art,
New York. Blanchette Rockefeller Fund.

126. David Smith, *Untitled (Study for Egyptian Landscape)* (recto), ca. 1950-51.
Estate of David Smith. Courtesy of M. Knoedler and Co. New York.

Smith: *Egyptian Landscape,* Private Collection, New York.

127. **Louise Bourgeois:**
Untitled, ca. 1949-50
Jean Louis Bourgeois
Photo: Donald Greenhaus.

Bourgeois:
Cumul I,
Collection Musée National
d'Art Moderne,
Centre National d'Art
et de Culture
Georges Pompidou, Paris.

Notes on the Drawings

ATTRIBUTED TO NANNI DI BANCO
Florence 1370/75—1421
Cat. 1

Recto: *Pilate Washing His Hands.* Early fifteenth century. Inscribed in Vasari's hand "Donatello" and preserved in the mount designed for his collection of drawings, the *Libro de' Disegni.* "Nanni di Antonio di Banco Scultore Fiorentino" is inscribed in a cartouche below the drawing, by or for Vasari.
Pen and brown ink.
292 x 376 mm

A later-fifteenth-century Florentine drawing of dogs by Pesellino(?) is mounted above. Vasari enlarged the page at left and along bottom, drawing over the left margin to "complete" the soldiers.

Christ stands to the left, his arms tied behind his back as Pilate on the judgment seat turns away from him to wash his hands. Pilate faces a hostile crowd to the right which calls for the crucifixion and Barabbas' release.
Verso: *Christ Carrying Cross.* In a setting designed by Vasari whose "carved" frame accentuates the drawing's relieflike character. A supposed portrait of Nanni (a woodcut from the second edition, 1568, of Vasari's *Lives*) is mounted above the drawing like a miniature altar, with flaming candles drawn to the left and right.
Pen over metalpoint on paper slightly tinted with pink.
288 x 378 mm.
Provenance: Giorgio Vasari.
Lent by the Trustees of the Chatsworth Settlement, Bakewell. Inv. 963.
Judging by the two inscriptions, Vasari first believed the *recto* to be by Donatello and then ascribed it to Nanni di Banco—presumably the same was true for the *verso.*

Though he was an uncertain connoisseur, Vasari's serious consideration of this page as by one or another of the major Florentine sculptors of the early Renaissance merits close attention nonetheless. Recent scholarship (Degenhart and Shaw) has shown that the page does indeed date from the time Vasari indicated, and not from the early sixteenth century, as Ragghianti believed. Though not identical with any of Nanni's surviving works, the Pilate is close to the spirit of his Saint Luke. The drawing shows a vitality that approaches the speedy, forceful graphism of another page from Vasari's *Libro de' Disegni*, probably by Donatello himself (2). The dramatically definitive presentation of both Passion scenes is the basis for the authoritative graphism of the late Renaissance, in such splendid drawings as Bandinelli's papal tomb (8).

C.E.

O. Kurz, "Giorgio Vasari's 'Libro de' Disegni,'" *Old Master Drawings*, XII, 1937, pp. 1-15, p. 9; C. L. Ragghianti, "Un 'Corpus Photographicum' di Disegni," *Critica d'Arte*, 1938, No. 6, p. xxv; B. Degenhart, *Italieniesche Zeichnungen des frühen 15. Jahrhunderts*, Basel, 1949, pp. 47-50; B. Degenhart and A. Schmitt, *Corpus der Italienischen Handzeichnungen, 1300-1450*, Berlin, 1968, Part I, Vol. II, (cf. p. 13) Cat. 264, pp. 342-343, p. 632, p. 636. J. Byam Shaw, *Old Master Drawings from Chatsworth*: a loan exhibition circulated by The Smithsonian Institution, 1969-70, Cat. 8; L. Ragghianti Collobi; *Il Libro de' Disegni del Vasari*, Florence, 1974.

DONATELLO
Florence c. 1386—1466
Cat. 2

Recto: *The Massacre of the Innocents.* Inscribed "Buonamico" at upper left. This and the "donatello" written on the *verso* at the upper right are probably both in Vasari's hand. Drawn with a fine pen immediately under the *Massacre* is a tabernacle in the style of the first half of the fifteenth century, an angel within. A first rendering of the Massacre in metalpoint has then been drawn over, by the same artist, with a thickly brushed very dark ink. Five or so mothers with their babies are shown resisting the Roman soldiers who will kill their infants (Matthew 2, 13-18). 288 x 204 mm
Verso: *David Triumphant.* A Latin numerical notation, possibly proportional, "CC-XXVIII" is placed perpendicularly, parallel with the standing figure. Drawn in pen with brown ink and pale grey wash. The nude victorious figure, a Herculean cloak tied over his chest, places his foot on Goliath's head. A study of the hero's bust in profile is drawn further to the right.
288 x 204 mm.
Provenance: Vasari's *Libro de' Disegni.* Among his largest drawings, the page has lost the mount Vasari made. At the Crozat sale of 1741 Mariette appears to have listed it as by Donatello. Bought for the Marquis de Robien, for whom the "No. 1" was written on the Massacre.
Lent by the Musée des Beaux-Arts, Rennes.
The *Massacre* is part of the left section of a horizontal composition originally drawn over a page about twice the present size. David occupies the verso, placed vertically. Both sides are firmly stated to be Donatello's by Degenhart-Schmitt, the foremost scholars of early-Renaissance drawings. They observe that Donatello's graphism was revived by such sixteenth-century masters as Bandinelli (see 7, 8), so scholars such as Ragghianti failed to realize that this page is the source, not the imitation. According to the German writers, the *David* is purely fifteenth-century in style, as is the tabernacle with the angel drawn under the *Massacre.* They also provide many convincing visual parallels, taken from Donatello's art of the 1420's and the early 1430's, for the features and style of the *David*, most obviously his total nudity, as in the famous bronze *David* of ca. 1430 (Florence, Museo Nazionale). Degenhart-Schmitt point out how Michelangelo's Louvre drawing of his first, lost bronze *David* (Fig. 11) has several features close to the Rennes page.

The aging Donatello became increasingly archaistic, as evidenced by his last work—the pulpits for San Lorenzo. Such revival of the passionate art of the Trecento may explain why Vasari thought his drawing of the *Massacre* to be by the supposedly mid-fourteenth-century legendary painter Buonamico Buffalmaco. C.E.

J. P. Mariette, ca. 1741. Crozat Sale Catalogue, Attributed to Donatello. Listed in the Rennes Museum catalogue of 1859 as by Buffalmaco and those of 1863, 1873, 1876, and 1884 as attributed by Mariette to Donatello. C. L. Ragghianti, "Un 'Corpus Photographicum' di Disegni." *Critica d'Arte*, III, 1938, No. 6, p. xxvi, as by Bandinelli; B. Degenhart and A. Schmitt. *Corpus der italienischen Handzeichnungen 1300-1450*, Berlin, 1968, Part I, Vol. II, Berlin, 1968, cat. 265, pp. 343-365; L. Ragghianti Collobi, *Il Libro de' Disegni del Vasari*, Florence, 1974, pp. 53-54; F. Bergot, *Dessins de la collection du Marquis de Robien conservés au Musée de Rennes*, XLVIIIe exposition du Cabinet des Dessins, Musée du Louvre, Paris, 1972, Cat. 1, p. 21.

BENOZZO GOZZOLI, Studio of
Florence 1420—Pistoia 1498
Cat. 3

Classical Torso, ca. 1475.
Silverpoint with white gouache on a prepared pink ground.
172 x 91 mm
Provenance: Giovanni Piancastelli, Rome (Lugt 2078a). Lent by the Cooper-Hewitt Museum, Smithsonian Institution, New York.
1901-39-2971.
A model book including three drawings presumably by Gozzoli himself, the remaining sides drawn by his studio assistants, was dispersed in the early sixteenth century, when Vasari purchased some of the pages. Today the drawings are found in museums in Europe and America, closely studied and catalogued by Degenhart-Schmitt. The largest number are at the Boymans-van Beuningen Museum, Rotterdam (D.-S. 434-37, 441-2, 445-50, 452-7, 459-60), all relating to his frescoes at Montefalco (1450-52). They may have been made by him after, rather than for, the paintings, as records.

Not drawn directly from an ancient statue, the page under consideration here is copied after a rendering, possibly Gozzoli's, and is very important as it shows how in the fifteenth-century Florentine workshops apprentices and masters alike learned by drawing after sculpture.

Gozzoli owned a cast of a foot, and perhaps one of a *Dionysius with a Putto* (D.-S. 463), used for his apprentices' training. A page from the model book shows the foot drawn from seven different angles (D.-S. 453). Both Gozzoli's employer, Ghiberti, and his patron, Piero de' Medici, had considerable collections of classical antiquities and he may have used these sources. C.E.

B. Degenhart and A. Schmitt, *Corpus der italienischen Handzeichnungen, 1300-1450*, Berlin, 1968, Part I, Vol. II, Cat. 461, p. 487, as Gozzoli Workshop.

MARCO (FRA MATTIA) DELLA ROBBIA
Florence 1468—ca. 1534
Cat. 4

Recto: *Contract Drawing for a Tondo of the Virgin and Child, the Young St. John, and Nun,* June 4, 1524.
Verso: *Sketches of the Same and Border Frame with Child Nearer Donor.*
Recto: Contract inscribed in pen and ink, the drawing in indian ink and wash over black chalk. Verso: Pen and ink; graphite.
405 x 292 mm
Provenance: Cav. Gian Carlo de' Rossi; J. P. Heseltine; Oppenheimer.
Lent by the Vistors of the Ashmolean Museum, Oxford.
The contract states:
Day four of June 1524. Fra. Andreas Mathias of Florence, of the sacred order of the Dominicans of his own free will etc. promised to the herein named Father Alberto Serra of the apostolic chamber of the Curie Causarum in the presence of the witness and my lord to construct and to make for him the figures moreover

constructed of clay called Cretan baked, glazed, and painted, and, likewise, a design predetermined of good, fine, and sufficient colors thus better put into order so that the space might be 3 palms wide and the garland with the cherubs might be taller than a palm and a quarter and the figures which he promised to make, of good clay, more over in 15 days and hence, those same ones to glaze, paint, bake, complete, and to deliver to this same aforenamed Father Albertus here in the city, to his own place of dwelling and further, one more month and a half from thence, next, he wishes to take possession of them for the payment of the below mentioned price and for the "double penalty and all damages" and he made pledge and the aforenamed Fra. Mathias promises to make it for a price and payment of two gold ducats of the treasury which the aforenamed Father Albertus is going to pay him in the presence of a witness etc. for whom etc. and on behalf of whom etc. and even if whatsoever does not come under the specific pledge and is not bound under the penalties, he is nevertheless bound by the apostolic chamber with the oath and constitution of the procurators and he undertakes in them all ecclesiastical judgments with an executive injunction etc. by a decision against him. This having been executed by office at Rome etc. in the presence of the witnesses Gerardo Poerssom clerk of the Tullian diocese and Walter Regis, clerk of the Tullian diocese. Thus it is Fra. Mathias by his own hand.

The *recto* shows the Virgin holding the standing Child on her left knee, while to her right the young John the Baptist stands in devotion and a nun of the Sistine Order kneels in the foreground. Concentric friezes of cherub heads and double garlands circle the central scene. A more active version of the same composition is delineated in the verso, which shows through the paper at the upper left of the recto. Here the child leans across to the other figures in a slightly different frame with a single garland.

This contract and drawing are of great interest as a rare record of a transaction between artist and patron, a legal illustration of what the finished work must resemble. I.W.

A. Marquand, *The Brothers of Giovanni della Robbia*, Princeton, 1928, pp. 23-29; K. T. Parker, *Catalogue of the Collection of Drawings in the Ashmolean Museum*, Oxford, 1956, Cat. 669, pp. 361-362; Consiglio d'Europa, *Il Primato del disegno. Firenze e la Toscana dei Medici dell'Europa del Cinquecento*, 1980, Cat. 201, p. 112.

AGOSTINO BUSTI,
Known As Il BAMBAIA
Busto Arsizio (?) 1483—Milan 1548
Cat. 5
Tomb Project, ca. 1515.
Pen and ink and wash. Pen work strengthened in black ink at a later date in most of the statuettes grouped round and on the sarcophagus.
296 x 336 mm
Provenance: W. Y. Ottley, Sir. T. Lawrence, S. Woodburn. Sale, Christie's, June 8, 1860, lot 1054. Bought for the Museum.
Lent by the Victoria and Albert Museum, London. 2315.
Woodburn, who owned this drawing in the mid-nineteenth century, believed it to be Bambaia's design for the tomb of Gaston de Foix. It was to house the violated corpse and display the effigy of the nephew of Louis XII who fell at the Battle of Ravenna in 1512 at twenty-three. Six sculptors in addition to Bambaia were freed from their duties at the Cathedral of Milan to execute the lavish tomb. Work ceased when the French left the city in 1521, and the project was never completed.

Many marble panels and statuettes from Bambaia's complex monuments survive. Those surely associated with Gaston's tomb are his effigy (Museo Civico, Turin), seven narrative reliefs (Villa Crivelli, Castellazzo), and six decorative panels (four in the Museo Civico, Turin; two in the Museo Civico, Milan). Clausse and Nicodemi accepted the page as Bambaia's rendering of the Frenchman's tomb. Pope-Hennessy did not find it explicitly connected with the project; Ward-Jackson suggested the drawing might perhaps be for Bambaia's *Birago Monument*.

Obviously intended for a military leader, this project places special emphasis upon the area where the effigy is to lie—the draped platform at the very top flanked by eight symbolic figures and six candelabra. The three relief names on the footed sarcophagus below are copied from those in the Berlin "Bambaia Notebook," which was drawn by the same hand as the tomb rendering and completed in 1514, one year before Bambaia was commissioned to prepare Gaston de Foix's tomb. Six standing Virtues below (with Fortitude and Charity near the middle) are reminiscent of

Bambaia's statuary. They, like the reliefs above and the six apostles seated on the base (Peter with key and Paul with sword near the middle) may have been paralleled by similar figures on the far side of the tomb.

With six sculptors working on the de Foix tomb, and more than one patron to please in its design, Bambaia may well have had several such highly finished renderings prepared to facilitate the choice of the final model and its execution. This splendid page is a uniquely important document, a major graphic record of the sculpture of the Lombard Renaissance. C.E. & I.W.

For the literature on this drawing see P. Ward-Jackson, *Victoria and Albert Museum Catalogues Italian Drawings Vol. I, Fourteenth to Sixteenth Century*, London 1979, Cat. 28, pp. 30-32.

ANDREA SANSOVINO
ca. 1467—Monte San Sovino 1529
Cat. 6
Design for Tomb for Pope (Leo X?) ca. 1521.
Pen and ink and wash.
400 x 242 mm
Inscribed on the central tablet are the first ten letters of the alphabet and the name "Leo X"; in another hand, lower left corner, "Giov. Dosio."
Provenance: J. Talman (Lugt, Supplement 2884A); Sir T. Lawrence (Lugt 2445); S. Woodburn (Sale, Christie's, 4-14 June 1860).
Lent by the Victoria and Albert Museum, London. 2260.
A cardinal's effigy lies on the sarcophagus at the top of this monument. Charity and Hope sit to the left and right on a platform below. Completing the trio of theological virtues, Faith stands to the left on a lower register opposite the cardinal virtue Fortitude, who leans on her attribute, the column. Blank areas are surmounted by cardinals' hats, while the epitaph space above them is filled by the first nine letters of the alphabet and the name Leo X. Above the epitaph a frieze of *bucranae* and *paternae*, with sacrificial import, completes the decoration.

Middeldorf mistrusted the "Dosio" inscription on this drawing and was the first to attribute it to Sansovino. It is likely that the tomb was designed for a cardinal and the inscription added later. Leo X's tomb by Bandinelli has no relationship to this drawing. De Tolnay finds that the arrangement of standing figures in the lower zone and seated ones on the platform presents one of the rare cases in sixteenth-century monuments in which a direct influence from Mi-

chelangelo's 1505 Julius Tomb project can be detected. This drawing is important for its relationship to Sansovino's idiom, which profoundly influenced European tomb sculpture. I.W.

U. Middeldorf, "Two Sansovino drawings," *Burlington Magazine*, LXIV, 1934, pp. 159-164 and fig. A; G. H. Huntley, *Andrea Sansovino*, Cambridge, Mass., 1935, pp. 97-101 and fig. 72; A. Venturi, *Storia dell'Arte Italiana*, II, Part I, p. 172 and fig. 152; C. de Tolnay, *Michelangelo, IV, The Tomb of Julius II*, Princeton, 1954, pp. 9 and 90, and fig. 238; P. Ward-Jackson, *Victoria and Albert Museum Catalogues. Italian Drawings, Vol. I, Fourteenth to Sixteenth Centuries*, London 1979, Cat. 312.

BACCIO BANDINELLI
Florence 1493—1560
Cat. 7
Project for the Base of the Doria Monument, ca. 1529-30.
Black chalk, pen and brown ink.
342 x 268 mm
Provenance: G. Piancastelli (Lugt 2078a); Brandegee (Lugt 1860c).
Lent by the Cooper-Hewitt Museum, Smithsonian Institution, New York 1938-88-1741
Bandinelli's grandiose projects for a monument to *Andrea Doria as Neptune*, commissioned by the Genoese Republic in 1529, went unfulfilled. Only a pale reflection of these schemes survives in the sad monument which now serves as a public fountain in Carrara. But several drawings, of which this is one, record the splendid work Bandinelli envisioned. This sheet, attributed to the sculptor by Dee and Oberhuber, shows a square base with a relief of a sea/land battle flanked by herms, surmounted by sea turtles, and capped by sphinxes. The better-known variation of the base (Louvre) maintains the classically inspired format, but the battle scene becomes considerably more rousing, the herms change to figures of Fortune, and other substitutions are made. Taking a typically Mannerist delight in the inversion of norms, Bandinelli lavished more invention on the base than on the sculpture it was to support. The precise hatching is similar to that in his tomb design (Cat. 8); both share the finished quality of his presentation drawings. I.W.

Providence Museum of Art, Rhode Island School of Design, *Drawings and Prints of the First Maniera 1515-1535* (exhibition catalogue), 1973, no. 7, p. 12.

Cat. 8
Design for Tomb of Pope Clement VII, ca. 1536.
Pen and brown ink on discolored white paper.
353 x 214 mm
Inscribed across bottom: "Tomb of a Pope" and at upper right "114."
Provenance: Sir Peter Lely (Lugt 2092); J. Talman (Lugt 2462); Dr. M. A. Goldstein (Lugt 2324); Rudolf Wien.
Lent by the Museum of Art, Rhode Island School of Design; Museum Works of Art Fund, Providence, Rhode Island, 51-507.

Bandinelli's concept for the tomb is remarkable: a pope reclining on a sarcophagus is flanked by torch-bearing genii, who hold a drape behind him, all set in a curved recess; above, five angels elevate a mandorla containing a nude youth representing the pope's soul. At the top of the niche, seated in a semicircle, are Christ, the Virgin, and six Apostles. God the Father and the Holy Ghost hover over all. This sheet represents a stage of the design around 1536, when a contract was made with the sculptor. As finally erected in Santa Maria sopra Minerva (rather than the original site, Santa Maria Maggiore), the monument took a completely different form: a triumphal arch with large reliefs above framing the seated pope flanked by saints.

Iconographically rare, Bandinelli's design was compositionally daring: unlike Sansovino's calm, static monument (6), the artist would have set all his figures in motion and focused his tomb on the upward ascent of the soul along the central axis. I.W.
D. Heikamp, "Die Entwurfszeichnungen fúr die Grabmäler der Mediceen-Pápste Leo X and Clemens VIII," *Albertina Studien*, IV, 1966, 134-152; Providence, Museum of Art, Rhode Island School of Design, *Drawings and Prints of the First Maniera 1515-1535*, 1973, No. 8, pp. 12-13.

BARTOLOMEO AMMANATI
Attributed to
Settignano 1511—Florence 1592
Cat. 9
Studies for Leda and the Swan and a Pietà. n.d.
Pen and brown ink on pale buff paper.
291 x 207 mm
Inscribed on mount: "Juliani Dani Sculptoris e San Gimignano. Fuit ilim G. Vasari, nunc J. P. Mariette, 1741."
Provenance: G. Vasari; J. P. Mariette; Comte de Fries; Heseltine.
Lent by the Museum of Fine Arts, Boston, Francis Bartlett Fund.

At the bottom of this drawing is a study of a *Pietà* with a separate sketch of the Virgin's extended left arm. Above this to the left is a *Leda and the Swan*, while to the right the same figure of Leda is drawn again as can be

seen from the right. Between the two is a small head.

Despite its indisputably high quality and late-Renaissance genesis, this drawing has been a subject of considerable debate (see Introduction). The very role of the drawing, whether preparatory or a study after the statue, is open to question.

However, the differences between drawing and sculpture indicate the page's preparatory function. On stylistic grounds the attribution of the marble Leda to Ammanati seems probable, and so his authorship of the drawing appears convincing.
C.E. & I.W.
H. Keutner, "The Palazzo Pitti *Venus* and other works by Vincenzo Danti," *Burlington Magazine*, C, 1958, V. 431; Victoria and Albert Museum, *Catalogue of Italian Sculpture* by J. Pope-Hennessy and R. Lightbrown, London, 1946, II, p. 458, Cat. 484; D. Summers, *The Sculpture of Vincenzo Danti: A Study in the Influence of Michelangelo and the Ideals of the Maniera*, Ph.D. thesis, Yale, 1969, V. 151, fig. 35; P. Kinney, *The Early Sculpture of Bartolomeo Ammanati*, New York (Garland), 1976, pp. 29 f.

BENVENUTO CELLINI
Florence 1500—1571
Cat. 10
Drawing of a Satyr for the Porte Dorée Fontainebleau, ca. 1543.
Pen and ink wash.
415 x 202 mm
Inscribed lower right: "Alla porta di fontana / Bellio di bronzo p. piu / di dua volta il vivo ... b. 72 erano dua variati."
Provenance: Coll. John Barnard (Lugt 1419); T. Lawrence (Lugt 2445); Calmann, London; Schab, New York.
Lent by Ian Woodner Family Collection, New York.

Around 1543 Cellini showed François Ier a model of the decorations he proposed for the vestibule of the Porte Dorée, principal entrance to the chateau of Fontainebleau. A lunette of the Nymph of Fontainebleau flanked by victories was to be supported by two atlantids in the guise of satyrs. The reliefs of the Nymph (now in the Louvre) and the victories (*moulages* of the lost originals also in the Louvre) were cast in bronze but never set in place. Instead Henri II presented the *Nymph* to his mistress Diane de Poitiers for her new chateau at Anet. According to the artist (Cellini, *Treatise on Sculpture*, Chapter I) models of the satyr/atlantids were never cast, and they are now lost.

With a goldsmith's precision Cellini details every wrinkle and lock of hair of the satyr's head, yet he conveys the figure's monumentality through crisp contour lines. The exquisite, highly finished drawing, surely

made to show his patron what the completed figure would look like, is the only visual record of the satyrs.
I.W.
Paris, Grand Palais, *L'Ecole de Fontainebleau* (exhibition catalogue), 1972, No. 51, for previous literature; C. Grodecki, "Le séjour de Benvenuto Cellini a l'hôtel de Nesle et la fonte de la nymphe de Fontainebleau d'après les actes des notaires parisiens (note additionelle par S. Pressouyre)," *Bulletin de la Société de l'Histoire de Paris et de l'Ile de France*, 1971.

GUGLIELMO DELLA PORTA
?—Rome 1577
Cat. 11a
Recto: *Design for the Rear Elevation of the Tomb of Pope Paul III*, 1549.
Verso: *Sketches for Three Holy Figures*.
Pen and ink.
139 x 142 mm
Provenance: J. Talman (Lugt 2462). Lent by the Victoria and Albert Museum, London.

Even before the pope's death in 1549 della Porta was at work on the seated statue intended for Paul III's tomb. This was decorated on the exterior by eight marble herms and four sarcophagi, each surmounted by a pair of reclining figures with the seated pope above. The model was criticized on several counts, not the least of which was Michelangelo's objection to a freestanding monument in the middle of St. Peter's, where he had originally hoped to place the ill-fated Julius II Tomb.

The drawings of rear and side elevations (11b) of the tomb represent alterations in the design which della Porta introduced to accommodate his critics. The terms were removed and the size of the monument seems reduced. But della Porta still clings to the concept of a freestanding monument, evidently large enough to contain a small chapel. Ward-Jackson observed that these drawings probably date from before 1554.

Eventually installed in a niche in St. Peter's in 1575, the tomb presents a much simplified pedestal with a single pair of reclining figures, inspired by Michelangelo's Medici Tombs. Viewed in the context of Michelangelo's Julius II Tomb projects and other papal tomb designs (see 15), della Porta's drawings evoke the unrealized ambition of a succession of sixteenth-century sculptors and their patrons: a monumental freestanding papal tomb in St. Peter's.
F. Gregorovius, *Le tombe dei Papi*, revised by C. Huelsen, Rome, 1932, Pl. 64 and pp. 88-89; H. Siebenhüner, "Die Ausstattung von St. Peter in Rom ... (1547-1606)" in *Festschrift für Hans Sedlmayr*, Munich, 1962, p. 239; P. Ward-Jackson *Victoria and Albert Museum Catalogue, Italian Drawings, Vol. I, Fourteenth to Sixteenth Centuries*.

Cat. 11b
Recto: *Design for the Side Elevation of the Tomb of Pope Paul III*.
Verso: *Sketches for Holy Figures*, 1549.
(Not illustrated.)
Pen and ink.
139 x 142 mm
Provenance: J. Talman (Lugt 2462). Lent by the Victoria and Albert Museum, London.

An examination of the reverse sides of this and the preceding drawing shows that they originally formed a single sheet. Although cut, these sketches seem to be three studies for one unusual sculpture. The haloed figures appear to be God the Father (holding an orb in the smallest sketch), flanked by Christ and the Virgin. The sculptor experimented with different formats for the work, conceived as three busts sharing a single pedestal: in two sketches the central figure rises above the others, while in the third he is placed at the same level. I.W.
P. Ward-Jackson, *Victoria and Albert Museum Catalogues, Italian Drawings, Fourteenth to Sixteenth Centuries*, London, 1979, Cat. 252, 253.

JACOPO TINTORETTO
Venice 1518—1594
Cat. 12
Recto: *Two Studies after Jacopo Sansovino's "Atlas"* ca. 1559.
Verso: *Two Studies of the "Atlas," and a Woman's Head*.
Black chalk heightened with white on tan paper.
255 x 390 mm
Inscribed "Tintoretto".
Provenance: C. R. Rudolph, London.
Lent by William H. Schab Gallery, Inc., New York.

Tintoretto and his studio prepared at least twelve pages of drawings after this statue by Sansovino, which is known from the small bronze in the Pushkin Museum. A cast must have been in the painter's possession by 1549, when he based on it the figure at the far left of *Saint Roch Ministering to the Plague-Stricken* (Venice, choir chapel, church of San Rocco).

Another later-sixteenth-century master, Stradanus, also turned to Sansovino's *Atlas*, showing many such figures in his drawing for Canto 5 of Dante's *Inferno* (Biblioteca Laurenziana, Florence). For painter and illustrator alike, Sansovino's statue was seen simply as a burdened man—the mythological associations were of little if any interest compared with the sculptor's mastery of anatomy. C.E.
Arts Council of Great Britain, *Old Master Drawings from the Collection of Mr. C. R. Rudolph*, 1962, Vol. 16, No. 69; for other drawings by Tintoretto and his studio after the Atlas, see Tietze and Tietze-Conrat, *The Drawings of the Venetian Painters in the 15th and 16th Centuries*, New York 1970; 1569, 1570, 1649, 1647, 1669, 1671, 1807, 1818, 1857, 1858. Also Stockholm, Nationalmuseum.

Cat. 13
Recto: *Study after Michelangelo's "Samson Slaying the Philistines."*
Verso: Same subject, without Samson's head or raised arm. (Not illustrated.)
Black chalk heightened with white on buff paper.
337 x 300 mm
Inscribed "michelangelo."
Provenance: Dr. N. Beets, Amsterdam.
Lent by M. Roy Fisher, New York.
A. H. Murray and R. J. Onorato, *The Process of Perfection*, Watson Fuller, Wheaton College, 1976, Cat. 42, 39-80's other drawings by Jacopo and Domenico Tintoretto and their studio after Michelangelo's *Samson Slaying the Philistines* include the following recorded by Tietze and Tietze-Conrat: 1559, 1564, 1567, 1708, 1733, 1734, 174l, 1763, 1772, 18ll-14, 1827, 184l-2, 1848, 1860, 1862; for a recent study of this subject see J. Byam Shaw, *Drawings by Old Masters at Christ Church*, Oxford, 1976, I, Cat. 763, p. 205.

ITALIAN ARTIST(?)
Working in France, ca. 1550.
Cat. 14
Study of a Tomb for Francesco(?) Pazzi. n.d.
Pen and brown ink and wash on cream woven paper.
266 x 187 mm
Lent by the Pennsylvania Academy of the Fine Arts, Philadelphia, no. 123.
Supporting a crucifix, two athletic genii sit on a sarcophagus and hold crossed femurs with their free hands; more bones lie below. Mourning *putti* support coats-of-arms on either side of the scrolled bracket intended for the inscribed epitaph.
This unpublished tomb design displays the arms of the Pazzi family of Florence: "Azure, semé with crosses crosslet fitchy in base, two addorsed dolphins or." Also the crucifix is itself shaped like the one on the Pazzi arms: the three short arms end in trefoils while the long one tapers to a point. The Florentine Pazzi were almost annihilated after their failed conspiracy of 1478. Some escaped to France, where two branches, the Panisse-Pazzi and the Sequins-Pazzi (the latter using the Pazzi arms), established themselves in Provence and the Dauphiné. At the Pennsylvania Academy the drawing is catalogued as "French, late sixteenth century." The locale may well be correct, since France was the most likely site for a Pazzi tomb in that century, but the date seems too late, since by then other influences would have been found. Perhaps this tomb was designed by a Florentine artist active in

France, such as Domenico Barbiere. Francesco Pazzi died in Rouen in 1548. This may have been his tomb.
C.E. & I.W.
Armorial information courtesy of Dr. H. Nickel; Rietstap, *Armorial General*, V, Pl. 245; H. s'Jacob, *Realism and Idealism: A Study of Sepulchral symbolism*, Leyden, 1954; Picot, "Les Italiens en France au XVIe Siècle," *Bulletin Italien*, II, 1902, p. 113.

VINCENZO DE' ROSSI
Fiesole 1525—Florence 1587
Cat. 15
Design for the Fountain of the Twelve Labors of Hercules, ca. 1560.
Black chalk.
433 x 253 mm
Inscribed "Bacchio 46."
Provenance: Sir Joshua Reynolds (Lugt 2364).
Lent by the Cooper-Hewitt Museum, Smithsonian Institution, New York, Purchase in memory of Mrs. John Innes Kane, 1942-36-1.
Purchase in memory of Mrs. John Innes Kane.
The Fountain of the Twelve Labors of Hercules was an ambitious project intended to glorify Duke Cosimo I de' Medici. This design and ten other preparatory drawings are thought to have been executed shortly after the work was commissioned in 1560. From the pedestal of the octagonal base to the celestial sphere balanced on the topmost Hercules' shoulders, the fountain would have measured almost fifty feet. Twelve Hercules groups (eight around the base, three above the *tazza*-shaped basin, with the crowning figure), eight bronze reliefs of scenes from Hercules' life, *putti* riding capricorns, and other ornaments were planned.
Six Hercules groups are indicated in the drawing: from left to right at bottom, Hercules slaying Cacus, fighting with a centaur, and struggling with Antaeus. Above, the hero grapples with Cerberus and the lion; at the top he holds the celestial sphere. De' Rossi himself carved the three groups sketched at the bottom together with the topmost one. The two middle groups in the sketch were never finished.
Borghini says that by 1584, seven over-life-sized Hercules marble groups (including three by other sculptors) were complete. In 1592 they were moved to the Sala dei Cinquecento in the Palazzo Vecchio, where all but the *Hercules Carrying the Celestial Sphere* (Villa Poggio Imperiale, Florence) remain to this day.
Since the fountain was never completed, the Cooper-Hewitt drawing remains the best image of its intended appearance. Devised by Borghini, the complicated scheme symbolizes the power of the Duke through his labors (representing twelve virtues) and his astrological destiny. Judging from the

other known drawings, de' Rossi went through numerous graphic exercises preparatory to his sculpture, from quick sketches to more finished studies. In addition, Brinckmann (*Barock-Bozzetti*, II, Pl. 1 and 2) has published a small-scale model for *Hercules Carrying the Celestial Sphere* which demonstrates that the sculptor carried his preparation through to three-dimensional models. In the chalk sketch de' Rossi composes the pyramidal structure of the fountain, arranges the proportions of its parts, and choreographs Hercules' furious movements to achieve what would have been an overpowering effect.
I.W.
H. Utz, "The Labors of Hercules and Other Works by Vincenzo de' Rossi," *Art Bulletin*, III, 1971, pp. 360-361, fig. 23; D. Heikamp, "Vincenzo de'Rossi disegnatore," *Paragone*, XV, No. 169, 1964, 40-41, fig. 52; Borghini, *Il Riposo*, Florence, 1584, pp. 595 f.

LEONARDO SORMANI
Savona (?)—Rome, after 1589
Cat. 16
Plan and Elevation for Tomb of Pope Pius IV, ca. 1577-82.
Pen and ink and wash.
387 x 212 mm
Inscribed on the mount in a later hand: "Leonardo da Zarzane Scultre."
Provenance: J. Talman (Lugt 2884a); Sir T. Lawrence (Lugt 2445); S. Woodburn (Sale, Christie's, 4-10 June 1860: bought for the Victoria and Albert Museum).
Lent by the Victoria and Albert Museum, London.
The plan and elevation call for a freestanding sepulchral chapel with an entrance at one end and three large reliefs (the visible one shows the Coronation of the Pope) on the other exterior walls. Pairs of figures similar to those sketched by della Porta (see 11a, b) and derived from Michelangelo's Medici Tomb lie on the curved pediments over the reliefs. Great pilasters flanking the main reliefs are decorated with lesser reliefs of standing allegorical figures above smaller narrative compositions. Kneeling female figures on top of each corner turn toward a giant effigy of the pope, seated in benediction, as angels hover above bearing his tiara. This crowning statuary group was probably intended for casting.
The chapel's plan below shows the pope's oval sarcophagus at the center, and an altar opposite the entrance. Pairs of engaged columns and niches alternate around the interior walls. Pius IV, deceased in 1565, must be the pope identified here by Medici arms placed between his celestial and terrestrial coronations. This ambitious project presents a colossal freestanding tomb in the tradition of Michelangelo's Julius II schemes. Ward-Jackson estimated that if the entrance were three feet wide, a normal size,

then the height of the structure would have reached fifty feet! Such dimensions seem implausible; perhaps the proportions of the drawing are not strictly to scale. This grand design illustrates the high ambitions of sculptors, more often nurtured by projects and drawings than realized in marble and bronze.
I.W.
F. Gregorovius, *Le Tombe dei Papi*, revised by C. Huelsen, Rome, 1931, p. x, No. 70 and Pl. 70; H. Siebenhüner, "Umrisse zur Geschichte der Ausstattung von S. Peter in Rom von Paul III bus Paul V," *Festschrift für Hans Sedlmeyer*, Munich, 1962, 251, Pl. 13; P. Ward-Jackson, *Victoria and Albert Museum Catalogue, Italian Drawings of the Sixteenth Century*, London, 1980, I, No. 320, pp. 320-321.

EMANUEL SCHWEIGGER
Near Strasbourg(?) Nürnberg 1634
Cat. 17
Epitaph Design with Jonah Relief. (Not illustrated.)
Pen and ink and wash. Cut around the image and mounted on another sheet. Inscribed near the bottom center "Grabschrifte" (Epitaph).
260 x 177 mm
Lent by the Arthur M. Sackler Foundation, New York.
A fanciful three-tiered composition has been devised for this epitaph, a memorial installed in a church. At the top, angels flank a cartouche filled with armorial bearings. The arms are typical for those of an ennobled German townsman; the halved eagle was a token of favor by the Emperor, who authorized ennoblement. These arms have not been identified. Schweigger may have sketched a sample epitaph with imaginary heraldry. The central frame contains a scene of Jonah and the whale, while allegorical figures stand on either side, one holding a cross (Faith), the other a bird (Hope?). The bottom space has been left blank to receive the epitaph. *Putti* heads, fruit-swags, and curling volutes ornament this Mannerist-inspired relief, possibly meant to be carved in wood.
A drawing in Berlin inscribed "Emmanuel Schweigger bildhauer Nürnberg" for a similar wall monument provides a basis of comparison (see Friedlander). German in its attention to detail, Mannerist in its complexity and fantasy, this is a fine example of a design suited to the Northern talent for carving.
I.W.
Armorial information courtesy of Dr. H. Nickel; M. J. Friedlander, *Die Zeichnungen des altes Meister in Kupferstichkabinett*, I, Berlin, 1921; Siebmacher, *Neues Grosses Wappenbuch*, Nürnberg (1605), ed. 1734, pp. 136-137.

MAXIMILIAN COLTE (POUTRAIN)
Arras? active ca. 1590-London 1645
Cat. 18a
Funerary Monument of Lady Elizabeth Savile, ca. 1627. Twice inscribed "Max Colte." (Not illustrated.)
Pen and colored ink washes
352 x 285 mm

Extremely handsome and austere in design, this tomb goes back to Tuscan prototypes of the first half of the sixteenth century, to the same Michelangelesque sources used for the Pazzi Tomb (14). Employment of stones of contrasting color was especially popular in northern Europe where Colte grew up, as well as in England. This tomb and its pendant are in the style of the sixteenth-century Southwark School. Statues of the three theological virtues appear at the top, Charity at the far left, Hope at the center, and Faith at the right. A strapwork cartouche has a circular boss with a black shield. Lady Savile's monument was destroyed, probably in 1791, when the church was extensively remodeled.

Cat. 18b
Funerary monument of Sir George Savile (obit 1622), ca. 1627.
Inscribed "Max Colte."
Pen and colored ink washes.
502 x 440 mm
Both for Church of Saints Peter and Leonard, Gorbury (West Riding, Yorkshire).
Provenance: Both from the Royal College of Arms, London.
Both lent by the University of Delaware Library, Newark Yorkshire Scrap Book, Q. Off. 914.27 y65, p. 23, right p. 21, right.
Sir George's tomb, which survives, is in a far more conventional style than his wife's. Emphasis is placed upon the effigy, shown in armor, hands joined in prayer. The deceased is placed in an altar-like architectural recess. A rectangular plaque surrounded by a series of military devices is above. A blank shield for the Savile arms appears at the very top set in a strapwork cartouche flanked by mannerist ornament and obelisks (symbols of eternity) at the far left and right. The contract for both tombs is found in the Scrap Book (p. 22) dated January 21, 1627, drawn up between the sculptor and Edward Ackroyd of Lincoln's Inn. C.E.
For both drawings see, J. Harris, *A Catalogue of British Drawings for Architecture, Sculpture, Decoration, and Landscape Gardening, 1550-1900, in American Collections*, Gregg Press, 1971, p. 76.

ALESSANDRO ALGARDI
Bologna 1598—Rome 1654
Cat. 19
Allegorical Scene. n.d.
Graphite.
375 x 510 mm
Inscribed on verso in ink "d'Algardi."
Provenance: William F. E. Gurley.
Lent by the Art Institute of Chicago. Lenora Hall Gurley Memorial Collection, 1922.3479.
While this allegorical subject has not been fully explained, Heimburger is surely correct in suggesting that it signifies the property and learning of Algardi's native city of Bologna. Mercury with attributes of the patron of commerce and Minerva with those of eloquence stand at the foot of a fruit tree bearing the arms of Bologna; the river god Reno reclines to the right before a view of the city of tall towers; Psyche, *putti*, Chronos and other figures fly about the tree.

Algardi frequently developed his drawings from an initial spontaneous sketch through to a detailed study. This aided him in the preparation of the carefully and beautifully modulated surfaces for which he is admired. The Chicago drawing illustrates the sweeping pictorial quality which animates much of the sculptor's work. I.W.

W. Vitzthum, "Disegni di Alessandro Algardi," *Bolletino d'Arte*, XLVIII, 1963, 76, fig. 5 (mislabeled as fig. 6); H. Joachim and S. F. McCullagh, *Italian Drawings in the Art Institute of Chicago*, Chicago, 1979, No. 68, Pl. 71; M.R. Heimburger, *Alessandro Algardi Scultore*, Rome, 1973.

JACQUES SARRAZIN
Noyon 1588—Paris 1660
Cat. 20
Standing Figure—Study for "Autumn." ca. 1630—32.
Red chalk. At upper left in pencil "3"; at lower left in ink, in an old hand, "Sarrasin." On the verso, figure studies in black chalk.
178 x 73 mm
Provenance: Said to come from the Peoli Collection; given in 1931 by the Misses Sarah and Eleanor Hewitt.
Lent by the Cooper-Hewitt Museum, Smithsonian Institution, New York 1931-64-242.
This rapid and luminous sketch of a standing Bacchus with a small figure at his feet is related to a series of statues of the Four Seasons conceived for the Chateau of Wideville between 1630 and 1632. Le Mercier, Vouet, Sarrazin, and Le Nôtre collaborated to make the chateau, its embellishments, and its gardens among the finest of the period. A series of *Four Hours of the Day* now fills the façade niches at Wideville, but engravings dated 1642 of classical gods as the *Seasons* bear inscriptions that they are after statues by Sarrazin. Bacchus is clearly engraved in reverse after

the statue for which this drawing is a study. A few changes were made between the drawing and the statue represented by the engraving. In the print Bacchus now looks down at the figure (discernible as a young Faun), who returns his gaze. In this early project drawing Sarrazin explores the composition of his two figures within the boundaries of space defined by their pedestal. I.W.
M. Digard, *Jacques Sarrazin, son oeuvre, son influence.* Paris, 1934, pp. 134-136; P. M. Charageat, "Abraham Bosse et Jacques Sarrazin," *Gazette des Beaux-Arts*, 1936, I, pp. 373-377; .P. Rosenberg, *French Master Drawings of the 17th and 18th Centuries in North American Collections*, London, 1972. Cat. 201, p. 112.

Cat. 21
The Element Fire. 1642—50. (Not illustrated.)
Black chalk heightened with white chalk on tan paper; red chalk line borders original sheet patches added to lower margin.
126 x 303 mm
Inscribed in brown ink on upper left recto: "Sarrasin."
Provenance: Marquis de Chennevières (Lugt 2073); sale, April 14-17, 1900, No. 464; Charles Saunier; Wildenstein, 1972.
Lent by private collection, New York.
Surrounded by four *putti*, Jupiter sits with his eagle among clouds and brandishes a thunderbolt, symbolizing fire. This is a preparatory study for one of four semicircular reliefs of Chantilly stone in the vestibule of Maisons. The theme of this decorative cycle was the Four Elements, each symbolized by a god or goddess.

The architect Mansart delegated the decoration of the building to Sarrazin, who in 1642-50 directed a team of predominantly Flemish pupils. No *modelli* for these reliefs are known. Sarrazin may have permitted the executants considerable freedom in the "plastic invention" of his design, as the great variety of decorative styles at Maisons would indicate. Perhaps drawings such as this sufficed to convey the sculptor's intentions to followers. Certainly the finished work is true to the drawing, while fleshing out those parts only implied by the sketch. An apparent difference is Jupiter's left leg, hesitantly indicated as tucked under the body in the drawing, but extended with the other leg in the relief.

Sarrazin scores the sheet heavily with black chalk, accentuating angular shapes and inventing abbreviated forms for facial features and other details.

This treatment is similar to *Study for Autumn* (20) and to the *Triumph of Silenus* (Metropolitan Museum of Art). I.W.

Marquis de Chennevières, "Une collection de dessins d'art français," *L'Artiste*, XI (1896), 259; Fogg Art Museum, *French Drawings from a Private Collection: Louis XIV to Louis XVI* (ed. by K. Oberhuber and B. Jacoby), Cambridge, Mass., 1980, No. 4.

ALONSO CANO
1601—Granada 1667
Cat. 22
Recto: *Studies for the Annunciation.* n.d.
Verso: *Madonna and Child.* (Verso not illustrated.)
Pen and brown ink bistre.
374 x 219 mm
Lent by the Courtauld Institute Galleries, London, Witt Collection.
Wethey connected the Virgin and the *putti* on the recto to Cano's painting of the *Annunciation* in Granada Cathedral (1655-56). While it is far from clear that these studies are preparatory to the painting, the *putti* holding a heavy curtain and some of the flying figures look alike in both works. The Virgin's pose in the drawing and her position on the plinth differ substantially from the painting, and the Annunciate Angel is absent.

Another *Annunciation* designed by Cano is the relief medallion over the central portal of Granada Cathedral. The artist became ill and died shortly after his plans for the Cathedral façade were accepted in 1667, so the sculptural decoration was not added until the early eighteenth century. The *Annunciation*, carved by Cano's follower José Risueno in 1717, was the only decoration which followed the original design.

The relief is a partial reprise of the painting's composition, but the Annunciate Angel is shifted far to the right. The drawing may be placed between the painting and the sculpture, adaptable to either medium. This reflects the balance of Cano's approach to both forms of expression: a painted *Immaculate Conception* (Museo Provincial de Alcala, Victoria) and a wooden statuette of the same subject (Granada Cathedral) share a certain weight, plasticity, and concern with the same tapering silhouette.

The bold and vigorous strokes of his pen date from Cano's late years. The *Annunciation* is among the finest records of Cano's draughtsmanship. I.W.

H. E. Wethey, "Alonso Cano's Drawings," *Art Bulletin*, 1952, 222-223, fig. 16 and 17, Cat. No. 8; Wethey, *Alonso Cano, Painter, Sculptor, Architect*, Princeton, 1955, pp. 9-10.

SEBASTIAN DE HERRERA Y BARNUEVO
1617—Madrid 1671
Cat. 23
Study for a Sculptural Group on a Pedestal—a Draped Female Figure, Putto, and Dolphin. n.d.
Bistre, pen and wash with black chalk underdrawing.
155 x 120 mm.
Lent by the Courtauld Institute Galleries, London, Witt Collection.

A draped woman gestures and regards a *putto* at her feet as a dolphin twirls his tail around and behind them. Chalk *pentimenti* outline the variations for the base.

The heavy outlines, flickering use of wash, crinkled drapery, and sharply tapering fingers relate this study to the distinctive draughtsmanship of such Herrera y Barnuevo drawings as *Mother of Samson* (Museo Municipal, Madrid) and *Allegory of the Death of Philip IV* (Metropolitan Museum of Art). While the attribution of this page may be confidently proposed, however, its subject and purpose are unclear. Does the dolphin indicate an Amphitrite or Venus Marina, as it so often does in sculpture? If so, why then is the female figure completely clothed? Is the *putto* Eros?

The composition is quite open and the figure's pose unrestrained for a Spanish sculpture of mid-century. Jonathan Brown suggests (oral communication) that the study might be for a temporary decoration, materially more flexible and structurally less demanding than a marble sculpture. Spirited and graceful, the composition is a delightful contrast to the strong but sober sculpture one usually associates with the Spanish Baroque.
I.W.

Palomino, *Vidas de los pintores y estatuarios eminentes españoles*, Madrid, 1724.

CIRO FERRI
1634—Rome 1689
Cat. 24
Reliquary Supported by Faith and Charity. n.d. (Not illustrated.)
Black chalk on brown laid paper.
393 x 232 mm.
Inscribed at bottom "Oy: Ciro Ferri."
Provenance: B.D. (Lugt 350); Francesco Maria Niccolo Gabburri (as described in the "Descrizione dei disegni della Galleria Gabburri a Firenze," no. 458, published in G. Campori, *Raccolta di cataloghi ed inventarii inediti . . .*, Modena, 1870, p. 568).
Lent by the Pennsylvania Academy of the Fine Arts, Philadelphia, 239.

Montagu has observed that the personification of "Humility," which figures with her companion "Obedience" in this attractive design, is related to a bronze statuette in the Museum für Kunst und Gewerbe, Hamburg. She identified the bronze as a *bozzetto*, probably cast following the drawing, to provide a craftsman with the basis to execute a detailed model to be cast in silver. The flame in the bronze's left hand was probably added to give meaning to her gesture.

It was thought that Ferri only *designed* sculpture, leaving the execution to others. But Montagu and Lankheit agree that in some cases, such as this, his artistic participation included the making of models and the supervision of the casting and chasing of his work as well. The costly finished object made from this design has been lost, but a reliquary of the right hand of St. John the Baptist in the Museum of the Co-Cathedral of St. John (La Valletta, Malta) convincingly attributed to Ferri by H.-W. Kunft, shows how such a work may have looked.
I.W.

J. Montagu, "A Bozzetto in Bronze by Ciro Ferri", *Jahrbuch der Hamburger Kunstsammlungen*, XVIII, 1973, 119-124; H.-W. Kunft "A Reliquary by Ciro Ferri in Malta," *Burlington Magazine*, LXII, 1970, 692-695; K. Lankheit, *Florentinische Barockplastik*, Munich, 1962.

PIERRE PUGET
1620—Marseilles 1694
Cat. 25
Ship Building Scene. n.d.
(Not illustrated.)
Brown pen over pencil. Below center: "original de Mr. peuget le père."
493 x 726 mm.
Lent by the Museum of Fine Arts, Boston. Gift of Dr. Hanns Swarzenski in memory of the Director of the Warburg Institute, Gertrud Bing. Marseilles, Musée des Beaux-Arts. Palais Longchamp. *La Peinture en Provence, au XVIIe siècle* (exhibitor catalogue), 1978, p. 185, fig. 12.

Well-known as a draughtsman of marine subjects, Puget drew many ships, as well as designs for their richly carved figureheads and other ornamentation, such as the ornate *Study for the Decoration of a Ship* (Metropolitan Museum of Art, New York) and a *Ship with Stevedore* (private collection, Paris), similar in subject matter to this sheet. Yet only one other drawing attributed to Puget represents a ship under construction (*Vaisseaux dans un port*, Paris, collection unknown; see *La Peinture en Provence*, p. 185, fig. 10). The precise rendering of a classical arcade framing the ship skeleton and the picturesque depiction of men at work evoke Puget's manifold activities as a designer for the Arsenal of Toulon. Producing the elaborately carved embellishments for ships provided many sculptors, including Colte (18a, b) and Algardi (19), with remunerative commissions.
I.W.

P. Rosenberg, *French Master Drawings of the 17th and 18th Centuries in North American Collections*, London, 1972, Cat. 120.

Cat. 26
Two Heads for a Relief. n.d.
Black crayon and white chalk on blue laid paper. Inscribed at lower left in pen and ink "pierre puget." At lower right in pencil, partially rubbed out, "du Puget sculpteur" (?).
300 x 226 mm
Lent by the Pennsylvania Academy of the Fine Arts, Philadelphia.

A sculptor's sense of volume is suggested by this rendering of two views of a man's head. Puget's penchant for the grotesque and his interest in physiognomy relate this sheet to various of his projects. Though Herding disputes it, the man's features tie this drawing to the figure of a soldier in the ill-fated Alexander and Diogenes relief for the Louvre. This is probably a preparatory drawing for that relief.
I.W.

P. Rosenberg, *French Master Drawings of the 17th and 18th Centuries in North American Collections*, London, 1972, Cat. 119.

CHARLES LEBRUN
Paris 1619—Paris 1690
Cat. 27
Studies of a Dragon, Lions, and Cerberus, ca. 1670.
(Not illustrated.)
Black and white chalk with grey wash on brown paper. Inscribed in ink above: "3p. 10 po," "bronze"; in the center: "3 pi"; in the lower part: "demie relief," "3 pied"; and beneath "au Magasin de Roy/au vieux Louvre" . . .
276 x 182 mm
Provenance: According to an inscription on the sheet "ces dessins m'ont été donnés par Horace/de Viel Castel Xbre 1859." Chennevières (Lugt 2073); Leon Decloux.
Lent by the Cooper-Hewitt Museum, Smithsonian Institution, New York. 1911-28-6.

A wild boar on another sheet in the same collection (1911-28-7) is by the same hand as this drawing. Once attributed to Charles-André Boulle (1643-1732), these two pages were tentatively attributed to LeBrun by Feray and later confidently ascribed to that master by Rosenberg with the support of Montagu. As the contemporary inscriptions inform us, these are studies after fairly large bronze reliefs then stored at the Louvre. LeBrun may have contemplated reusing them in another decorative ensemble. Animals fascinated the artist. He illustrated the parallels between the heads of various species and human physiognomic types in a famous series of drawings. Hissing, roaring, snarling, the bronze animals spring to life in LeBrun's spirited yet accurate studies.
I.W.

Chronicle of the Museum for the Arts of Decoration of the Cooper Union, June 1952, fig. 7; R. P. Wunder "Nous avons aussi des chimères" and Feray's answer, in *Connaissance des Arts*, June 1961, p. 45; Worcester Art Museum, *The Practice of Drawing*, 1951; P. Rosenberg, *French Master Drawings of the 17th and 18th centuries in North American Collections*, London, 1972, Cat. 77.

GIAN LORENZO BERNINI
Naples 1589—Rome 1680
Cat. 28
Recto: *Design for Neptune Fountain, Palazzo degli Estensi, Sassuolo,* ca. 1652.
Verso: *Neptune and Amphitrite.*
Black chalk.
347 x 238 mm
Lent by Her Majesty Queen Elizabeth II, Royal Library, Windsor Castle, 5624.

Francesco I d'Este, whose bust Bernini carved, was so impressed by the magnificent *Fountain of the Four Rivers* completed by Bernini for the Piazza Navona in 1651 that the duke asked him to design three fountains for his palace at Sassuolo near Modena in 1652.

Bernini never saw the atrium of the palace, perched high on a rock, which his fountains would grace. Two are in recesses, a Neptune wrestling with a great fish at the right and Galatea at the left. Neptune is shown again in the larger central fountain. Four studies for the central group survive, of which this one, showing Neptune alone, may be the first. Here the sculptor returns to his great *Neptune and a Triton* (Victoria and Albert Museum) of 1620 and to Tuscan Neptune fountains of the sixteenth century. This single main figure proved to be his final solution.

Hand on hip, clasping his trident with the other, Neptune straddles his base of twin shells supported by two sea centaurs. The *verso* shows his wife, Amphitrite, Queen of the Seas, holding out her crown as Neptune climbs the rock on which he is seated. Another study of this compositon, more fully rendered, is also at Windsor. Bernini may have selected black chalk for these studies because it lends itself to a vivid evocation of the cascades of water, providing a special sense of space and motion.

Compared with their brilliant drawings, the statues themselves are disappointing. That Bernini left the execution of the sculpture to local talent is all too evident.
C.E.

H. Brauer, R. Wittkower, *Die Zeichnungen des Gianlorenzo Bernini*, Berlin, 1931, reprint, New York, 1970, 37, 38; U. Donati, "Tre fontane berniniane," *L'Urbe*, VI, 1941, ii, p. 11; A. Blunt, H. H. Cooke, *Roman Drawings at Windsor Castle*, London, 1960, pp. 24-25; A. S. Harris, *Selected Drawings of Gian Lorenzo Bernini*, New York, 1977, cat. 52, p. XIX.

Cat. 29
Design for the Tomb of Pope Alexander VII, ca. 1671-78.
Bistre and brush and pencil on sepia-tinted laid paper.
223 x 167 mm
Provenance: P. Crozat (? Lugt 474); T. Hudson (Lugt 2432); B. Delany (Lugt 350); Sotheby's (June 5, 1872, p. 195, Cat. 28) sold to James (?) Hamilton.
Lent by the Pennsylvania Academy of the Fine Arts, Philadelphia.

This unpublished drawing shows the seated pope with the pointed beard seen in portraits such as Bernini's *Memorial Statue of Pope Alexander VII* (Cathedral, Siena). Plans for the papal tomb passed through three phases. Bernini was awarded the commission in 1655. After Alexander's death in 1667, his successor Clement IX decided to move the projected tomb from its intended site in St. Peter's to the tribune of Santa Maria Maggiore as a pendant to his own tomb. When this plan was abandoned about 1670, the tomb was returned to St. Peter's and completed in 1678.

Three preparatory drawings for this Alexander VII tomb, all in Windsor Castle, are known. Our drawing relates to the last sheet, especially in the motif of two trumpeting figures of Fame holding a coat-of-arms and papal insignia above and the door below. These features and the style prompt Suzanne Wells to date the Pennsylvania Academy sheet about 1670, when the sculptor is known to have made renderings and models for the final stage of the tomb.

Occasionally, as here, Bernini sketched with broad strokes of the brush and then inked in detail with precise staccato touches of pen. As this drawing has undergone considerable damage and subsequent repairs, including partial bleaching, it is difficult to make a hard and fast judgment as to the page's autograph quality; it may have been made at a time when Bernini was no longer able to produce such precisely delineated, highly detailed presentation drawings, leaving all but the sculptural elements to his studio. C.E. & I.W.

Cat. 30
The Penitent St. Jerome, 1672-73.
(Not illustrated.)
Brush and brown wash over black chalk.
156 x 222 mm
Provenance: Chennevières-Pointel (Lugt. 2073); B. Chesnais; sold at Sotheby's (July 7, 1966, lot 11).
Lent by the Courtauld Institute Galleries, London, Witt Collection.

This flowing wash drawing relates to a group of compositions of Saints Jerome, Francis, and Mary Magdalene, each shown kneeling in adoration over the crucifix. As Blunt notes, the style and technique of this sheet are comparable to a drawing at Windsor for one of the angels on the altar of the Cappella del Sacramento (St. Peter's). Bernini made a number of drawings of pious subjects for presentation to his patrons. Its freshness and abstract use of light and shade give this page the appearance of a personal reflection complete in itself, never meant for sculpture. I.W.
A. Blunt, "A Drawing of the Penitent St. Jerome by Bernini," *Master Drawings*, XIII, 1975, 20-22, Pl. 16.

PIERRE-ETIENNE MONNOT
Besançon 1657-Rome 1733
Cat. 31
Allegory of Faith. n.d.
(Not illustrated.)
Black chalk.
268 x 192 mm
Provenance: Christie's, Nov. 26, 1974, Cat. No. 104.
Lent by private collection, New York.

After completing reliefs and a portrait bust of Prince Livio Odescalchi in 1696, Monnot was commissioned by the Prince to execute his major work, the tomb of Innocent XI (Benedetto Odescalchi, 1611-1689) in Saint Peter's. The rich monument rests on a base of cipollino. The black marble sarcophagus is supported by gilded lions. White marble statues of Faith and Strength are at the enthroned pope's right and left, each seated on the sarcophagus. A relief, between the Virtues, shows the Liberation of Vienna from Turkish Assault in 1683. There is some dispute over attribution, since many artists contributed designs for Innocent's tomb, including Maratta, but Monnot is quoted as saying that his was the design chosen. His name alone is prominently incised as the monument's maker, and this vigorous continuation of the art of Algardi is something one would not expected from the elderly Maratta. As seen in this vigorous drawing, the major indication of Monnot's graphic style, his art points toward the eighteenth-century taste. C.E.
G. Sobotka, "Ein Entwurf Marattas zum Grabmal Innocenz XI im berliner Kupferstich-kabinett und die Papstgräber der Barockzeit," *Jahrbuch der Kon. preusz. Kunstsammlungen*, XIV, 1914, 22-42; R. U. Montini, *Le tombe dei Papi*, Rome, 1957, Cat. 241, 374-375. A *bozzetto* (Museo Nazionale, Florence) presumably by Monnot for the tomb of Innocent XI, has very little to do with the finished work (Montini, fig. 161).

UNKNOWN ARTIST active in Italy, early eighteenth century
Cat. 32
Winged Merman from a Fountain Group, ca. 1700. (Not illustrated.)
Red chalk, brush and brown wash, pencil.
253 x 182 mm
Provenance: Piancastelli. Purchased with funds from Mr. and Mrs. Edward D. Brandegee.
Lent by the Cooper-Hewitt Museum, Smithsonian Institution, New York, 1938-88-501.

Extravagantly animated, this vigorous figure of a winged bronze merman draws upon Mannerist and Baroque sources. Such ties to both the sixteenth and seventeenth centuries make the page hard to place securely—a date close to 1700 seems reasonable. Faint renderings of other (bronze?) decorative figures appear above and to the left. The merman's raised arms suggest that this fountain figure may have been meant to support a basin. He is one of a group of marine creatures cavorting in the waters.

With the passage of time the major fantasies of the Baroque became domesticated and reduced in size, applicable to a host of household tasks. Though still charged with Berninesque energy, this merman points to just such a new sense of the "applied": his highly unconventional wings would come in handy to support musical instruments and console tables. C.E.

PIETER VERBRUGGEN
THE ELDER (?) Antwerp ca. 1609—1686
THE YOUNGER (?) Antwerp ca. 1640—1691
Cat. 33
Design for a Tomb. n.d.
(Not illustrated.)
Pencil, pen and brown ink, grey wash.
Inscribed in Dutch, across top: Pillar of the church; on plaque: "black stone and green letters."
193 x 191 mm
Lent by Cooper-Hewitt Museum, Smithsonian Institution, New York, 1931-64-259.

This elegant drawing is a study for an unknown tomb. At the bottom, a recumbent veiled female (Urania?) leans upon a sphere, her left hand extended to grasp a serpent biting its tail, a common emblem of eternity. An attendant *putto* at the right helps support the snake; his right arm braces an escutcheon destined to bear the coat of arms of the deceased. The pediment of "black stone" intended to carry the epitaph doubles as a support for a funerary brazier at the top. Additional *putti* hover at either side flourishing palms and floral wreaths. A notation at the top identifies the vertical field of wash as representing the column of a church against which the tomb was to be placed.

The page was formerly ascribed to Jan Claudius de Cock, and dated ca. 1725-50. We owe the present tentative attribution to E. Haverkamp-Begemann, who kindly pointed out the stylistic affinities between the present sheet and a body of drawings associated with the Verbruggen. The use of summary arcs to describe the hair and similar profiles is also found in a drawing at Yale signed P. Verbruggen (*Angel Seated on a Balustrade Playing a Harp*). J.G.
E. Haverkamp-Begemann and Anne-Marie S. Logan, *European Drawings and Watercolors in the Yale University Art Gallery, 1500-1900*, New Haven, 1970, I, p. 333; II, Pl. 308. Cat. 624.

ROBERT HARTSHORNE
active 1715—1728
Cat. 34
Design for a Monument to Sir Thomas Powys (Thorpe Achurch, Northamptonshire), ca. 1720.
Pen, black ink pencil, and grey wash.
Cut out all around perimeter and laid.
360 x 270 mm
Extended commemorative inscription inscribed at bottom "Monument of Sir Thomas Powys one of the Judges—of the Queen's Bench. He died in 1719—probably at [illegible]."
Lent by the Avery Architectural Library, Columbia University, New York.

This rendering shows Hartshorne's finest surviving sculptural group. The focus of the design is a portrayal of the deceased in judge's attire, alert and gesturing, as was customary on English tombs of this period. Powys' figure is flanked by personifications of Justice and Truth (left and right respectively). Corinthian columns support a broken entablature topped by the massive escutcheon, and these enclose a huge commemorative inscription recounting Powys' virtues, his various legal offices, and his ancestry.

Hartshorne here deploys with considerable skill a tomb format popularized in Britain by the Stanton workshop. Despite the top-heavy crowning element, the design achieves a simple elegance rare in British sculpture of this period. The almost Rococo fluency of the drapery, swags, *putti*, and allegorical figures suggests Hartshorne's cognizance of contempory Continental developments. J.G.
J. Harris, *A Catalogue of British Drawings for Architecture, Decoration, Sculpture, and Landscape Gardening 1550-1900 in American Collections*, New Jersey, 1971, pp. 110-111.

PIETRO BRACCI
1700—Rome 1773
Cat. 35
Project for the Tomb of James III, the "Old Pretender," ca. 1766. (Not illustrated.)
Pen and brown ink with brush, and brown and blue washes heightened with gouache, over traces of graphite on buff tinted paper, squared in graphite.
272 x 250 mm
Inscribed lower left in brown ink, "Pet. Bracci Inv. et Deli," and "Palmi" and "Trenta" at either end of a numbered scale below the elevation of the tomb.
Provenance: The artist's family (according to Pini di San Miniato); Count Arturo di San Miniato.
Lent by the Art Institute of Chicago, 1966.353. Gift of Margaret Day Blake in memory of Robert Allerton.
Bracci had erected the tomb of Maria Clementina Sobieska in St. Peter's in 1739. When her husband James III (the Old Pretender) died in 1766, the sculptor was chosen to design his tomb as well. The site was probably to have been opposite the Sobieska tomb in the last bay of the left aisle of St. Peter's; lack of funds prevented the monument's execution. (In 1819 Canova's design for James' tomb was erected in St. Peter's, commissioned by the English government.) At least five project drawings by Bracci for the tomb survive, all formerly in the Bracci family collection. The drawing exhibited here is one of these. James III is seated in a niche between two great Corinthian columns in the guise of a Roman emperor extending his baton in a gesture of authority; at his feet two allegorical figures, Courage holding a shield and Truth with a mirror, flank the sarcophagus. The helmet and arms atop the sarcophagus refer to James' qualities as a warrior in battle, while the lion beneath represents England.

The Chicago drawing represents a simplification in design frequently noticeable in projects for St. Peter's: once a sculptor's awe of the setting was tempered by practicality. One of the last works from Bracci's hand, this drawing responds to the continuity of tradition which characterizes Roman eighteenth-century art in general and the St. Peter's tombs in particular. I.W.

F. van den Broeder, *Rome in the Eighteenth Century,* Storrs, Connecticut (exhibition catalogue), 71-72, No. 61, fig. 17; H. Joachim and S. F. McCullagh, *Italian Drawings in the Art Institute of Chicago,* Chicago, 1979, No. 129.

GIOVANNI BATTISTA FOGGINI
Florence 1652—1725
Cat. 36
David Victorious over Goliath, ca. 1723.
Black chalk and brown ink and wash.
210 x 133 mm
Lent by the Avery Library, Columbia University, New York.
Over a period of four years Anna, Electress Palatine, ordered a series of twelve bronze groups, all on religious themes. Two of these (executed in 1723, according to Baldinucci) were by Foggini: *The Baptism* (Palazzo Pitti, Florence) and a lost *David Victorious over Goliath,* for which this preparatory drawing and the *bozzetto* survive.

A wax cast from the lost bronze *David* and a replica in Doccia porcelain are in the Museo di Doccia (Sesto Fiorentino). In comparison with Foggini's very free rendering, his clay sketch is far more compact. He stresses the contrast between the boyish David and the huge Goliath much more clearly in the sculpture by making David look even younger and more vulnerable, holding the great severed head nearer his body. C.E.

W. Vitzthum. Review, *Master Drawings,* III, 1965, p. 177, Pl. 38b; A. A. Tait, "Foggini's 'David and Goliath,'" *Master Drawings,* IV, 2, 1966, p. 169; *Gli ultimi Medici, Il tardo barocco a Firenze, 1670-1743,* Florence 1974, Cat. 12; J. Montagu, "The bronze groups made for the Electress Palatine," *Kunst des Barock in der Toskana, Studien zur Kunst unter den letzten Medici,* Munich, 1976, pp. 126-136; F. Baldinucci's life of Foggini is reprinted by K. Lankheit in *Florentinische Barockplastik-Die Kunst am Hofe der letzten Medici,* Munich, 1962, pp. 223-238.

AGOSTINO CORNACCHINI
Pescia 1685—Rome (?), after 1740
Cat. 37
Study for "Fame": Sketch for a Costume, 1712. (Not illustrated.)
Inscribed on verso: D'Agostino Cornacchini scultor Fiorent.º pensiero per la Flora, per l'Acc.ª del Prpe Elettorale di Sassonia del 1712.
Pen and ink with washes of blue, yellow and pink watercolor.
319 x 222 mm
Lent by the Koenig Theater Collection, Virginia Museum of Fine Arts, Richmond.
Sculptors sometimes designed temporary decorations for triumphal entries, operas, and other theatrical events where dramatically effective figures and settings were required. Bernini (28-30), Herrera y Barnuevo (23), and Noguchi (110) sometimes engaged in such productions. This drawing, for the costume of Fame, is for a singer in the opera *Il Vero Onore,* performed in Florence in 1712.

Cornacchini designed costumes for all the main performers and three of the dancers, including Fame, Flora, Minerva, Mars, and Mercury. He also prepared a rendering of the opera, now in the Biblioteca Marucelliana (Florence), once owned by his patron Gabburri, who owned all the costume studies as well. Gabburri's inscription on the back of this page confuses its identification with that of Flora—he seems to have switched their subjects when writing.

Whether planning a stationary group such as his *Judith with the Head of Holofernes* or an operatic costume, Cornacchini brings much the same festive graphism to bear, always employing a celebratory style. C.E.
P. Cannon-Brookes, "The paintings and drawings of Agostino Cornacchini," *Kunst des Barock in der Toskana, Studien zur Zeit unter den letzten Medici,* Munich, 1976, pp. 118-124.

JOHANN WOLFGANG VON DER AUVERA
Würzburg 1708—1756
Cat. 38
A Sheet of Studies. n.d.
Pen, brown and black ink with grey wash over traces of pencil.
253 x 415 mm
Old numbering: "189" at upper left.
Lent by the Martin von Wagner Museum of the University, Würzburg, Inv. no. D H2. 161.
Master of a large workshop, Auvera provided his assistants with drawings to be followed for the stream of commissions for pulpits, tabernacles, reliquaries, and other decorations that came to him from Catholic churches throughout the area. Personifications of Faith—a woman with a cross and an angel with a flaming heart—are at the drawing's lower left; the Good Shepherd is toward the upper right; angelic messengers with speech scroll and lily branch are at the lower right. Other figures and Rococo architectural ornament are also found on this page, for execution in wood or stucco with touches of gilding and color. An extraordinary spirit of animation pervades the sheet, typical of the art of the period. Auvera may have drawn this page in the 1740's, when he was working on the Parish Church at Heusenstamm (1744) and on the decorations for Brühl. C.E.
D. Graf, *German Baroque Drawings,* the Heim Gallery, London, 1975, Cat. 9.

GIOVANNI BATTISTA TIEPOLO
Venice 1696—Madrid 1770
Cat. 39
Zephyrus and Flora, ca. 1743. (Cover)
Pen and wash over black chalk.
220 x 279 mm
Lent by the Victoria and Albert Museum, London.
Although Tiepolo frequently employed illusionistic *grisaille* figures in his grand decorative schemes, he seems to have been more directly concerned with the sculptural process on only one occasion. In October 1743 he was at work on the ceiling of the Villa Cordellina at Montecchia Maggiore near Vicenza, where his frescoes of the *Family of Darius before Alexander* and *The Continence of Scipio* survive. Apparently he was asked to contribute designs for sculpture to adorn the villa's gardens.

Seven of these drawings are preserved in the Victoria and Albert Museum. Our sheet is one of the three which depict Zephyr and Flora at affectionate play. Portents of spring, these characters are ideal subjects for an *al fresco* sculptural scheme. Save for Zephyr's paper-thin wings and materialized breath, Tiepolo's design could have been translated into sculpture with relative ease, though none modeled after it is known to survive. The adjustment of the extended foot of Zephyr, for example, may represent an attempt by Tiepolo to rein in his customarily expansive approach, a stylistic concession to the practical use for which the drawing was intended. Meanwhile, save for the conspicuous base, this could well be an elegant study for one of Tiepolo's paintings. J.G.
G. Knox, *Catalogue of the Tiepolo Drawings in the Victoria and Albert Museum,* (London, 1960), 16-17, 55-56, Cat. 78.

EDMÉ BOUCHARDON
Chaumont 1698—Paris 1762
Cat. 40
Academy-Standing Male Nude,
ca. 1737.
Red chalk, inscribed at lower left
over pencil: "Bouchardon."
582 x 322 mm
Lent by private collection, New York.

This *Academy,* as noted by Rubin-Levine, is drawn from the same model Bouchardon posed in a study for the *Plague at Milan,* a relief in the Versailles Chapel of 1737, providing an approximate date for the drawing. In order to hold his pose, the model is supported by a stick at the left and may perhaps have held onto a rope with his right hand. Drawn when the master was about forty, this page shows Bouchardon's extraordinary graphic command, the basis of all of his major sculptural projects.

The model's pose may have been freely adapted from a classical source. Bouchardon's close study of such works in Rome had led to his publication, in 1732, of a *Recueil de 50 statues antiques dessinées à Rome.* Deeply interested in the art of Antiquity, Bouchardon made this drawing in the same year that he entered the Académie des Inscriptions et Belles-Lettres. Studies of this kind led the way to his publication in the following year (1738) of *Livre de diverses figures d'académie dessinées d'après le naturel.*

The brilliant rendering recalls Caylus' eulogy of Bouchardon, in which he wrote "often, without having to repeat or erase, he drew with such confidence that the contour of an entire figure went without interruption from the neck to the heel." C.E.

J. H. Rubin and D. Levine, *Eighteenth-Century French Life-Drawing,* The Art Museum, Princeton University, 1977, pp. 46-7, Cat. 3.

AUGUSTIN PAJOU
Paris 1730—1809
Cat. 41
Project for the Funerary Monument of the Maréchal de Belle-Isle, 1761.
Pen, pencil, and black ink, brush and various watercolors with gouache white heightening on brown paper.
Signed: Pajou inve. fe. 1761.
Inscribed at bottom: Allegory. The Maréchal enters the sepulchral chamber containing the tombs of his wife and son, the Court of Gisors, who both predeceased him. Their spirits are supposed to have left their tombs in order to greet him, and the Angel of Death is shutting the door of the sepulchral chamber in order to indicate that the Maréchal was the last of his family.
902 x 569 mm
Lent by the Cooper-Hewitt Museum, the Smithsonian Institution, New York, 1931/73/234.

This extravagant design was conceived as an *hommage* to an aristocratic lineage that had died out. The deceased, Maréchal Charles-Louis-Auguste Fouquet, Duc de Belle-Isle, left no descendants. Audaciously, Pajou seized upon the extinction of the family line as his funerary theme. At the center is the erect figure of the Maréchal shown as a classical general, but for his incongruously bare feet. The shades of his deceased Magdalen-like wife and his son, both dressed *all'antica,* rise from their graves to offer a melancholy welcome. Thus we are privy to a macabre drama of reunion within the family burial chamber. Scythe in hand, the airborne Angel of Death is closing the heavy door of the tomb upon the world of the living for the last time. Smoking braziers provide an atmosphere of tenebrous gloom. An open book and olive branch at the lower left symbolize the arts of peace, countered at the lower right by the club of Hercules, a Roman cuirass, and other martial trophies which evoke the family's military heritage.

The Maréchal's heir decided after settling the estate's debts to reject Pajou's elaborate project in favor of a simpler, less expensive monument. Could the design have been successfully realized at any price? Many cast shadows suggest that Pajou envisioned a largely freestanding execution. How this would have been engineered must remain a mystery, but Pajou's grand presentation drawing conveys his original idea in all its visionary splendor. Playing his febrile pen-line against judiciously deployed masses of dark shadow, Pajou has succeeded in capturing the sombre drama of his mournful theme. J.G.

Michel N. Benisovich, "Drawings of the Sculptor Augustin Pajou in the United States," *Art Bulletin,* XXXV (1953), pp. 295-298; Henry Hawley, *Neo-Classicism: Style and Motif* (exhibition catalogue), Cleveland, 1964, no. 38.

CAT. 42
Studies for Two Reliefs for the Opéra, Versailles, ca. 1768-70.
Ink over red chalk.
Inscribed in chalk across top: *Segond saute (?)/premiers a droite estampe adousse a la loge;* in chalk above bottom design: *Segond;* Inscribed in ink, upper design: *armide;* lower design: *pigmalion.*
101 x 182 mm
Lent by the Arthur M. Sackler Foundation, New York.

Construction of a court theatre at Versailles has been contemplated since the reign of Louis XIV, but the project came to fruition only when the marriage of the Dauphin to Marie Antoinette occasioned the creation of a grand celebratory structure. The present studies are for two of thirteen gilded limewood relief panels Pajou designed for the second loge level (*l'étage du Roi*). All of these are mock-heroic representations of *putti* as figures from classical mythology (Bacchus and Ariadne, Castor and Pollux) and as allegories (Astronomy and Music).

The upper drawing gently burlesques a famous moment from Torquato Tasso's sixteenth-century poem *Gerusalemme Liberata.* The witch Armida, intending to wreak havoc in the camp of a party of Christian warriors on Crusade, has fallen unexpectedly in love with one of their number, Rinaldo. Here we see him, spear in hand, taking leave of a devastated, swooning Armida. The lower drawing playfully mocks the myth of Pygmalion. In the center, a child Pygmalion falls on one knee before a child Galatea, miraculously come to life from the figure he had modeled. On either side, fellow sculptors momentarily cease work on a recumbent nude and herm to watch this astounding spectacle.

Two distinct moments of the creative process, are juxtaposed on this sheet. The red chalk underdrawing manifests the facility and speed with which Pajou initially described the overall compositional idea. The more deliberate ink overdrawing reveals the play of Pajou's corrective intelligence, adjusting the outline of a head here and an arm there. J.G.

Henri Stein, *Auguste Pajou,* Paris, 1912, pp. 177-193; Comte de Fels, *Ange-Jacques Gabriel: Premier Architecte du Roi,* Paris, 1924, pp. 120-144.

JOHAN TOBIAS SERGEL
Stockholm 1740—1814
Cat. 43
Tobias and the Fish with the Demon Asmodeus, ca. 1770.
Red chalk.
352 x 236 mm
Lent by the Nationalmuseum, Stockholm, NMH 927.18.75.

This beautiful study is for the earliest surviving sculpture undertaken by Sergel in Rome and the only one to treat a non-classical subject. Tobias, the young hero of the apocryphal Book of Tobit, struggles with a giant fish controlled by the evil demon Asmodeus. By omitting Asmodeus from the completed terra cotta, Sergel has simplified the action to the basic struggle between man and watery beast. Tobias' perilous balance in the study has become the powerful muscular thrust of a Herculean figure in the round.

This uncommissioned work shows Sergel taking in Rome's artistic riches. The aqueous subject and exuberant spiral composition show the impact of Bernini's fountains (28) on the drawing, while the heightened severity of the terra cotta manifests Sergel's study of antiquities and the frescoed *ignudi* by Annibale Carracci in the Farnese Palace. The vigor and freedom with which Sergel deploys his French academic training is remarkable, notably in the pulsating delineation of Tobias' torso. J.G.

Johan Tobias Sergel (exhibition catalogue), Hamburg, 1975.

JEAN GUILLAUME MOITTE
Paris 1746—1810
Cat. 44
The Marital Libation, 1781.
(Not illustrated.)
Signed: *Moitte Sculpteur 1781*
Pencil and brown wash.
335 x 321 mm
Lent by the Crocker Art Museum, Sacramento.

Hands clasped in ritual profession of mutual loyalty, the central couple in this drawing offers libations upon a columnar altar in anticipation of their nuptial consummation. A prominent bed to the rear clarifies the marital context, while a kneeling attendant at left presents the pair with garlands of flowers to be offered up for conjugal fertility. The planar composition and the shadows cast by an implied light source to the left identify this as a study for a projected relief, but none based on this unpublished design is known. Moitte has succeeded in evoking the play of light over a carved marble surface with only minimal application of wash. The garrulous, wiry pen line is reminiscent of drawings by Greuze and other French artists of the period.

The drawing may have been conceived to commemorate a marriage, perhaps Moitte's own to Adelaide-Marie-Anne Castellas. But such themes were generally popular during this period. The present sheet, with its Baroque drapery, *all'antica* dress and accoutrements, and rather vapid figural canon, embodies the hybrid vision of Antiquity characteristic of many French decorative works of the later eighteenth century. J.G.

Le Neo-Classicisme Français: Dessins de Musées de Province (exhibition catalogue), Paris, 1975, pp. 97-102; Stanislas Lami, *Dictionnaire des Sculpteurs de l'Ecole Française au Dix-Huitième Siècle,* Paris, 1911, II, pp. 164-169.

JOSEPH NOLLEKENS
London 1737-1823
Cat. 45
The Monument to Naval Captains William Bayne, William Blair, and Lord Robert Manners.
ca. 1782
(Not illustrated).
Brown wash over pencil.
542 x 384 mm
Signed: J. Nollekens. Inscribed at right: 25 feet high. Lent by the Yale Center for British Art, New Haven, Paul Mellon Collection.

This is a study for Nollekens' largest monument, commissioned in 1782 by the British government and erected in Westminster Abbey, in memory of three naval captains killed during recent engagements with the French. The design features a semi-recumbent Neptune awkwardly perched upon a seahorse, and a standing Britannia paying mournful homage to a trio of *all'antica* medallions bearing portraits of the deceased heroes. These are attached to a column whose projecting ships evoke antique monuments to naval prowess and supports a winged Victory holding a laurel crown. The maritime theme is expanded by two relief panels with anchor and sextant, flanking a central commemorative inscription on the base.

Nollekens apotheosizes the three captains by using an exalted neo-Classical idiom. His design is replete with references to antique prototypes: Neptune, modeled after ancient representations of river gods, Britannia after a Minerva, and the portraits follow the *imago clipeata* found on Roman tombs. Use of an impressive catafalque formula, already employed in England by Rysbrak and Scheemakers, unifies the design. But the awkwardness of the overall conception, notably the inconsistent scale, drains the whole of conviction. An earlier, rejected design (Victoria and Albert Museum) is even more jumbled, offering the peculiar spectacle of Neptune spearing an unfortunate victim with his triton while an exultant Victory sounds her trumpet. The executed monument is quite close to our presentation drawing, and, while improving the initial proposal, it remains an unresolved *pastiche* typical of much official British sculpture of the later eighteenth century. J.G.
John Physick, *Designs for English Sculpture 1680-1860*, London, 1969, pp. 146-147.

ANTONIO CANOVA
Possagno 1757—Venice 1822
Cat. 46
Study for Hercules and Lycas, 1795.
Pen and brown ink.
157 x 270 mm
Lent by Michael Hall, New York.

This sheet carries several preliminary sketches by Canova for the group now in the Museo Nazionale d'Arte Moderna in Rome, whose plaster model is at Possagno. The marble was commissioned in April 1795, by Prince Onorato Gaetani of Aragona, who specified the violent subject. Though changes in Gaetani's political fortune led to his withdrawal of the commission, Canova continued to work on the project. In 1814 the marble was completed and purchased for 18,000 *scudi* by the Marchese of Torlonia. It depicts the climactic moment of an involved story of treachery and slighted love narrated in Euripides' *Trachiniae* and Ovid's *Metamorphoses*. Having just clothed himself in a white robe to make sacrifices to the gods, Hercules is overcome by the burning poison in which the robe had been soaked by his wife Deianira. Maddened by his agony Hercules flings the innocent servant who had delivered the poisoned garment to his death in the Euboean Sea.

Another study, dated October 19, 1795 (Bassano), reveals that Canova had then discovered the final pose for Hercules. There, he holds Lucas by the feet, his left arm tensed overhead, in a feat of strength. All four sketches on the Hall sheet depict Hercules extending both arms downward to seize his victim's hair, thus dating this drawing with relative security between April and October of 1795.

Canova devoted several hours each day to life-drawing, often requesting his models to assume poses related to works in progress. The deliberate line of the Bassano page identifies it as such a life-study. The Hall drawing shows Canova in a more spontaneous mood, testing ideas with a rapid, vigorous pen-stroke. J.G.
C. L. Ragghianti, "Studi sul Canova," *Critica d'Arte*, July/August 1957, "Disegni in Relazione con Opere Realizzate," pp. 56, 86-99; E. Bassi, *Il Museo Civico di Bassano; I disegni di Antonio Canova* (Venice, 1959), pp. 82-83; H. Honour, "Canova's studio practice," *Burlington Magazine* CXIV, 1972, pp. 146-159, 214-229.

JOHN FLAXMAN
York 1775—London 1826
Cat. 47
Study for "Britannia by Divine Providence Triumphant", 1799.
Pencil.
180 x 153 mm
Inscribed: "Colossal statue 230 feet high proposed to be erected on Greenwich."
Lent by the Victoria and Albert Museum, London.

The immense *Britannia* in this presentation drawing was Flaxman's entry in a government-sponsored competition for a naval monument to the victory over Napoleon at the Battle of the Nile. Flaxman envisioned his figure as towering above Wren's Naval Hospital on Greenwich Hill outside London. Flaxman's personification of the British Nation reflects the Athena Parthenos, thus comparing the new power of Britain and that of ancient Greece. This exercise in chauvinistic bombast was never to be erected; upon the revival of the Napoleonic threat in 1803 national monies were channeled elsewhere and the project was abandoned. J.G.
M. Campbell, "An Alternative Design for a Commemorative Monument by John Flaxman," *Record of the Art Museum, Princeton University*, XVII, 1958, 65-73.

Cat. 48
Study for a Monument to Dr. Warton, ca. 1800-01.
(Not Illustrated.)
Pen and ink and wash.
302 x 222 mm
Lent by the Victoria and Albert Museum, London.

This study for a funerary monument to Dr. Joseph Warton (d. 1800), poet and headmaster of Winchester College, was commissioned in 1801 by a group of friends and colleagues. Flaxman first thought to commemorate the antiquarian interests of the deceased through archeologically exact references to the classical world. But a comparison of this drawing with another (British Museum) with the completed monument indicates that the patrons encouraged the sculptor to modify his approach considerably, substituting a doctor's pedagogic robe and wig for the classical garb initially proposed. The wreathed portrait medallions were finally placed upon the marble block with images of Dryden and Pope, poets whose work Warton had edited. The two herms within the central relief are identified by inscriptions in the executed work as Aristotle and Homer. Flaxman here displays his ability to infuse human warmth into an all too-often glacial neo-Classical idiom. J.G.
N. Penny, *Church Monuments in Romantic England*, New Haven, 1977, 153-156.

CAT. 49
Study for a Monument to the Reverend John Clowes, ca. 1820.
Pen and grey ink and brown wash over pencil.
263 x 190 mm
Inscribed, at intervals across bottom: "Grandsire/Bible beside Mr. Clowes/Guardian Angel."
Lent by the Yale Center for British Art, New Haven, Paul Mellon Collection.

This is a study for a monument honoring the Reverend John Clowes on the occasion of his fiftieth year as incumbent of Saint John's Church, Manchester. An admired preacher, he was also known for his pedagogic skill and his active concern for child welfare. The commission offered Flaxman another occasion to represent one of his favorite themes, the transmission of tradition from one generation to another. Clowes is seen to the right in ecclesiastical robes, arm raised, driving home a rhetorical point to his five young listeners. A couple to the left inclines towards a large Bible propped open upon a table, to peruse the sacred text expounded by Clowes. Roman numerals on the wall behind indicate his theme, the Ten Commandments.

The present sheet was clearly executed as one of the presentation drawings Flaxman customarily produced for his patrons. The inscriptions across the lower border indicate alterations they wished him to make in the corresponding positions within the composition. Comparison of the drawing with the plaster model produced subsequently (University College, London) reveals that Flaxman followed their recommendations. The head and shoulders of an elderly "grandsire" have been inserted behind the couple at left. The Bible has been rotated to face Clowes, clarifying his role as intermediary between Holy Writ and the Faithful, and an ecclesiastic to his rear in the drawing has become a nimbused "guardian angel."

But despite these changes the basic compositional idea of the drawing has been retained. As in the best of Flaxman's small monuments, there is a disarming juxtaposition of sentimentality (e.g., the picturesque grouping of the children) and formal sobriety. After having been transferred from Saint John's to Saint Matthew's Church, Campfield, the monument was destroyed when the latter was demolished in 1951.
J.G.
N. Penny, *Church Monuments in Romantic England*, New Haven, 1977, 156-158.

PIERRE PAUL PRUD'HON
Cluny 1758—Paris 1823
Cat. 50
Study for River Rhine, ca. 1801.
Black and white chalk on blue paper (now faded to ochre).
607 x 409 mm.
Lent by David Daniels, New York.

This sheet has been associated with Prud'hon's submission to the 1801 design competition for a memorial column commemorating the French soldiers lost during the early Napoleonic campaigns. Intended for the Place de la Concorde, it was never erected. Prud'hon's (unsuccessful) scheme manifests a rare instance of his involvement with sculpture. It features allegorical representations of the Nile, the Po, the Rhine, and the Danube Rivers placed at each side of the base, all geographic reminders of recent French victories. These four figures are shown as river gods, reclining and holding flowing urns. The Michelangelesque nude is seated upon a vessel. Despite this discrepancy of pose, such an *académie* might well have been produced as a preliminary study for Prud'hon's entry. Nineteenth century references to this work as "The Rhine" lend support to such a theory. Certainly the monumental character and elegiac mood of the figure would have made it appropriate for such a project.

Whatever the circumstances of its creation, this drawing is a characteristic example of Prud'hon's superbly assured draughtsmanship. The transitional planes articulated with deliberate parallel hatchings suggest a rigorous academic exercise, but the end result is modeling of a velvety, Correggioso smoothness. With its bowed shoulders, disheveled hair, and anguished expression, this figure conveys a powerful impression of physical and emotional strain.

J.G.

Drawings from the David Daniels Collection, Cambridge, Mass., 1968, Cat. 32. J. Guiffrey. *L'Oeuvre de Prud'hon* Paris, 1924, p. 338, no. 902. A. de Montaiglon. "Pierre Prud'hon: Projet de Colonne Monumentale à la Gloire des Armées Francaises," *Archives de l'Art Francais*, XI, 1858-60, pp. 340-350.

BERTEL THORVALDSEN
Copenhagen 1770-1823
Cat. 51
Study for a statue of Bacchus and Hector with Paris and Helen's Maids, 1804.

Above the drawing, a draft for a letter from Thorvaldsen to the Danish painter I. L. Lund, probably written from Montenero near Livorno, June 1804: "Would you be kind enough to look after my studio so that no damage is done ... Thank you for the amount which you paid for me, and I ask you not to give more to anybody for the time being.

Would you have the kindness to look after my workshop now and then, that nothing will be damaged ... I have modeled baron ..."(Translation courtesy of Dyveke Helsted.)
Black chalk, pencil, and pen on paper.
204 x 175 mm.
Lent by Thorvaldsens Museum, Copenhagen A2, 50 (recto).

In 1803 Thorvaldsen had enjoyed his first major success with a monumental plaster *Jason*, all vigor and active stride. Three-quarters life-size, the *Bacchus* of the following year offers a melancholy counterpart to the earlier work. Thorvaldsen views the classical god of wine as contemplative, turned in upon himself; he is depicted in a quiescent, restrained pose which tends toward the planar. In general disposition it is reminiscent of Michelangelo's *Bacchus* (1496-98, Museo Nazionale, Florence), which Thorvaldsen could well have seen on an excursion to Florence. If that was his model, he has sobered it up, omitting any hint of the groping stumble and mindless stare so remarkable in Michelangelo's Bacchus. Here Thorvaldsen remains true to his professed esthetic commitments, offering a Bacchus that even Winckelmann could have loved.

The unpublished sketch reveals Thorvaldsen setting down his first thoughts on this subject, here, as so often, casually scribbled on a stray scrap of paper. While the sensuous swing he initially imparted to the figure was toned down in the plaster, the basic pose was retained in reverse.. The serpentine notations on either side of the legs indicate that inclusion of a cape was considered and rejected. Thorvaldsen's first impulses to reverse the pose are registered in the revised placement of the head and the second *thyrsus* drawn as supported by the right hand.

The sketch for a group to the left of the *Bacchus* represents Paris and Helen's Maids, and is probably related to the relief *Hector with Paris and Helen* modeled in Rome in 1809. The rough, calligraphic quality of these drawings is characteristic of Thorvaldsen's preparatory studies. They were intended for his eyes alone. After the most basic compositional decisions had been made he preferred to work directly in a plastic medium such as plaster. But these rapidly executed "notes" have a graphic vitality extremely attractive to the modern eye.

J. G.

Bertel Thorvaldsen Eine Ausstellung des Wallraf-Richartz-Museums, introduction by S. Schultz Cologne, 1977, I-II, pp. 9-20.

GIOVANNI BATTISTA FRULLI
died Bologna 1826
FRANCESCO STAGNI
died Bologna 1830
Cat. 52
Design for the Tomb of Sebastiano Tanari, ca. 1809
(Not illustrated.)
Brown and black pencil.
305 x 107 mm.
Inscribed "Piedi" and "di Bologna" on either side of a scale ruled 0 to 5 at the bottom of the sheet.
Lent by the Pennsylvania Academy of the Fine Arts, Philadelphia No. 124.

Soon after the conversion of the Carthusian monastery outside Bologna to a cemetery in 1801, it began to fill with funerary monuments to prominent citizens. The early nineteenth century was a period of rapid expansion for such public cemeteries. An unusual feature of the one in Bologna is its large number of painted *trompe l'oeil* and stucco tombs.

Wardropper has identified this drawing as a design for one such painted tomb. Frulli and Stagni were responsible for the figures and ornament, respectively, of the neo-Classical work. To commemorate Sebastiano Tanari, deceased in 1809, they devised a mausoleum decorated with his portrait medallion and a classically inspired relief of his deathbed scene. Religion stands atop the edifice while Erato, muse of lyric poetry, with lyre and swan and Urania, muse of astronomy, with globe and stars, sit at the entrance of the tomb, both accompanying the soul in harmony. Finally, the mausoleum is set within a domed building whose oculus evokes the Pantheon, symbolic resting place for men of genius.

When the Marchese Antonio Tanari and his wife Brigida died years later, the steps and entrance to the fictive mausoleum were painted over to make room for their epitaphs. By combining neo-Classic sculptural forms and a vast interior lifted from theatrical sets, the designers have conjured up a monument worthy of the Tanari aspirations but budgeted for their pocketbook.

I.W.

FELICE GIANI
Alessandria 1758—Rome 1823
Cat. 53
Design for Severoli Family Tablets, ca. 1811.
(Not illustrated.)
Pen and brown ink.
426 x 289 mm.
Inscribed in upper right tablet: "Severoli on ... Dal'Armi Fren ..."
Provenance: Piancastelli
Lent by the Cooper-Hewitt Museum, Smithsonian Institution, New York 1901-39-1374.

Four designs of the commemorative tablets are penned above. Two giant columnar monuments and a niche framing trophies on a pedestal below are shown to scale by the inclusion of tiny figures.

In 1811 Giani decorated two rooms in the Palazzo Severoni, Faenza, commissioned by General Filippo Severoni, an officer of the Napoleonic army, whose name is among those carved on the Arc de Triomphe. The scale and military character of these monument projects are appropriate to a soldier of Severoni's standing. Despite their neo-Classical imagery, the designs are rendered in Giani's dramatic and spontaneous manner, reminiscent of Piranesi. I.W.

S. Acquavista and M-Vitali, *Felice Giani, un maestronella civilta figurativa faentina,* Faenza, 1979, 278-279, figs. 68, 69.

WILLIAM RUSH (Attributed to)
Philadelphia 1756-1833
Cat. 54
Recto: *Columbia,* ca. 1812.
(Not illustrated.)
Red chalk.
235 x 171 mm.
Scroll left with motto: *God . . .;*
Lower left in pencil: "T. Badger", lower right in red chalk: "Go; . . ."
Motto on scroll: *God Armeth The Patriot.*
Verso: Pencil sketch of monument, inscribed in red chalk.
Lent by the Museum of Fine Arts, Boston, M. & M. Karolik Collection.

Whether or not Rush drew before carving is unknown, but the practice of drawing was very important to his art. In 1794, he joined with such artists as Charles Wilson Peale and Giuseppe Cerracchi to form The Columbianum—"an association of the Artists in America for the protection and encouragement of the

Fine Arts"—and later helped to found the Pennsylvania Academy of the Fine Arts in December 1805. Eisler has attributed *Columbia* to Rush on the basis of its sculptural style, and the subject may have been selected to stand for his fine-arts society. *Columbia* is remarkably close to Rush's *Nymph*, particularly in the clinging drapery style, retaining a certain wooden quality of form. She gestures upward with her right hand, while holding a billowing flag behind her with the other. The sketch is inscribed T. Badger (1792-1868), a portrait painter, but is not thought to be by that artist. D.J.H.

G. Hendricks, "Eakins' William Rush Carving His Allegorical Statue of the Schuykill," *The Art Quarterly*, Vol. 31, Winter 1968, pp. 382-404. H. Marceau, *William Rush 1756-1833: The First Native American Sculptor*, intro. by Dunton, The Pennsylvania Museum of Art, 1937.
M. & M. Karolik Collection of American Watercolors & Drawings, 1800-1875, Vol. I, no. 22, p. 68.

LORENZO BARTOLINI
Savignano 1777—Florence 1850
Cat. 55
Study for the "Carità Educatrice," ca. 1817-24.
Pen and brown ink with traces of pencil on off-white wove paper.
273 x 156 mm
Lent by private collection, New York.
This bold drawing is a study for Bartolini's *Carità Educatrice*. The marble version was commissioned for a niche in the new chapel at the Villa Poggio Imperiale in 1817 (it is now in the Palazzo Pitti). There are slight differences between this drawing and the finished work; the woman's headdress is omitted and there are changes in the drapery, suggesting that the present drawing is a preparatory study. Bartolini was to repeat the general theme of the *Carità Educatrice* in a figure on the *Demidoff Monument* and in various bas-reliefs. The work represents a marked departure from the prevailing neo-Classical tradition and points to the later, more Romantic trend in Bartolini's oeuvre. He modeled the gesso directly from a woman and children posed in candlelight. Intended for a devotional setting, this allegory of Teaching Charity shows a dynamic, didactic virtue, imparting holy love to the very young.
 R.J.M.O.
Lorenzo Bartolini. Prato, Palazzo Pietonio, 1978, Cat. 10. p. 42. Entry for the gesso and its preparatory drawings.

HORATIO GREENOUGH
Boston, 1805—
Somerville, Massachusetts, 1852
Cat. 56a
Roman Sketchbook, 1826.
(Not illustrated.)
The pages are in pencil, some with additions in pen and wash.
242 x 187 mm.
Lent by Nathalia Wright, Maryville, Tennessee.
The young sculptor began this sketchbook in January 1826, at the beginning of his Roman residence. A little more than a third of its pages are after the works of other artists and about a third are of nudes, portraits drawn from life and original compositions. The rest show landscapes and studies of foliage, or are renderings after anatomical casts which Greenough bought to draw from. These, in his own words, helped him see Antiquity "with a different eye." Though most of the drawings are after celebrated Classical statutary in Rome, he also drew after casts of the Panthenaic frieze. He may have seen these at the French Academy at the Villa Medici, where he was a student. Several pages are after Michelangelo and Thorvaldsen, whose studio he visited. Possibly felled by malarial fever and afflicted by severe depression, the sculptor returned to Boston for convalescence in 1827. D.J.H.

Cat. 56b
Drawing of the model of "Washington," for Capitol, ca. 1832-4.
Pen and ink, mounted on cardboard.
Sent to Edward Livingston, 28 January 1834 (Letter 73). RG 59, General Records of the Department of State, Accession 161, Item 135.
286 x 234 mm.
Lent by the National Archives, Washington, D.C.
Greenough was commissioned by Congress in 1832 to execute a heroic marble statue of George Washington for the Capitol's rotunda, completed in 1840. According to Wright, the sculptor took two years to complete the drawings for government approval. Greenough remained firm, insisting upon his Classical god-like conception of Washington despite much opposition. He sent the drawings, such as this one, to Edward Livingston, the Secretary of State, along with lengthy explanations.
Greenough realized early in his career that drawing was an important tool to train his eye. From Florence he wrote to Allston in November, 1829 ... "twas drawing that taught me that the planes of a form are shaded in proportion to their obliquity to the source of light. The foundation of modeling lies in this fact..." D.J.H.
N. Wright, *Horatio Greenough, The First American Sculptor*, Philadelphia, 1963, pp. 43-4.

ANTOINE-LOUIS BARYE
Paris 1796-1875
Cat. 57a
Four Sketches of Snakes.
Pencil on paper, double leaf from notebook.
93 x 131 mm
Lent by the Walters Art Gallery, Baltimore.
Snakes were used by Barye in various ways, symbolic, naturalistic, and purely decorative. Sometimes a complex interweaving of all three took place. This drawing comes from a notebook which dates from the later 1820's or early 1830's, and was consulted by Barye throughout that decade. *Lion Crushing a Serpent*, a major life-size work of 1833, could be the first project to have employed this sheet. Bengye related a measured drawing of a snake from the same notebook for this group. His *Python Attacking a Gnu* (Walters Art Gallery) of 1837 may have also involved this page. Forms very like this snake are found in a bronze *Python Swallowing a Doe* 1840. The serpent is shown on a narrow oval base which increases the sense of its sinuous, menacing form. C.E.

Cat. 57b
Studies of Measurements of a Dead Elephant.
Pencil on paper.
452 x 142 mm.
From notebook.
Provenance: Vildieu Barye, purchased from Fabius Frères, Paris, 1949.
Lent by the Walters Art Gallery, Baltimore 37.2232 A-B.
Long beloved by the French as a symbol of unity of the state, sagacity, chastity, and long life, the elephant, by the nineteenth century, also came to represent the far-flung reaches of her empire. Barye made many studies of it. An *Asian Elephant* was completed in 1833 and sent to the Salon. Another was exhibited in the Salon of the following year. Drawings like this were used for the *Senegalese Elephant* (Walters Art Gallery) and for the *Cochin Elephant*. Barye's bronzes of elephants show them in motion perhaps the ultimate challenge to the *animalier's* skills. With the help of many measured drawings such as this one and with anatomical studies and drawing from life, such an achievement was made possible. C.E.
De Pajou a Rodin, Louvre, 1964,
L. Johnson, "Delacroix, Barye and 'The Tower Menagerie': An English influence on French Romantic animal pictures," *Burlington Magazine*, CVI, 1964.
G. F. Bengye, "Barye's use of some Gericault drawings, *Journal of the Walters Art Gallery*, XXXI-XXXII, 1968-69, pp. 13-27.

JEAN-JACQUES-JAMES PRADIER
Geneva 1790-Bougival 1852
Cat. 58
Study of "la Comédie Sérieuse, for the Molière Fountain, ca. 1841.
(Not illustrated.)
Black chalk.
215 x 411 mm.
Inscribed "Pradier" and "Fontaine Moliere".
Lent by the Arthur M. Sackler Foundation, New York.
Through the efforts of the actor Francois-Joseph Regnier, a national subscription was organized to erect a monument to the playwright Molière. Work began in 1841 on the site of the old Fontaine de l'Echaude, near the Comédie Francaise, opposite the house where Molière died. The architect Louis Tullius-Joachim Visconti (1791-1853) designed the edifice. Two sculptors were involved. Bernard-Gabriel Seurre (1795 1853) executed the statue of the seated poet in bronze, and Pradier carved two overlife-sized marble figures, *La Comédie legere* and *La Comédie sérieuse*, flanking the pedestal on which Molière sits, and the "Genie tenant des couronnes" in the tympanum above.
This chalk drawing is a detailed study of Pradier's right-hand figure, finished in 1842. Stiff and angular, the pose which the sculptor drew for his classically inspired figure corresponds almost exactly to what he carved. Indications of the plinth on which she stands show that the figure is seen slightly from the side. The precise draughtsmanship and schematic rendering of the drapery relate to other Pradier drawings, such as his *Personification of Fame* (Los Angeles private collection, *Romantics to Rodin*, Cat. 175). This rendering is from a stage far along in the work's development, perhaps after a *maquette*. A chronological list of Molière's plays was carved on the scrolls held by the two marble figures. I.W.
L. Gielly, "Les Pradiers au Musée de Geneve", *Genava*, III, 1925, 350. Ministère de l'Instruction publique et des Beaux-Arts, *Inventaire général des richesses d'art de la France: Paris, Monuments Civils*, Paris, 1879, I, 220.

ERNEST JULIUS HAHNEL
Dresden 1811—1891
Cat. 59
Study for Section of the Bacchic Frieze for the Dresden Hoftheater, 1845. (Not illustrated)
Signed and dated at lower left. Verso inscribed: H.E. Herritz (?)/ "Drawing for sculptural frieze on-/Alte Konigliche Hochtheater, Dresden"/(Destroyed by fire)
Pencil with brown wash on off-white wove paper, slightly stained.
159 x 753 mm
Lent by private collection, New York
This study is for a section of the sculptured attic frieze on the rear façade of the destroyed Alte Hoftheater in Dresden. The original sculpture was burnt in the fire of 1868-69, which devastated Semper's first building. A model of the original frieze is preserved in the Albertinum. The drawing is inspired by the format of Greek friezes like the Parthenon's and the subject of Roman Bacchic *sarcophagi*.

Because of its highly finished quality, this may have been a presentation drawing. A delicately drawn work, it shows the idealism advocated by Hähnel, the precision of nineteenth-century German draughtsmanship, as well as the strengths and weaknesses of German academic sculpture. In spite of its neo-Classical subject matter, Hähnel has conveyed the abandon and rhythmical movement of the wildly drunken procession, together with a sense of light and depth by the application of a faint wash. The dionysiac drawing also seems to reveal the influence of Genelli. R.M.J.O.

HENRY KIRKE BROWN
Leyden, Massachusetts 1814—Newburgh, New York, 1886
Cat. 60
Drawing for "The Pleiades" ca. 1845.
Brown ink.
203 x 245 mm
Sketchbook M, p.54.
Lent by the Library of Congress, Washington, D.C.
Before returning to America, Brown made many biblical and mythological statuary. The Pleiades are the daughters of Atlas and the ocean nymph Pleione who gave their name to a small constellation in the neck of Taurus. This is a preliminary drawing for a bas-relief of the sisters. A work entitled *The Pleiades* was exhibited by Brown in the first one man show to be held

in the National Academy of Design in 1847, its owner listed as "W. S. Hemmin." The sculpture has since been lost but the drawing suggests its appearance, much in Flaxman's manner. Brown boasted to his friend, the gifted painter George Fuller, "I have made many hundred careful drawings since I have been in Europe, and shall do many more before returning; it is my recreation. I am making an entire set of outlines from the antique, and have had the compliment paid me of making a more correct drawing in crayon from an antique *basso relievo* than the best draftsman in Rome." (February 2, 1844.)
 D.J.H.
W. Craven, "Henry Kirke Brown in Italy, 1842-1846," *The American Art Journal* I, Spring 1969, pp. 65-77.

ALFRED GEORGE STEVENS
Blandford (Dorset) 1817—London 1875
Cat. 61
Design for a Medal for the Department of Science and Art, ca. 1856.
Pencil.
365 x 325 mm
Lent by The Art Museum, Princeton University, Platt Collection.
Stevens prepared this project for a Local Prize for the Department of Science and Art of the South Kensington Museum, a circular composition to be placed on the reverse of the annual student medal. His competitors were still working in the earlier nineteenth-century tradition of sharply defined form while Stevens elected a bolder, freer approach. Finally, after as many as fifty trials and re-trials, he lost the commission to A. Vechte. While the drawing is somewhat Michelangelesque, it also shows close study of Raphael's art, especially of the frescoes in the Villa Farnesina.

Stevens also designed the National Prize medal in the same year. An oval wax model survives at the Victoria and Albert Museum, closer to Michelangelo, with a portrait medal at the center recalling the style of fifteenth-century Italy.
 C.E.
K. R. Towndrow, *Alfred Stevens,* London, 1939, pp. 122-24.

WILLIAM RIMMER
Liverpool, England 1816—Milford, Massachusetts 1879
Cat. 62
Tri -Mountain, ca. 1870-79
Pencil.
190 x 264 mm
Signed lower left "W.R." and inscribed at the bottom: "Tri Mountain." Lent by the Boston Medical Library, The Francis A. Countway Library of Medicine.
Entering his classroom Rimmer would say—"Here is a face I saw on the way here"—and draw a remarkable likeness on the board. His method of instruction would first include an independent anatomical study, and only then show it in relation to the physical make-up of the entire figure. Often taking a step beyond reality, he would continue the teaching exercise covering the blackboard with winged beasts, angels, and atmospheric props to stage a battle. *Tri Mountain* is an exception among Rimmer's drawings. It is the first sketch of a monumental group which Rimmer designed, symbolizing the three hills of Boston, and its citizens' civic spirit. The clay models do not exist but Weidman has dated them c. 1863-64. The Michelangelesque figures show remarkable solidity and weight. D.J.H.
Bartlett. *The Art Life of William Rimmer: Sculptor, Painter and Physician.* James R. Osgood and Company, 1882. Rimmer. *Art Anatomy.* Boston: 1877; New York: Dover Publications, 1962 (reprint). Intro. Robert Hutchinson.
Weidman. Correspondence on the drawings by William Rimmer, his *Catalogue Raisonné* in progress.
Whitney Museum of American Art and Museum of Fine Arts, Boston, *William Rimmer 1816-1879* (text by Lincoln Kirstein) 1946.

JEAN-BAPTISTE CARPEAUX
Valenciennes 1827—Courbevoie 1875
Cat. 63
a. *Study for the "Ugolino Group"* ca. 1856
(Not illustrated.)
Pencil.
92 x 124 mm
b. *Study for "Ugolino"* ca. 1857
(Not illustrated.)
Black and white chalk on brownish paper
108 x 149 mm
c. *Study for the Modeling Stand of the Ugolino Group* ca. 1860
Pen and brown ink.
171 x 142 mm
Paris, Galerie Manzi, Joyant, Dec. 8-9, 1913.
All three lent by The Metropolitan Museum of Art, New York
Gift of Daniel Wildenstein, 1975 (1975.98.3-1).

As early as 1854 the young Carpeaux wrote a friend that, "A masterpiece of the human spirit would be a statue devised by the singer of the *Divine Comedy* and created by the father of Moses." Two years later, as a fourth-year *Prix de Rome* winner, the sculptor began a demanding project that was to attempt such dimensions. Proving even more ambitious, it also drew upon Gericault and, as Carpeaux noted in 1857, was "dramatic to the first degree, there is a great likeness to the *Laocoon.*"

Carpeaux's theme had been popular in painting since the eighteenth century. Delacroix was so moved by Dante's passage that he made his own translation of the lines from *The Inferno* (XXX, 1-90), in which the traitorous Pisan count Ugolino was walled away, condemned to death by starvation together with his sons and grandsons. Not understanding Ugolino's gesture of biting his hands in grief over the tragic fate of those about him, his sons offer their bodies to assuage the count's presumed hunger.

At first Carpeaux thought of the subject in terms of an arched relief, (63a shows this initial composition) his composition influenced by Flaxman's engraved scene. Gradually Carpeaux brought the group out of a relief format and into the round. Studies of Ugolino alone may have begun this new thought, such as 63b. He prepared a special model (Louvre, R.F. 2995) in Paris to convince the committee to grant an extension of his fellowship, but his composition was to prove still more complex with the addition of another figure. Many models in the round for the figure of Ugolino alone and for the ensemble survive (Beyer-Braunwald, Cats. 73, 76, 77, 78) as well as a large number of drawings toward the final version (Beyer-Braunwald, Cats. 66, 72, 75 are some of these).

A rapid indication of the finished work's appearance was penned by Carpeaux in a measured rendering (63b) prepared for his Roman cabinet-maker whose turntable would support the final model in its making. Here, as in so many of the master's drawings, he returned to the graphic conventions of the Renaissance, inspired by Michelangelo's drawings with the use of broad hatching.

Carpeaux' early *chef d'oeuvre,* so indebted to Michelangelo's painting and sculpture, proved the major source for his own most gifted pupil's best known work. Rodin's *Thinker,* placed above *The Gates of Hell,* continues the tragic reflections found in Carpeaux' anguished Count from *The Inferno.*
 C.E.

Cat. 64
Study of Satyrs, n.d.
Red chalk over pencil.
275 x 172 mm
Lent by The Art Institute of Chicago, 1974.28, Worcester Sketch Fund.
These powerful figures, realized with the force of the sculpture and draughtsmanship of the sixteenth and seventeenth centuries, have much in common with the most vigorously rendered forms drawn by Carpeaux during his later *Prix de Rome* years at the Villa Medici. At this time he was making his most intense study of Michelangelo's paintings, drawings, and sculpture. Ancient marbles, with those of the Renaissance and later periods could have also provided the young French sculptor with the source for these satyrs.

Near the completion of his deep relief, *The Dance*, for the Paris Opera façade, Carpeaux decided to introduce the figure of a Michelangelesque *Faun*, half-hidden, menacingly placed behind the circle of moving figures. For the preparation of this bacchic addition he made a drawing in pen toward 1866 after Michelangelo (Valenciennes, Musée des Beaux-Arts). This fine page is thought to have been done at that time. C.E.

Cat. 65
a. *Study for "La Danse"*.
Black crayon.
205 x 268 mm
b. *Study for "La Danse"*.
Pencil, red and black chalk.
205 x 128 mm
Provenance: From the artist's family.
Both lent by The Art Institute of Chicago, 1974.56; 1974.29, Worcester Sketch Fund
These drawings come from the beginning of the second phase of Carpeaux's work for his most distinguished and controversial decorative relief project. When his friend Garnier was entrusted with building the splendid new Paris Opera House in 1861, the architect planned a series of four seated composer statues for the interior, Gluck to be protrayed by Carpeaux. Garnier also selected four themes pertaining to music, song, drama, and dance for the exterior, deep reliefs to be given to different sculptors. He drew the basic composition and measurements for such a group, a winged central Genius flanked by smaller personifications (Louvre, R.D. 285).

Carpeaux returned to the *Laocoon*, so important for his earlier *Ugolino*

(63c), to study its spiralling movement (drawing, Musée des Beaux-Arts, Valenciennes). He changed his theme to a personification of The Dance. In an almost rococo rise of spirits, the central winged figure flies above the dancers whose arms join before her. A faun lurks at the left and a figure of the Folly of Love is inserted at the base.

In addition to a vast number of preparatory drawings and oil sketches for the relief, Carpeaux also painted a panel in oils (Paris, Private Collection) to commemorate its completion. A sketch of the Genius, hastily drawn on an 1871 newspaper (Louvre, R.F. 8645) is a singularly suitable *envoi* to this magnificent work.
C.E.

F.A. Yates, "Transformations of Dante's Ugolino" *Journal of the Warburg and Courtauld Institute*, XIV, 1951, pp. 92-117. G. Varenne, "Carpeaux a l'Ecole de Rome et la genese d'Ugolin", *Le Mercure de France*, 1908, pp. 579-593. Correspondance of Schnetz in H. Lapauze, *Histoire de l'Académie de France à Rome*, Paris, 1924, pp. 320-344. A. Braunwald and A. Wagner, "Jean-Baptiste Carpeaux (1827-1875), *Metamorphoses in Nineteenth Century Sculpture*, Fogg Art Museum, pp. 113- 123. V. Beyer and A. Braunwald. *Sur les traces de Jean-Baptiste Carpeaux*, Grand Palais, 1975, Paris, n.p. Text for cats. 49-85.
For many of the drawings pertaining to *La Danse* and to the initial project see V. Beyer, A. Braunwald, *Sur les Traces de Jean-Baptiste Carpeaux*, Grand Palais, Paris, 1975, unpaginated. See the entries for Cats. 285-96, 299,313, 315, 317-318. Preparatory drawings are located in The Louvre, the Musée des Beaux-Arts, Valenciennes and several other public and private collections. A. Braunwald and A.M. Wagner, "La Danse," pp. 125-45, *Metamorphoses in Nineteenth Century Sculpture*, edited by J.L. Wasserman, Harvard University, Fogg Art Museum, 1975.

ALBERT-ERNEST CARRIER-BELLEUSE
Anizi-le-Chateau 1824—
Sèvres 1887
Cat. 66
Nude in Niche. n.d.
White and black chalk on brown paper.
184 x 119 mm
J.P. Heseltine (Lugt 1507,8)
Lent by Michael Hall, New York.
Like some of the drawings reproduced in the Goupil's publication of Carrier-Belleuse's designs of 1866, this study is typical of the sculptor's decorative

approach. Eighteenth-century art was his immediate source of inspiration. Appropriately, some of Carrier-Belleuse's most extravagant works were made for the lavishly decorated hotel of a famous courtesan, La Paiva, now used by the Travelers' Club. Fitted into a faintly Oriental, keyhole-like recess, there's still a touch of the School of Fontainebleau, of the mannered eroticism of the late Renaissance, to this courtly nude. The model has raised her drapery aloft, as if that popular eighteenth-century statue, *La Frileuse*, had wakened to drop her transparent drapery. Many of Carrier-Belleuse's drawings were done in white chalk on dark paper, creating a cameo-like relief effect that was often translated into glazed decoration at Sèvres and elsewhere. C.E.

DANIEL CHESTER FRENCH
New Hampshire 1850—
Massachusetts 1931
Cat. 67
Sketchbook: Drawing after "Apollo Belvedere" for the Minute Man.
April 1874.
Pencil on paper.
273 x 178 mm
Lent by Chesterwood, Stockbridge, Massachusetts, a property of The National Trust for Historic Preservation.
After abandoning his original model for The Minute Man, French decided to capture the American's readiness to fight in the Battle of Concord, defending the land he had just begun to sow. In a sketchbook he drew the gun, its firing mechanism, the plow, the positions of the hand and feet, the portrait, and two proposals for a pedestal. Richman suggested that French drew after a cast of the Apollo Belvedere to help him resolve the problem of the placement of The Minute Man's legs and feet. This page copies the position of the Apollo's legs, while in The Minute Man the pose is reversed—French's borrowing was specific.

French collaborated with many architects on his commissions, in particular, Henry Bacon (1866-1924), who exchanged ideas with the sculptor on monuments for over two decades. Bacon provided an initial drawing when the setting of the statue was of major concern. French made a preliminary sketch in clay and would ask the architect to draw a suitable design for the base. D.J.H.

THOMAS EAKINS
Philadelphia 1844—1916
Cat. 68a-d
Four preliminary drawings for Eakins' painting "William Rush Carving His Allegorical Figure of the Schuylkill River" 1875-6.
(Not illustrated)
a. *Study for "George Washington" after Rush*.
b. *Study for "The Schuykill Freed" after Rush*.
c. *Study for "Nymph and Bittern" after Rush*.
d. *Study of Woman with Parasol*.
All pencil
All 153 x 118 mm (irregular)
Verso: Anatomical notes in Pittman shorthand, not known if by Eakins
All lent by The Hirshhorn Museum and Sculpture Garden, Smithsonian Institution, Washington, D.C.
"Sculpture for its own sake was of secondary interest to Eakins", wrote Moussa Domit, "but, like his interest in anatomy, it appealed to him as an important supplement to painting i.e. as a means of achieving greater understanding of mass and volume." For his painting *William Rush Carving His Allegorical Statue of The Schuylkill River*, Eakins drew eight preparatory sketches (1875-1876) including exhaustive costume studies for Rush, the chaperone, and the model's clothes thrown on the chair. He then reproduced three drawings in wax reliefs for greater study and copied Rush's sculptures, *Nymph and Bittern* (68c), *Washington* (68a), and *The Schuylkill Freed* (68b) in little models. Eakins also made models in wax of the nude model (now lost), her head, and of Rush's sculpture. As Hendricks observed, Eakins had a personal reason to portray Rush in his studio working from the nude. He may have wanted to show that he was not the first Philadelphia artist to reject puritanical convention. Several of Eakins' later reliefs originated with this scene of Rush's studio. The painting celebrates both the beginning of sculpture in America and the first use of the nude model, supporting Eakins' own concern with "the naked truth". D.J.H.

G. Hendricks, "Eakins' William Rush Carving His Allegorical Statue of the Schuylkill," *The Art Quarterly*, XXXI, 1968, pp. 382-404. M.M. Domit, *The Sculpture of Thomas Eakins*, The Corcoran Gallery of Art, Washington, D.C. 1969. P. Rosenzweig, *The Thomas Eakins Collection of the Hirshhorn Museum and Sculpture Garden*. Washington, D.C. 1977. D. Sellin, *The First Pose: Turning Point in American Art, Howard Roberts, Thomas Eakins and a Century of Philadelphia Nudes*. New York: 1976.

HENRI CHAPU
le Mée 1833—Paris 1881
Cat. 69
Studies for a Relief, a Nude Youth, and an Atlantid. (Not illustrated).
Red and black chalk.
465 x 299 mm
Lent by the Galerie Fischer—Kiener, Paris

At the bottom are three studies of a semicircular relief. The central motif of a woman reaching across an oval cartouche is reworked in a small sketch above. At the top are studies of a youth pouring from a vase and of a man with arms raised in air as if to support a burden.

The studies appear to be for a large façade decoration. Chapu frequently used allegorical nudes such as *Vapor* for the Gallery of Machines at The Universal Exposition (1889) or the nude holding a mask in the unfinished *Monument to Balzac.* The central figure on this sheet is close to a number of sketches for the *Monument to Flaubert* (1880-90), which feature the nude *Truth* pointing toward a medallion of the writer (see Pingeot, figs. 5-8, 11, 13-15).

The torso may be for an atlantid in the tradition of Puget's figures from the Hotel de Ville, Toulon. Around 1873 Chapu executed a pair of atlantids—one young, one old—for the chimney of the Hotel Sedille, Paris (Fidere, p. 84). Perhaps this study bears some relation to the Sedille project. This unpublished sheet is a fine example of Chapu's fluid, suggestive draughtsmanship and the multiple studies demonstrate the thorough process of revision the sculptor practiced to prepare for each work.　I.W.

O. Fidiere, *Chapu, sa vie et son Oeuvre,* Paris, 1894. J.E. Hunlsak, "Henri Chapu", P. Fusco, H.W. Janson, *Romantics to Rodin,* Los Angeles County Museum of Art, pp. 172-174.

JULES DALOU
Paris 1838—1902
Cat. 70
Fisherwomen of Boulogne at Church, ("Boulonnaises à l'Eglise").
Pen and ink
377 x 274 mm
Signed and dated 1876
Lent by The Arthur M. Sackler Foundation, New York

In 1876 Dalou exhibited a life-size terra-cotta group titled *Boulonnaises à l'Eglise* at the Royal Academy (Cat 1385). The Duke of Westminster, who owned several of the sculptor's works, added this to his collection. It still belonged to the Duke in 1903, when Dreyfous published a photograph of it, but it has subsequently disappeared.

The drawing is a careful study after the finished terra cotta, prepared in the special graphic style that was adopted by many sculptors in the late nineteenth century as it lent itself to especially good photographic reproduction in the art magazines of the period. Rodin used a similar approach for his earlier works so that they would carry well on the printed page. Along with other drawings by Dalou after his own sculpture, the *Boulonnaises à l'Eglise* is illustrated in an article by Louis de Meurville, "L'oeuve de Jules Dalou au point de vue decoratif," *Revue des arts decoratifs,* 1899, p. 37.
　I.W.

ANTOINE-AUGUSTE PREAULT
Paris 1809-1879
Cat. 71
Study for a Reclining Genius, 1876 (Not illustrated)
Pencil and ink
132 x 210 mm
Signed and inscribed: "A mon ami René-Paul Huet—AP, 1876"
Lent by the Arthur M. Sackler Foundation, New York.

Splashing wash across the page, the artist has brushed the broad outlines of a Genius or Victory reclining on a pedestal. Its huge wings envelop the figure and the object (a cuirass?) over which it holds a wreath. With the same loose strokes Préault has signed and dated the work and dedicated it to the son of Paul Huet, one of his best friends.

This drawing has no connection with most of his known projects, like the statute of *Jacques Coeur,* on which Préault was engaged in the 1870's. It may be related to a commission he was engaged on in 1876, a monument to Lamartine (1790-1869).

Préault's Parisian project was to be a victory atop a granite column, but the monument never passed beyond the planning stage. For the pose of the figure Préault has drawn on the classical tradition of reclining river gods. But his principle source is the Adam from the *Creation of Man* on the Sistine Chapel ceiling. Compared by the historian Michelet, a friend of Préault, to the *Day* of Michelangelo [from the Medici Tomb in Florence], he said "it is not only a strong work but it will be an eternal one." Preault's reputation has not grown to the stature of a Michelangelo, but as this sweeping sketch demonstrates, he was a free spirit of his age, one of the most Romantic and pictorially talented sculptors of his generation. I.W.

E. Chesnau, "Auguste Preault", *Peintres et sculpteurs romantiques,* Paris, 1880, p. 125. Michelet, *Histoire de France,* Paris, VII, n. 323.

JOHN LAFARGE
New York City 1835—Providence, Rhode Island 1910
Cat. 72
Cross on a Decorated Base: Study for The Edward King Monument, ca. 1876. (Not illustrated)
Pencil
305 x 198 mm
Lent by The Art Museum, Princeton University, Mather Collection.

"John LaFarge's return to earlier cultures for inspiration was in part an attempt to avoid an industrialism that now seemed to artists and intellectuals to be threatening their very humanity," wrote Novak. "In his version of the English Arts and Crafts movement—in concert with the architect Henry Hobson Richardson and the sculptor Augustus Saint-Gaudens in the decoration of Trinity Church, Boston, or with McKim, Mead and White in the decoration of the Church of the Ascension, New York—LaFarge attempted to use the cooperative efforts of artists and craftsmen, as the Middle Ages and the Renaissance had done, to create public monuments that would be great works of art." Such a creative concurrence produced the Edward King Monument in Newport, Rhode Island.

Stanford White brought the young Saint-Gaudens to LaFarge's studio to assist the painter in various sculptural projects. LaFarge prepared this early scheme of the monument for the sculptor to copy. Saint-Gaudens was sent first to Rhode Island to confer with Mrs. King and he obligingly suggested alterations of his patron's wishes to include acorns, foliage, and flowers in the design. LaFarge thought they were "inartistic," but Saint-Gaudens stubbornly believed that Mrs. King should have what she wanted—acorns and all—so LaFarge sketched a page of oak leaves, enlarged for carving or modeling on the base. Ross noted that the Avery Library, Columbia University, has another oak leaf study by LaFarge drawn from nature on a smaller scale, not yet enlarged for the sculptor to follow. Saint-Gaudens supervised the cutting of the marble in Paris by French craftsmen and LaFarge was pleased with the result.　D.J.H.

B.T. Ross. *American Drawings in the Art Museum,* Princeton University, Cat. 65, p. 66 B. Novak, *American Painting of the Nineteenth Century,* 2nd Ed. New York, 1979.

OLIN LEVI WARNER
Suffield, Connecticut 1844—New York 1896
Cat. 73
Indian Slaying a Panther, sketchbook, p. 16, verso.
ca. 1869-75. (Not illustrated)
Pencil.
98 x 145 mm
Lent by The National Museum of American Art, Smithsonian Institution, Washington, D.C., Gift of Mrs. Carlyle Jones.

After his return from Paris, between 1873 and 1875, Warner composed a group in plaster entitled *Indian Slaying a Panther.* George Gurney has provided all the information on this lost work, known from descriptions by critics and pages of Warner's sketchbook. Gurney believes that Warner was possibly inspired by Antoine-Louis Barye's small animal and figurative groups (58a, b) while he studied abroad. Upon his return, the young sculptor wanted to do an "American" subject, as had Henry Kirke Brown. Charles de Kay in 1889 wrote of the resulting plaster *Indian Slaying a Panther:*

> The period of Indian statuary through which all our sculptors must pass with the regularity of a disease of children brought him no further harm than a statuette, conceived in no petty spirit, in which an Indian brave has a panther down which he is dispatching with his tomahawk in a position that leaves little hope of life to the victor.

Three groups sketched on this page show the sculptor's thoughts as he tackled the problem of balancing two forms—both in precarious positions—on a base. Warner continued to study the panther on another page of the sketchbook, but the figural composition was never cast.　D.J.H.

Gurney. *Olin Levi Warner (1844–1896): A catalogue Raisonné of His Sculpture and Graphic Works.* Doctoral dissertation, University of Delaware, June 1978.

LOUISE ABBEMA
Estampes 1858—Paris 1927
Cat. 74
Drawings of Sarah Bernhardt in Sketchbook, 1871-1875.
Pencil.
102 x 146 mm
Lent by Michael Hall, New York
In 1871, Abbema met Sarah Bernhardt (1844-1923) and made a portrait medallion of the famous actress in 1875. The bronze was exhibited at the Salon of 1878 along with Bernhardt's marble bust of Abbema. They remained close friends and Abbema made numerous drawings of Bernhardt on and off stage—shown reciting verse, in costume, or standing at her easel—as preparatory studies for painted portraits. Fusco believes that Abbema probably decided to make a sculpture from these drawings. Several pages in Abbema's sketchbook show Bernhardt in profile wearing a delicate lacy blouse, which frames her fragile neck, as shown in the medallion. Abbema has captured the texture of the actress's thick, untamed hair, said to be a burning shade of red. Her first graphic impression is maintained in the bronze relief. D.J.H.

PAUL WAYLAND BARTLETT
New Haven, 1865—Paris 1925
Cat. 75
Drawing for Bohemian Bear Tamer From Sketchbook. ca. 1887.
Pencil and ink.
305 x 356 mm
Lent by the Library of Congress, Washington, D.C.
The *Bohemian Bear Tamer* won a Grand Prix from the International Jury on Sculpture at the Exposition Universelle in 1899, but Bartlett, a member of the International Jury, could not accept the award. Bartlett's concern for anatomy reflects his Beaux-Arts training. This is seen in the preparatory drawing for the Indian boy. Attention to such details as the youth's hair are richly modeled in the finished bronze. "Not only is the technique sure and facile, the observation of form and action just," Taft observed, "but the conception is one in which imagination has played a distinct part..." D.J.H.
W. Craven. *Sculpture in America*, New York, 1931

JOHN QUINCY ADAMS WARD
Near Urbana, Ohio 1830-New York City 1910
Cat. 76
Sketchbook—Sketches for Statue of George Washington.
ca. 1881. (Not illustrated)
Pencil on paper.
127 x 81 mm
Lent by the Albany Institute of History and Art.
In the photograph of Ward in his studio, there is a very prominently placed blackboard covered with drawings, a statement of the sculptor's working method. These pages from one of his many sketchbooks show Ward's preliminary thoughts in pencil for the *George Washington*, a federal commission. His sources were most likely a plaster cast of the *Apollo Belvedere*, Stuart's Athenaeum portrait, and Houdon's marble statue at the Virginia State Capitol. Ward's bronze was placed at Federal Hall in 1883 (New York City) just where the first president was sworn in. One of the preliminary drawings has Washington's right palm up. He is in simple military dress, head turned in the opposite direction. Details are carefully considered before modeling: the proper cuff on the sleeve, the style of lappet, hosiery, and hat. These are the first stages of form on paper as Ward developed his own image of how Washington might have appeared on the momentous occasion of his inauguration. D.J.H.

JEAN-ALEXANDRE-JOSEPH FALGUIERE
Toulouse 1831—Paris 1900
Cat. 77
Studies for Sculpture and a Painting (recto)
Two studies for a statue (verso)
(Not illustrated)
Black Chalk
206 x 285 mm
Signed in pencil "A Falguière" and inscribed in ink at lower left "Croquis du Maitre/offert par Mme. Ve. A. Falguière/a sa bonne petite amie/Mme. Fanny Mare, son élève distinguée"
Lent by the Arthur M. Sackler Foundation, New York.
Centered on the *recto* is a scene of a man stretched out in a darkened room with another figure standing in the doorway. To the right are two sketches of a woman, one knee drawn up, head thrown back. A figure with arms raised leans forward on an object to the left. The triangular form

beneath may be a design for the top of its pedestal. The *verso* presents two variations of a statue in a dancing pose standing on the left foot and holding aloft an object which disappears behind its back.
This unpublished sheet offers several problems of indentification. Fanny Mare, to whom the drawing is dedicated by Falguière's widow, is not listed among the sculptor's pupils, (Tristan Klingsor, "Falguière et les jeunes", *La plume*, 1898, pp. 82-85) nor is she known as an artist. Furthermore, none of these studies is clearly preparatory for known works. The artist's paintings, such as *L'Abatage d'un boeuf* (1881), *l'Eventail et Porguard* (1882), *Victor Hugo sur son lit de mort*, and *Cain et Abel* (1876) show a taste for violence and death. The central rectangular scene shares the romantic air of tragedy and slightly morbid mood of these works and may represent an idea for a canvas dating from the 1870's or after, when the artist began to paint.
The *verso* studies are analogous to one of Falguière's favorite sculptural types—the standing nude. The sinuous, graceful pose is reminiscent of such marble statues as the Eve and Diana of the 1880's in the Carlsberg Glyptothek, Copenhagen. The leaping figure on the *recto* reminds one of such late-nineteenth-century ecstatic figures as Carpeaux's *La Danse*. Interesting for its mise-en-page, this sheet reveals the artist's occupation with sculpture and painting. F.W.

AUGUSTUS SAINT-GAUDENS
Dublin 1848—Cornish, New Hampshire 1907
Cat. 78a
Sketch for Violet Sargent Relief,
1890.
Purple ink
112 x 175 mm
Cat. 79b
Sketch for Violet Sargent Relief,
1890.
Pencil
201 x 258 mm
Both lent by the Cooper-Hewitt Museum, Smithsonian Institution, New York.
The sculptor first met John Singer Sargent's sister, Violet, at a party given in the studio of William M. Chase. He was so taken with her beauty that he asked to do her portrait. In exchange, Sargent agreed to paint Saint-Gaudens' wife Augusta. The first study shows two alternate plans for the relief, the first a slender, elongated form with the subject standing at the upper right and then placed in a seated pose at the lower left.

Finally the sculptor chose the latter pose, further developed in the ink drawing, then elaborated into a relief where Violet is shown playing a guitar, a theme that could have been suggested by Sargent.
The preparatory drawings are characteristically energetic. The movement of Saint-Gaudens' pen is almost visible as he explored profile and volume on paper by a series of vibrant lines. Both studies include a frame. In the second, with Violet seated, scribbles suggest a decorative motif to fill the upper right corner.
 D.J.H.

Cat. 79
"Striding Liberty" Study for U.S. Twenty Dollar Gold Piece of 1907
ca. 1905
Pencil on paper
260 x 197 mm
Lent by Dartmouth College Library, Hanover, New Hampshire
In response to President Theodore Roosevelt's personal inquiry on the coinage designs, Saint-Gaudens wrote:

Up to the present I have done no work on the actual coins, but have made sketches, and the matter is constantly on my mind. I have about determined on the composition of one side, which would contain an eagle very much like the one I placed on your medal, with an advantageous modification. On the other side would be some kind of a (possibly winged) figure of a Liberty striding energetically forward as if on a mountain top, holding aloft on one arm a shield bearing the stars and stripes with the word "Liberty" marked across the field, in the other hand perhaps a flaming torch; the drapery flowing in the breeze. My idea is to make it a living thing and typical of progress... (November 11, 1905)

Only the twenty-three drawings possess the life Saint-Gaudens sought to strike in metal. His studio assistant, Henry Hering, proceeded to complete the difficult project of adapting the coinage designs to meet the practical standards of the Philadelphia Mint after Saint-Gaudens' death in 1907.
 D.J.H.
H. Saint-Gaudens, editor, *The Reminiscence of August Saint-Gaudens* I, II, New York 1913. Reprint 1976.

GEORGE MINNE
Ghent 1861—Laethem St. Martin 1941
Cat. 80.
Study for "Le Petit Agenouillé," ca. 1895-6.
245 x 185 mm
Pencil
Provenance: Mme. Vercruysse-Minne
Lent by Albert Alhadeff
Boulder, Colorado.

Among the earliest reviews of Minne's works is one written in 1889, prompted by the sculptor's first exhibition. The critic noted:

One senses youth, sincerity and life.... Minne, freeing himself from all conventions, turns his back on bombastic effects and elocution which are but the rhetoric of contemporary sculpture. He concentrates upon a special world of melancholy and religion... Immeasurable sadness and the pathos of the forlorn live in his plasters. He knows how one prays, how one despairs, how one cries and how one suffers. He says it all in his art and he says it well.

These remarks apply to all Minne's works, from his first to his last efforts as a Symbolist. The pristine, lucid line which encircles the kneeling figure is a metaphor for the youth's "immeasurable sadness". Minne's new spiritual world realized by his sculpture may be defined in terms of reticence and withdrawal. Through silence his nudes commune with truths only they can know.

No mere personification of youth, this figure is more than a preparatory study for Minne's well known *Le petit agenouillé* (1896) as it is taken from Minne's *Saint John the Baptist* of 1895. The statue embodies the complex, ambivalent aspects of Symbolism, embracing both the secular and the spiritual. A.H.

Alhadeff, *George Minne's Symbolist Sculptures and Illustrations, 1885–1900,* New York University, Institute of Fine Arts, dissertation. van Puyvelde, *George Minne,* Brussels, 1913.

FREDERICK WILLIAM MACMONNIES WITH MARY FAIRCHILD MACMONNIES
Brooklyn 1863—1937
Cat. 81
Proposed Monument to General George B. McClellan, (Side view, Project 2) 1904
(Not illustrated)
Pencil and watercolor
990 x 641 mm
Lent by The National Archives, Washington, D.C. 65.27. R.G.79

Soon after the Civil War's onset, Major General George Brinton McClellan (1828-1885) defeated the Confederate forces in Western Virginia. In 1861, he commanded the department of the Potomac which was encamped where his statue now stands. Despite his many victorious battles, Lincoln lost patience with this superbly efficient but overly cautious general and removed him from his command. The Army of the Potomac, however, revered him as Washington's saviour and commissioned this memorial to him in 1901.

A competition was held in 1902. Twenty-one artists presented four-foot plaster models. The judges, Saint-Gaudens (80), French (67), and McKim found none satisfactory; four sculptors submitted new models but were rejected again. The Commission offered MacMonnies, living in Paris, the $50,000 appropriated for the monument, pedestal, and site preparation. He signed a contract specifying an equestrian statue fourteen-feet high on a twenty-six foot pedestal. The ink and color-wash drawings (three views) were the only ones sent for design approval. Possiblly the artist made an ink outline which his wife elaborated on, fleshed out and colored. The commission refused his request for either an additional $10,000 or a reduction of scale. The sculptor responded that "in the interest of a fine work of art," (letter October 11, 1904, National Archives) he would execute everything according to the design as submitted, at his own expense.

MacMonnies consulted nine Matthew Brady photographs of McClellan. None showed him mounted, but two depict him with his fist at his hip, as in the statue. The statue has a forceful realism, absent from the drawings, which were intended only for design approval. The bronze group, set on a rise, was cast by E. Gruet Fils in Paris and first exhibited prominently at the 1906 Paris Salon.

Boldly rendered in the drawings, and a first in such scale and depth on American monuments, are the eleven-foot high flags and the trophies, a Roman motif used in Tacca's *Henry IV.* Huge eagles hold oak and laurel garlands. All the elements were cast as drawn except for four escutcheons.

In 1907, Congress appropriated $2500 for four days of unveiling ceremonies culminating with an address by President Roosevelt. He praised "those who had the good taste to choose a great sculptor... erected here in so well-chosen a site a statue which... because of its own intrinsic worth adds to the nobility and beauty of the Capital City of the country."
A.F.G.

J.M. Goode, *The Outdoor Sculpture of Washington, D.C.,* Washington, D.C. 1974, cat. entry, B-6.

AUGUSTE RODIN
Paris 1840—Meudon 1917
Cat. 82
"Iris" seen from above, ca. 1900
Watercolor and pencil
311 x 199 mm
Signed below center in pencil "AR"
Lent by The Museum of Modern Art, New York, Gift of Mr. and Mrs. Patrick Dinehart.

When Rodin drew this image of the messenger of the gods, the sculptor told his follower Bourdelle (83, 4), "My drawings are the result of my sculpture." By 1900, when this page was drawn, Rodin's words were certainly true. He equated the theme of the flying woman with that of artistic inspiration, including a wingless one embracing the artist shown standing before his work in a drawing from the early 1880's (Collection Mrs. Noah L. Butkin) inscribed *la genie de la Sculpture.*

Iris is freely adapted from one of the inspiring figures placed above Victor Hugo in the many different versions of the projected monument for the Pantheon. Rodin was given the commission in preference to Dalou a year after Hugo's death in 1886. Different versions in plaster, made between 1886 and ca. 1890 show this figure winged and unwinged, Hugo first seated, then standing. A small bronze of 1893 shows the single winged figure above the standing Hug̅ as does the final version of ca. 18(̅, exhibited in the Salon of that year.

Just how the artist prepared such late drawings is recorded by Clement-Janin, who saw the sculptor at work and described the process on the basis of an interview with Rodin within a few months of *Iris'* rendering:

In his recent drawings, Rodin uses nothing more than a contour heightened with a wash. Here is how he goes about it. Equipped with a sheet of ordinary paper placed on a board, and with a lead pencil—sometimes a pen—he has his model take an essentially unstable pose, then he draws spiritedly, without taking his eye off the model. The hand goes where it will; often the pencil falls off the page; the drawing is thus decapitated or loses a limb by amputation... The master has not looked at it once. In less than a minute, this snapshot is caught ... each section has its contours and the cursive, schematic indication at its modelling. The correction lines are numerous. Often the pencil, in the swiftness of its progress, misses the contour of a breast, the flex of a thigh; Rodin then goes back over this part with hasty strokes which mix together, but in which the just line is found.

Describing Rodin's graphic approach as that of a snapshot was very close to Rodin's interests in the late nineteenth century, when he actually used photographs of the plasters of his works for study and development, drawing right over the photo, as he did for his *Burghers of Calais.*

His bold, innovative style has made drawing in the manner of *Iris* popular among collectors, leading to extensive forgery. Varnedoe has suggested that the wash on this very fine page may have been added by a hand other than Rodin's. *Iris* shows the mature Rodin's concern with the basic, drawing straight to the heart of the matter. Such bold freedom, authority, and the strong sense of inner necessity in the sixty-year-old sculptor's art is seen in the late styles of such varied masters as Titian, Michelangelo, and Rembrandt. C.E.

The above text is from Clement-Janin, "Les Dessins de Rodin," pp. 286-87, *Les Maitres Artistes,* October 15, 1903, from the translation published by A. Elsen, J.K.T. Varnedoe, *The Drawings of Rodin,* New York, 1971, pp. 75—76. For Rodin's late drawings see E. Geissbuhler, *Rodin-Later Drawings,* Boston 1963; A. Elsen and J.K.T. Varnedoe, *The Drawings of Rodin,* New York, 1971; Varnedoe, "Rodin as a draftsman—a chronological perspective," op. cit., pp. 69-120. For forgeries of the late Rodin, see Varnedoe, op. cit., "True and False," pp. 157-185.

EMILE ANTOINE BOURDELLE
Cat. 83
Leda and the Swan, ca. 1913
pen and ink, watercolor
231 x 177 mm
signed lower right: E.A. Bourdelle
Lent by The Art Museum, Princeton University, Platt Collection.
Leda and the Swan is one of many Bourdelle drawings and sculptures of mythological subjects—a constant resource for the arts in their humanity and universality; Daphne, Apollo and, above all, Leda with her "volupteuse poésie et la blancheur immaculée du cygne" found expression in his work. Standing in shallow water in an ecstatic pose, Leda is enveloped by the Swan. Bourdelle's daughter associates this watercolor with a bronze relief of the same subject, ca. 1913, where the swan is beside Leda and her ambivalent gesture of rejection is now made with outstretched arms. The sculpture, in turn, is linked to Bourdelle's 1912 plaster relief of *Tragedy* for the decoration of the Théatre des Champs-Elysées. S.R.G.
B.T. Ross, *19th and 20th Century Drawings from The Art Museum*, Princeton University, 1972, cat. no. 8.

Cat. 84 *Head of Beethoven.* n.d.
(Not illustrated).
pen and ink
233 x 208 mm
Lent by the Art Institute of Chicago, Gift of Madame Emile Antoine Bourdelle, 1962, 778.
From 1880 until his death, Bourdelle was deeply concerned with Beethoven, the artist and the man. He made several portrait busts as well as innumerable drawings and pastels devoted to this theme, deeply moved by the great composer's genius and tormented life. Through such works Bourdelle sought to express his own desires and frustrations, an identification with Beethoven shared by many artists of the later 19th century.
The composer's anguished head emerges through the dramatic use of vigorous diagonal lines. Partially obscured, the left side of the face lurks in the shadows as the eyes look out, directionless. Broad lines delineate the chin and cheek and carve deep hollows around the eyes. The comparable sculpture (1902) shows a similar expression, but the eyes are downcast and the head itself is somewhat turned down. While the drawing suggests profound anxiety, the bust expresses deep tragedy. Other sculptures of the composer include: *Beethoven with Short Hair* (1890); *Beethoven with Long Hair* (1891); *Draped Figure of Beethoven* (1910); *Head of Beethoven as a Capital* (1924). S.R.G.
Antoine Bourdelle, 1861-1929, National Gallery of Art, Ottawa, 1961; R. Bourdella-Dufet, *Leda Bestiaire et metamorphoses*, Musée Bourdelle Paris, 1978.

HENRI MATISSE
Le Cateu, 1869—Cimiez, Nice 1954
Cat. 85
Standing Nude Seen From the Back
ca. 1905-7
pen and dark brown ink
289 x 187 mm
signed lower right Henri Matisse
Lent by The National Gallery of Canada, Ottawa, 17924
This drawing leads to Matisse's series of great reliefs, particularly *Back I.* He made four different sculptures of this theme, as well as an earlier clay work; their precise dating presents problems. According to Barr, *Back I* was long dated 1904 but Matisse and his wife remembered it was modeled in the Issy studio, where they moved in late 1909, making ca. 1910 a reasonable date for its genesis.
The nude is seen from the back, at a slight angle, her arms raised, right leg supporting her weight as she leans upon a cushion against the wall. Loose cross-hatching defines the volumes presenting a dynamic balance of form. The broadly modeled bronze part of his most monumental cycle juxtaposes forms more aggressively: here the nude stands parallel to the wall, her left side supports her weight, her right side is relaxed, the legs end abruptly above the ankle, the left hand curls tautly over the ledge. Like Bourdelle's *Leda* relief, Matisse's sculpture analyzes the expressive equilibrium and primeval force of the human body. S.R.G.
A. Elsen, *The Sculpture of Henri Matisse*, New York, 1971, Cat. 242.

MALVINA HOFFMAN
New York City 1885—1966
Cat. 86
a *Sketchbook, Dance "Gavotte",*
1914-15
pencil
130 x 95 mm
b *"Anatomy" Sketchbook* n.d.
(Not illustrated)
pencil
284 x 219 mm
c *"Africa" Sketchbook*, 1926 (Not illustrated)
pencil
146 x 108 mm
Lent by ©Malvina Hoffman Properties.

Cat. 87
Drawing, Nude Study for Gavotte.
1915
pencil on cardboard
406 x 370 mm
Lent by ©Malvina Hoffman Properties.
Hoffman wrote, "the most important foundation for the making of a good sculptor is the ability to draw well.

This cannot be over emphasized. It is a *sine qua non*." She advised the student always to carry a sketchbook to record what is seen:
> Whether he drives in a car or rides in a subway or bus, he can always learn something from an accidental expression of the passenger opposite, or the folds of cloth in a dress, or the way light falls sharply across the features of a fellow traveler. He must constantly observe and memorize what passes before him in the endless panorama of life...

Capturing the moment in pencil was important to Hoffman. This is seen in her sketchbooks of people at large (86b) and in her studies of dancers (86a, 87). During her seven years association with Pavlova, she made countless sketches as she viewed the ballet from the wings or the audience. After the performance, sculptor and dancer would examine the drawings together to decide which caught a movement accurately, and those showing action just before or after the moment they wanted to record in bronze. "Gavotte" was such a dance by Pavlova. Using sketches from the nude model (Pavlova?), Hoffman sculpted the *Nude Study* in 1915. The completed sculpture, *Gavotte* includes the appropriate costume and color. Hoffman's so-called *Bacchanale Frieze* 1915-1924 is a series of twenty-five panels, in plaster, of Pavlova and her partners. Never cast, the Hoffman estate owns several editions of the twelve that were produced. The drawings are in the Fine Arts Museum of San Francisco. As documented in the photograph of Hoffman's studio, these studies provide a remarkably rich example of a sculptor's use of drawing for a major project. D.J.H.
M. Hoffman, *Sculpture Inside and Out*, New York, 1939.

ELIE NADLEMAN
Warsaw 1882—Riverdale, New York 1946
Cat. 88
Standing Nude. ca. 1906-7.
Ink.
286 x 127 mm
Lent by The Robert Schoelkopf Gallery, New York.
When Andre Gide saw Nadelman's first one-man show in Paris in 1909 he wrote: "Nadelman draws with a compass and sculpts by assembling rhomboids. He has discovered that every curve of the human body accompanies itself with a reciprocal curve, which opposes and corresponds to it. The harmony which results from these balancings smacks of theorems. The most astonishing thing however is that he works from the live model ..." (Kirstein, *Nadelman*, p. 273.)
Standing Woman embodies this description, drawn free hand, without mechanical devices, filled with the

"life of form" which Nadelman continuously seeks in his work. Spear has identified his eight drawing styles. *Standing Woman* belongs to a wider classification defined by Baur as based on intersecting curves, arcs, and sinuous lines, here without shading. Kirstein wrote:... "When he drew, he seemed to be determining his final materials. In modelling or carving, his hand repeated what it had already defined on a flat paper..." (*Drawings*, p. 26.) This observation is made evident when comparing Nadelman's bronze *Standing Female Nude* of 1909 with the drawing. D.J.H.
L. Kirstein. *Elie Nadelman*. New York: The Eakins Press, 1973.

GERTRUDE VANDERBILT WHITNEY
New York 1875-1942
Cat. 89
Studies for the "Titanic Memorial, Sketchbook, ca. 1912.
pencil
124 x 85 mm
Lent by the Archives of American Art, Smithsonian Institution, Washington, D.C.
The sculptor's first cruciform design for her *Titanic Memorial*, unveiled in 1930, were drawn in 1912. With this commission, sponsored by the Women of America for those who went down with the Titanic in 1912, Whitney reached her greatest heights. Cross and figure—symbol of sacrificial death—became one in sculpture. Primary indications of drapery are included in the sketches which enhance the ephemeral effect of the monumental work. Whitney described her feelings about the statue in a letter to Andrew O'Connor:
> ...I have tried to keep it simple and young...the details I have left—to be put in if necessary afterwards. I have gone through every motion while doing it—moments of such despair and agony as to be absurd and then exhilarations that could not be accounted for... (Friedman, *Whitney*, p. 341).

These powerful drawings suggest a monument of greater force and originality than the final solution. Did she abandon the cross as inconsistent with the faith of some of the statue's major sponsors? D.J.H.
B.H. Friedman, with the research collaboration of Flora Miller Irving. *Gertrude Vanderbilt Whitney*, Garden City, New York: Doubleday, 1978.

CONSTANTIN BRANCUSI
Hobitza, Rumania 1876—Paris 1957
Cat. 90
Nude. n.d.
Pencil on Board
610 x 457mm
Lent by the Solomon R. Guggenheim Museum, New York

Upon reviewing some Brancusi drawings in 1907, Rodin commented to a mutual friend that not a single page was adequate and recommended that the contours be strengthened (Geist, p. 31). Geist comments how, in this "construct of linear rhythms,... we see precisely the artist whom Rodin criticized. The older man would have made a clearer distinction between figure and ground. It is the virtue of Brancusi's drawing that the figure is not more insistent than the elegant tracery of pencil lines laid like filaments on the page, itself designed into spaces that, with respect to the figure, know no 'inside' or 'outside.'" (Geist, p. 36.).

Brancusi fills the page with a fresh and graceful line. The sweeping image of the shy nude charms the viewer with a simplicity reminiscent of the essential forms of Brancusi's sculpture. The cursive forms enclose an area which represent at once the sensuality as well as the womb of Woman. The drawing recalls the four Torsos of smooth white marble Brancusi carved between 1909 and 1923.

This drawing was not "reduced" enough for the artist. "There are too many lines," he once complained (Geist, p. 36.) Perhaps we can infer from this statement the reason why Brancusi has bequeathed us with so few drawings: the purest distillation of form can only be achieved in three dimensions. E.M.

Cat. 91
View of the Artist's Studio 1918
(Not illustrated).
Gouache and Pencil
328 x 411 mm
Gift of the artist to Margaret Chavin.
Lent by the Museum of Modern Art, New York.
Joan and Lester Avnet Collection

This scene provides a view of Brancusi's studio which also served as his home. Like many of Brancusi's photographs, it shows finished sculptures of bronze, wood, and stone surrounded by blocks of unworked stone and wood. Chairs and benches, all designed and carved by the artist, are placed among finished pieces and sculpture in progress. Here, Brancusi worked, thought, slept, and entertained among his favorite creations. Surrounded by his *oeuvre* he could revise familiar themes or create anew. "It isn't hard to do things," he once commented, "the difficulty lies in getting into the mood to do them."

The studio provided the mood. Disheartened by the fact that his work did not reach enough people, he once said, "I live in a desert, alone with my animals."

Brancusi moved his studio from 54 Rue de Montpar nasse to 8 Impasse Ronsin in 1918. That year, confined to his bed with a broken leg, he began to paint. This gouache could well date from this time, as no other work on paper survives which is so complete, rich, and colorful. The essential shapes which Brancusi sought in his sculpture are found here. Although familiar to their creator, some forms are too general to be recognized by the viewer. From left to right, the sculptures may be:
1. *Danaide*, bronze, 1918, Philadelphia Museum of Art
2. Pedestal for *Bird* sculptures
3. Either the *Sleeping Muse*, the *Newborn*, or the *First Cry*, on a bench of Brancusi's making
4. *Column of the Kiss*, 1916-1918
5. *Sculpture for the Blind (the Beginning of the World)*, marble, 1916, Philadelphia Museum of Art
6. *Little French Girl*, wood, 1914-1918, Solomon R. Guggenheim Museum, New York.
7. *Caryatid*, wood, 1916-1926, Fogg Art Museum, Cambridge, Mass.
8. Another *Column of the Kiss*, among unfinished blocks of wood and marble

Geist noted (p.33) that Brancusi not only records the scene before him in the studio but, also, in the bottom most zone of the drawing, the top of the drawing board and sheet on which he is working. The artist thus creates "both physical and psychological depth in a field where the usual indications of depth of any kind are altogether absent." (Geist, p.33.)

The ultimate effect of the gouache is that of a shadowy group portrait of the works he loved and lived with. A reconstruction of Brancusi's studio, as found at his death, is preserved at The Pompidou Center for Modern Art in Paris. E.M.

Cat. 92
Hands. n.d.
Pencil
406 x 536 mm
Lent by private collection, Atlanta

Undated, this powerful drawing attests to the artist's definitive ability as draughtsman. The hands are lovely and animated. The artist has achieved a graceful effect through strong contours. Brancusi may have drawn this page during the numerous sittings of Mlle. Pogany in 1910, for the bust completed in 1913. In a letter dated 1952 Margaret Pogany recalled, "once I had to sit for my hands but the pose was quite different from that of the present bust, he only wanted to learn them by heart as he already knew my head by heart," (Geist, p. 191.).

This drawing could well stem from that session, but a later date cannot be excluded. Mlle. Pogany's image and a fascination for hands stayed with Brancusi throughout his life. He recreated her portrait in 1920 and 1931. In each the hands are differently placed. Brancusi also carved a single hand of yellow marble in 1920 (Fogg Art Museum) where the drawing's sensuous qualities are rendered in three dimensional form.

Like fallen leaves, the hands cascade upon the page in a multiplicity of images which can be viewed from any direction. There is no top or bottom to the drawing, only a swirl of beckoning forms. What better subject could there be for the artist-sculptor whose strong hands executed powerful works in stone and wood? *Hands* recalls his caress of marble and bronze, brought to a finish, satin to the touch. On the back of this drawing is an unfinished sketch. E.M.

S. Geist, *Brancusi: A Study of the Sculpture*, New York, 1968. C. Giedion-Weicker, *Constantin Brancusi*, New York, 1959. I. Jianou, *Brancusi*, London, 1963

AMEDEO MODIGLIANI
Livorno 1884—Paris 1926
Cat. 93
Carytid, ca. 1910-12
Pencil
260 x 203 mm
Signed
Lent by the San Diego Museum of Art, Bequest of Pliny F. Munger

This drawing is akin to the sculpture of ca. 1914. Crouching, the figure bears an unseen burden on her half raised arms. An abbreviation of the nude, executed in a few quickly drawn lines, the *Carytid* suggests great sculptural force in its geometric form. Modigliani has expressed the essential woman with remarkable economy of means, readily translatable into the third dimension.

Taken with the theme of multiple carytids supporting an entablature, the artist dreamed of producing hundreds of such "colonnes de tendresse" in the amorous idiom of Brancusi.

S.R.G.

WILHELM LEHMBRUCK
Duisberg-Meiderich 1881—Berlin 1919
Cat. 94
Standing Figure, 1912.
Pencil.
493 x 310 mm
signed lower left: W. Lehmbruck
Lent by the Museum of Modern Art, New York
Gift of Edwin M. Otterbourg.

Standing Figure is typical of Lehmbruck's work during his stay in Paris. Classical in pose, the figure recalls Maillol. His model may represent a bather, a favorite subject in Lehmbruck's oeuvre dating back to 1902. In style the page is not far from Brancusi's (90-2) whom the young German knew in Paris. This drawing relates to Lehmbruck's last major Parisian sculpture, his *Bathing Girl* of 1913-14 (Stuttgart, Collection of the artist's family). Sparing in his approach, the artist delineates contours and catches the paper's rough grain with the side of the lead pencil to emphasize graceful classical solidity of form. The drawing is typical of the sensitive style found in Lehmbruck's numerous studies for sculpture.

L.K.

HENRI GAUDIER-BRZESKA
St. Jean de Braye 1981—
Neuville St. Vaast 1915
Cat. 95
Two figures entwined. n.d.
pencil
217 x 108 mm
Lent by The Museum of Fine Arts, Boston
Gift of the Kettle's Yard Collection.

Gaudier-Brzeska's drawings are usually characterized by economy of line, stressing contour alone. *Two figures entwined* reveals the artist's working method, his shapes loosely and hastily sketched, preparatory to sculpture. Both figures are locked in a wrestling pose suitable for a dense, powerful sculpture. Tubular and almost faceless, the athletes recall Cycladic marbles. The sheet relates to a bas-relief of *Wrestlers* in the Boston Museum of Fine Arts where the figures are, compositionally, more closely confined.

L.K.

ALEXANDER ARCHIPENKO
Kiev 1887—New York 1964
Cat. 96
Figure in Movement, 1913.
Cut and pasted papers, crayon and pencil.
465 x 314 mm
Lent by the Museum of Modern Art, New York
Gift of the Perls Galleries, New York.

In his studies for sculpture, Archipenko frequently used collage to create an image. *Figure in Movement* is composed of subtly applied forms of off-white paper on tan, showing a female figure (a circus dancer or acrobat?) sketched in with sepia crayon. A sense of dynamism is indicated by short blue strokes and streamlined shapes, and by the combination of frontal and profile views. The collage relates to *Médrano I* (lost) or *Médrano II*, a mixed-media construction of 1913, but the latter is more static and vertical than is the work on paper. Archipenko spoke of drawings as two types: a registration or memorandum, or a project for future work. The second category includes *Figure in Movement*, "regardless of whether it s a sketch or a finished work, the essence remains in its transformative character, which evolves into a style expressive of the personality of the artist, through specific forms, lines, patterns, and techniques." L.K.
Museum of Modern Art, *Archipenko: The Parisian Years*, 1970, Cat. 8. Metropolitan Museum of Art, Cooper, *The Cubist Epoch*, 1970, Cat. 3, p. 242. Museum of Modern Art, *100 European Drawings*, 1974, Cat. 1.

JACQUES LIPCHITZ
Druokienki, Lithuania 1891—Capri 1973
Cat. 97
Girl with Braided Hair, 1914
Pencil
199 x 158 mm
Signed
Lent by the Museum of Modern Art, New York, Mr. and Mrs. Milton J. Petrie Fund, 296.74.

This study is preparatory to the full-length bronze *Woman with Braided Hair*, and its maquette, *Head*, both of 1914. Angular and curvilinear forms are rhythmically rendered in the model's profile: each diagonal tempered by a curve, the gentle puncuated by the harsh, the flat by the sculptural. Heavy contours delineate each shape, and shading creates depth.
Not as varied as the drawing, the *Head* is marked by weaker contrasts between the angular and curvilinear. In the full-length bronze nude, Lipchitz expresses his concern most aggressively. The head is nearly identical to that of the drawing. S.R.G.

Cat. 98
Study for Prometheus Strangling the Vulture. n.d.
Ink wash, with additions of white
308 x 238 mm
Signed
Lent by The Art Museum, Princeton University, Purchase through the Laura P. Hall Memorial Fund, 6-86.

In 1928 Lipchitz, responding to the deaths of his father and sister, turned toward classical and Biblical themes. His style moved from the Cubist to a neo-Baroque plasticity. *Studies of Prometheus*, interpreted as victor, first appeared in his works of the 30's, to symbolize the triumph of light over darkness, defeating the brutal world of Nazi Europe. Commissioned for the 1937 Paris World's Fair, the monumental *Prometheus Strangling the Vulture*, for which Lipchitz received a gold medal, was designed to be placed 80 feet above ground.
This drawing is closely related to the small bronze *Prometheus Strangling the Vulture*. Prometheus grapples with the bird who daily devoured his liver. Dramatic highlights in white imbue the muscular forms with a sense of passionate struggle.
The struggle turns to strangulation in the bronze. Hunched over, with a bird-like head, a bulky Prometheus contrasts sharply the vulture's atrophied form. Lipchitz' work embodies the destruction of evil strength. S.R.G.
J. Lipchitz, *My Life in Sculpture*, with H.H. Arnason, New York, 1972, figs. 123, 124, 125.

VLADIMIR TATLIN
Kharkov 1885—Moscow 1953
Cat. 99
Untitled, 1921-22 (Not illustrated.)
color crayon
305 x 255 mm
signed lower right
Lent by La Boetie, Inc., New York

Tatlin's preparatory drawing follows the active, not reflective process by which his free spatial constructions were realized. Materials were crafted to follow the movements of nature. Assemblages of wood, metal, and glass were based on the inherent properties of the materials. The sculptor's metal constructions experiment with tension and rhythm, founded on his theories of color relationships. A break with traditional representational art is evident in the title "Construction", so often applied by him to his works.
By mastering the tools and materials of modern industrial production, an objective art for the proletariat, following form and function, was supposed to be achieved. In welcoming the machine Tatlin emphasized the union of artist and engineer. C.V.

IVAN MESTROVIC
Vrpolije, Croatia 1883-1962
Cat. 100
Dancing Figure, 1920
(Not illustrated.)
Colored chalk signed and dated "XX" in pencil Mestrovic.
508 x 373 mm
Lent by the Art Institute of Chicago, Gift of Robert Allerton. 1925.375.

Méstrović's biographer, Kećkemet, noted how "In many cases the creative process was confined to the drawings and sketches he made on paper. After that it was more or less a technical matter, often done by pupils or professional stone masons." This frankly decorative drawing represents a powerful figure, seen from the rear, with arms extended. It shows the master at his best, working in a vigorous manner without the totalitarian element found in so much of his *oeuvre*. The use of colored chalks is admirably suited to rendering the muscular body, contouring the planes of the back and arms with textured strokes. The style is linked with Méstrović's contemporary wood bas-reliefs of the 1920's which show the same "Art Deco" approach. L.K.
D. Kećkemet. *Katalog Galerie, Ivana Mestrovica u Splitu*. Split, 1957.

F. DERWENT WOOD
Keswick (Cumberland) 1871-London 1926
Cat. 101
Recto *Abundance*, before 1926.
Verso *Fountain Design*
(Not illustrated.)
Pen and ink and wash.
297 x 210 mm
Lent by the Victoria and Albert Museum, London.

This group of a nude woman and infants, placed upon a plinth, shows Wood working in a sixteenth-century style, recalling Tuscan monuments from the late Renaissance. Clearly, the ensemble stems from allegories of Charity. Putti support a coat of arms on the base. The sculptor's brisk, calligraphic approach is seen on the verso as well, where a standing figure is drawn upon a large, basin-like support. Both projects suggest very free ideas for decorative sculpture, probably meant for a park-like setting. Wood may have benefited from the new interest in French eighteenth century sculpture. Works such as Rodin's *Brother and Sister* (ca. 1890), with its Rococo freshness, could well have influenced the fresh way in which Wood's figures are presented. C.E.

ARTISTIDE MAILLOL
Banyuls-sur-Mer l861—near Banyuls-sur-Mer 1944
Cat. 102
Reclining Nude. n.d.
Pencil
190 x 242 mm
Monogram
Lent by The Art Institute of Chicago, 25.340. Gift of Robert Allerton.

Less conventional than most Maillol drawings, this unusually beautiful study is defined by freely articulated lines. Reminiscent of classical nymphs and river gods, this figure shows Maillol's devotion to antiquity and to the art of Michelangelo. "For Plato ideas and form were one, and that is how I see it," he wrote. Though not for a known work, the drawing is akin in pose, to *The Mountain* 1937 and in feeling to *The River* (1938-43).
 L.K.
J. Rewald, *Artistide Maillol, 1861–1944*, Solomon R. Guggenheim Museum, New York, 1975.

GEORGE KOLBE
Waldheim 1877—Berlin 1947
Cat 103
Nude Bending Over Sideways, ca. 1920
Pen and ink and wash
483 x 374 mm
Signed in ink GK at lower left
Lent by the Art Institute of Chicago, 1923.1109, Gift of Robert Allerton.

Kolbe's drawings are characterized by the use of wash to produce powerful modeling. This *Nude* is a typical example of his skilled graphism, in which an undulating pen line is shaded with broad areas of wash. Kolbe produced many drawings and sculptures of nudes reminding us of Maillol. Unconnected to any published sculpture, the *Nude* nonetheless communicates Kolbe's approach to statuary. L.K.

REUBEN NAKIAN
College Point, NY 1897—
Cat. 104
Animal Study #2. ca. 1921.
Crayon.
254 x 377 mm
Lent by the Whitney Museum of American Art. New York 1931. 31.560
Trenchant in design, Nakian's *Bull* is drawn with style and wit. A sense of mannered elegance may come from the artist's work for Manship and his friendship with Lachaise. The *Bull's* sweeping arabesque lines exaggerate and almost distort the form of the animal; the scribbled curls of the tail and underbelly add a note of humor. Broad strokes of crayon catch the paper's texture for rich graphic effect. The creature is close in spirit to Nakian's wood sculpture *Bull and Cow* (1924) and the pink marble *Young Calf* (1929). L.K.

LASZLO MOHOLY-NAGY
Bacsbarood, Hungary 1895—
Chicago 1946
Cat. 105
Untitled. ca. 1923
Watercolor and pencil
496 x 678 mm
Signed lower right corner in pencil Moholy-Nagy
Lent by the Museum of Modern Art, New York; Gift in honor of Paul J. Sachs
This drawing is one of several through which Moholy explored changing patterns of light. Prisms intercept a sphere casting variegated shadows that create dimensional effects. The *Light Display Machine* at the Busch-Reisinger Museum (Harvard University) both concludes and indicates the product. Constructed of incandescent lamps attached to a metal drum, the rotating sculpture created various colored patterns of light, in "a celebration of the infinite wealth of vision in motion through the mastery of space and line, color and superimposition, light and kinetics." (Chicago, p. 18) S.R.G.
L. Moholy-Nagy, *Vision in Motion*, Chicago, 1947 *Moholy-Nagy*, Museum of Contemporary Art, Chicago, 1969.

JOHN STOORS
1885 Chicago—1956 Mer, Loire-et-Cher, France
Cat. 106
Design for Fabrication of Abstract Metal Sculpture. ca. 1924-25
Ink on paper.
388 x 276 mm
Lent by Raymond Learsy, New York
"Throughout his abstract work, Storrs retains a creative individuality and structural strength related to an interest in architectural sculpture (he collected a choice group of 12th and 13th century French sculpture)," Bryant wrote. "As early as 1917 he expressed his belief that sculpture is closely allied with architecture and that sculpture should be conceived with this in mind." *Design for Fabrication of Abstract Metal Sculpture* (architectural form) comes from a series of works Storrs began in the twenties called "Studies in Architectural Form" and "Forms in Space." His sculptures were constructed of combined metals, granite, marble, and plaster which belonged to the modern imagery of "The Machine Age." Some of these works may refer to or suggest buildings. Preparatory ink sketches include shaded and crosshatched areas which resemble architectural cross sections. Such specifications are noted in *Design for Fabrication of Abstract Metal Sculpture.* Sharp-edged lines soar upward as diagonal planes of black shadows and white light meet to give a sense of the sculpture which Storrs planned for metal construction. D.J.H.
E. Bryant. "Rediscovery: John Storrs," *Art in America.* LVII, May/June, 1969, pp. 66-71.

MAHONRI M. YOUNG
Salt Lake City, Utah 1877—
Norwalk, Connecticut 1957
Cat. 107
Fighter, ca. 1926-27.
(Not illustrated.)
conté crayon on grey paper.
318 x 483 mm
Lent by the Weyhe Gallery, New York.
Young followed his subject matter very closely from paper to sculpture. This study shows two views of the same fighter, seen from the back, practicing a right arm jab. His drawings of nude male athletes are very similar to his sculpture—well defined, with broad planes giving an impression of powerful solidity. Many bronzes of boxers were executed, *Right to the Jaw* (1926-29), *Joe Gans* (1926) and *Groggy* (1926). He drew innumerable studies of men in the ring. Young occasionally tried on his own pair of boxing gloves. Recalling the time he and Leo Stein were "only tapping" when he landed a right hook on Leo's head and breaking his own right thumb, he was unable to touch clay for five months. D.J.H.

LOUISE NEVELSON
Kiev, Russia 1900—
Cat. 108
Untitled. 1928 (Not illustrated)
Pencil on paper
222 x 279 mm
signed lower right; Nevelson 1928
Lent by The Whitney Museum of American Art, New York. 1969.69.228 Gift of the artist.
Nevelson wrote: "My life had a blueprint from the beginning and that is the reason I don't need to make blueprints or drawings for my sculpture. What I am saying is that I did not become anything, I was an artist..." But, at the start as this early example reveals, she approached her work through drawing. Nevelson's primary concerns as a sculptor—to fill space as a dancer passes through air— are evident here, suggesting a monumental figure on paper. She explored the relationship of mass to rectangle in her drawings from the model made between 1930 and 1936. According to Johnson, Nevelson believed, "the figure was clearly the presentation of a complex flexible form to be arranged or packaged into the rectilinear format of the page..." She seemed to be working toward her constructions even before her hands touched wood. D.J.H.
U.E. Johnson. *Louise Nevelson: Prints and Drawings, 1953-1966.* The Brooklyn Museum, 1967.

WILLIAM ZORACH
Eurburg, Lithuania 1887—
Bath, Main 1966
Cat. 109
Two Figures. 1929
Conté crayon
749 x 464 mm
Signed lower right: Zorach
Lent by the Whitney Museum of American Art, New York. 74.69. Gift of the artist's children in honor of John I.H. Baur 1974.
...I have no set rule of procedure in carving," Zorach wrote, "Sometimes I let the stone suggest its possibilities. Sometimes I work from drawings. Sometimes I make a rough model in clay; this gives me a mass or design and allows me freedon to develop my final form. I always feel free to change and follow the development of the forms as they grow. A small sketch in clay will give a sense of dimension and depth, of direction and plans...
As a student in New York, Zorach had spent his spare hours in the 42nd Street Library, studying prints after drawings by Holbein, Dürer, and Ingres in the Metropolitan Museum of Art. In view of his favorite draughtsmen, Zorach's clear, lucid approach comes as no surprise.
This drawing of his wife (?) and daughter shows Zorach's interest in the School of Paris, as close to painting as to sculpture. A hint of primitivism in the sculpture made the following year is far more pronounced than in the drawing. D.J.H.
W. Zorach. *Art is My Life: The Autobiography of William Zorach.* Cleveland and New York: 1967.

ISAMU NOGUCHI
Los Angeles, 1904—
Cat. 110
Reclining Baby. 1930
brush and ink on Chinese paper mounted on hanging scroll
803 x 990 mm
Lent by Mrs. Jacob M. Kaplan, New York.
Noguchi's evocative image, *Reclining Baby*, presents an infant huddled in a fetal position, the surrounding space suggesting the womb. The brushwork with its flowing line is in the Oriental tradition, as is the hanging scroll on which the paper is mounted. Line is used sparingly yet expressively, its contour changing from thick to thin, corresponding to the forms of the baby's body. The sheet recalls Brancusi's *Study for the New Born* (1914, Philadelphia) and his sculpture of the same title (1915, Philadelphia), which suggests the elemental egg. In effect, Noguchi blends the primeval image of East and West in this scroll, which, though unrelated to any specific sculpture, expresses Noguchi's artistic principal "the perception of space, the continuum of our existence." L.K.
S. Hunter, *Isamu Noguchi*, New York, 1968.

ERIC GILL
Brighton 1882—Middlesex 1940
Cat. 111
Study for Ariel of "Prospero and Ariel" Relief, BBC Façade, 1931 (Not illustrated.)
Pencil
387 x 267 mm
Inscribed "4.2.'31" at lower left, signed Eric G.
Provenance: Hartnoll & Eyre, Ltd., London
Lent by David Daniels, New York
Drawn from below the shoulders, a youth is shown turned to the right. His crossed legs, depicted from the calf down, are repeated at the right in a larger scale. These delicate but strong studies are for the Ariel and Prospero relief, one of Gill's major commissions. His model was the Old Vic actor Leslie French, who was playing Ariel at just the time when the relief was planned. In the finished work, the boy is seen frontally with far less of the lyrical quality so strongly felt in this study. Carved in deep relief, the group has a rather primitive mannered quality. Ariel is also shown in two smaller reliefs on the facade, placed below the Broadcasting Building's projecting towers. In one of these, where he learns "the music of the spheres", Gill based his

figure on a medieval statue by Pisano. The other relief shows Ariel with dolphins, symbolizing short wave broadcasting.

Five years before Gill drew from the model for this work, the sculptor wrote, "Drawing from life properly comes late in life rather than early. For the training of the imagination is the first thing to be seen to, and that is best achieved by life and experience..."(Preface to *Twenty-five Nudes*, published in 1938). This page shows Gill at his best, both sensual and austere, returning to the model in his late maturity as a guide for a major sculpture. C.E.

R. Speaight, *The Life of Eric Gill*, New York, 1966, pp. 216-219. Page 218 describes Leslie French's posing for Ariel.

PABLO PICASSO
Malaga 1881—Mougins 1973
Cat. 112
Still Life with Torso, 1933
Pen and ink
460 x 498 mm
Inscribed lower right "Picasso, Cannes 27 Juillet XXXIII"
Provenance Galerie Simon, Paris; Bucholz Gallery, New York; James Pendleton, California.
Lent by E. V. Thaw and Co., Inc., New York

This drawing was made after a period of intense sculptural activity, within a few years of instruction in welded iron from Gonzales (117), and at a time when the artist expressed the keenest admiration for Giacometti (124). From Picasso's Surrealist phase, the drawing's subject and disposition of elements recall de Chirico's *The Uncertainty of the Poet* (Sir Roland Penrose, London) 1913. *The Technical Manifesto of Futurist Sculpture* written by Boccioni in Paris in 1912 has lines which, in some ways, anticipate those of Picasso's drawing. The Italian wrote, "It is necessary to proclaim loudly that, in the intersection of the planes of a book, and the angles of a table, in the straight lines of a match, in the frame of a window there is more truth than in the breasts and thighs of heroes and Venuses which enrapture the incurable stupidity of contemporary sculpture."

As if illustrating Boccioni's text, Picasso's Venus is shown reflected in a mirrorlike frame window. Perched absurdly above this image, is the meandered helmet of a Trojan hero, as is the ugly leg below. A coarse, caesarean hand breaks through the glass, destroying the surface and the torso's limpid reflection. C.E.

The drawing is reproduced by L. Glozer, *Picasso und der Surrealismus*, DuMont Schauberg, 1971, p.41, No. 20. For Picasso and Futurism see Marianne W. Martin, "The Ballet Parade. A dialogue between Cubism and Futurism", *Art Quarterly*, Spring, 1978, pp. 85-109.

GASTON LACHAISE
Paris 1882—New York City 1935
Cat. 113
Nude Number I, n.d.
Pencil.
267 x 203 mm
Signed lower right:
G. Lachaise/Nude #1.
Lent by the Whitney Museum of American Art, New York, 1932.
Kirstein wrote for the Retrospective Exhibition:

Lachaise is the only sculptor in this country who handles his medium with the assurance of a master experienced in all its possibilities, and too reverent to force them. He has so thoroughly assimilated the lessons of the past that he works healthily in tradition without having to express himself in the style of any particular period or artist. He never confuses the possibilities of various media, and so his drawings are not sketches for sculpture, no means to an end, but ends in themselves and exist on their own right.

Nude Number I, then, is not a specific drawing for sculpture—Lachaise did not draw with this purpose in mind—but it has a sculptural quality. Volumes are determined by the side of the pencil and more pressure has been exerted on the lead to stress certain areas. Nordland wrote how the sculptor would wake at his desk in the morning, snowed in by piles of paper upon which he sketched furiously the night before. He would review the pages and those which did not capture the requisite spontaneity and directness were thrown out. Lachaise's drawings, like his sculpture, are dazzling combinations of force and grace, heroic and erotic at the same time.
 D.J.H.

Gaston Lachaise: Retrospective catalogue reprinted in *Five American Sculptors*, New York MOMA and Arno Press, 1969.

HUGO ROBUS
Cleveland 1885—New York 1964
Cat. 114
One and Another. ca. 1934
Pencil.
241 x 177 mm
Inscribed lower left: One and Another; lower right: Hugo Robus
Lent by the Forum Gallery, New York

One and Another is one of several drawings the artist kept after the sculpture was completed. Robus first modeled *One and Another* in clay and prepared the finished model in plaster and then metal, polishing the forms with abrasives. Robus wrote:

the subject of this sculpture is the always fascinating one of motherhood. The two figures are

in an open composition, which metal permits, with the protective arch of the mother form over the child form.

A fusing of form and movement seemed to most completely express both the action of the figures and the flowing quality of polished metal.

My interest was one of trying to create the simple rhythmic forms suggested by the naturalistic and be so daring to make a more complete expression of the subject matter.

His message is already made clear in pencil, from the protective curve of the Mother's arms to the shape of her body. Robus' drawing suggests a style from the turn of the century, bringing to mind the work of Minne (80) and of the Secession. The sculpture is more in keeping with the streamlining of the Thirties. D.J.H.

H. Robus. "The Sculptor as Self-Critic," *Magazine of Art*, XXXVI, March 1943, pp. 94-98.

PAUL MANSHIP
St. Paul 1885—New York 1966
Cat. 115
Study of a Baboon. n.d.
a. Baboon, frontal view
127 x 114 mm
b. Two Baboons, side views
76 x 140 mm
Graphite
Signed lower right "PM"
Both lent by the Minnesota Museum of Art, Saint Paul. Bequest of Paul H. Manship.

In Manship's many drawings, we see the craftsman at work. With a swift and sure hand he explored natural and mythological themes. His role as *animalier* parallels that of Pompon whose elegant beasts may have influenced the American's. Manship's sketches of baboons were drawn from life as a part of his preparatory studies for a major commission he received in 1926—The Paul J. Rainey Memorial Gateway for the Bronx Zoological Park. It took Manship eight years to complete the lavish, huge project. Meanwhile, his love for animals and birds made him sculpt individual pieces during various stages of the gateway such as Baboon (1932), resting nobly on his own turf, nearer to Egypt than the Bronx. D.J.H.

BURGOYNE DILLER
New York 1906-1965
Cat. 116
Second Theme, 1938.
(Not illustrated).
Pencil and crayon.
318 x 324 mm
Signed lower right "B"
Lent by the Whitney Museum of American Art, New York; The List Purchase Fund, 1979, 79.5.

Second Theme presents a series of interwoven bands forming a grid. In addition to the dominant thick black lines there are secondary horizontal bands of pale blue and pink, all on a white ground, enclosed by a shaded border. Diller explored three different themes in his drawings and constructions, defining the second, shown here, as "element generated by continuous line", as opposed to the "free element" (single block) of the first and "element submerged in activity" (maze of woven bands) of the third. Diller's drawings reflect the same lyricism which differentiates his sculptures from their De Stijl predecessors. In relation to Diller's sculpture, this sheet is close to a wooden relief at the Newark Museum from the same year, *Construction #16*. L.K.

Walker Art Center, Minneapolis. *Burgoyne Diller, Paintings, Sculpture, Drawings*, 1972.

JULIO GONZALES
Barcelona 1876—Arcueil 1942
Cat. 117
Woman Combing Her Hair 1937
(Not illustrated.)
colored crayons
265 x 189 mm
Signed J.G. lower left.
Lent by Beatrice S. Kolliner,
Los Angeles

This drawing shows one of Gonzales' favorite themes, popular since the Renaissance. His first full-size construction made in 1931 (Paris, Private Collection) represents this subject, which was again selected in 1934 (Moderna Museet Stockholm) and in 1936 (Museum of Modern Art, New York). Gonzales' preparatory drawings for these sculptures are rough chalk sketches on inexpensive paper. This sheet is an example of an independent finished drawing, resuming the theme of earlier statuary. After 1935, Gonzales tended to refine his drawings, executing them in ink, pastel, and other colored media on costly, handmade papers, carefully dated, as opposed to the earlier sheets, suggesting their role as finished works.

Gonzales' association of drawing with sculpture was articulated in an unpublished essay of 1936. * He defended Picasso's open-structured sculptures by comparing them to cathedral spires and stars, to "points in the infinite... precursors of the new art: To draw in space." The woman shown at her toilette recalls aspects of Constructivism in its assembly, but Surrealism is manifest in the cruel armature of spindly limbs. Still Gonzales conveys a sympathy for the challenges to human existence also found in Picasso's works of the same date (*Guernica*). L.K.

J. Withers, *Julio Gonzales: Sculptor in Iron*, New York, 1976.
*Reprinted in Withers, 1976, Appendix.

JOHN B. FLANNAGAN
North Dakota 1895-New York 1942
Cat. 118
Study for the Triumph of the Egg, 1937
Brush and ink.
254 x 305 mm
Signed: lower right with title.
Lent by the Museum of Art of Ogunquit, Maine.

Three years before Flannagan took his own life he wrote his credo in a letter: "My aim is to produce sculpture as direct and swift in feeling as drawing—sculpture with such ease, freedom, and simplicity that it hardly seems carved but rather to have endured so always. This accounts for my preference for fieldstone: its very rudeness seems to me more in harmony with simple direct statement. There are often necessary compromises, but the shape of the stone does not determine the design; more often the design dictates the choice of stone..." (Museum of Modern Art Cat. 1942).

With broad, quick strokes of an ink-laden brush, Flannagan conveyed the thickness of the shell wall from which the chicken had just emerged. The granite sculpture shows the shell cracked away as the bird now takes on its own form. The theme is used again in 1941. This time the egg's shape is maintained as in the drawing, the bird's head not yet raised from the broken shell. Flannagan's love of line—seen in many drawings—is directly translated into carved wood or stone. He frequently outlined or drew upon the finished stone rather than carving form in-the-round, a practice also followed by John Storrs (106). Flannagan always signed his drawings, thus certifying their value to his work, even though the artist desired to approach form with only a chisel in hand. D.J.H.

New York, The Museum of Modern Art. *The Sculpture of John B. Flannagan* New York, 1942.

HENRY MOORE
Castleford, Yorkshire 1898-
Cat. 119
Seated and Reclining Figures, 1942.
Watercolor and pencil, wax crayon, black chalk.
354 x 225 mm
Signed right corner in black ink Moore/42
Lent by the Museum of Modern Art, New York; The James Thrall Soby Bequest.

Moore's encyclopedic page brings together a rich anthology of themes, some realized in his past, others to be worked in the coming decade. An inscription at the upper right reads: "two seated figures, two talking figures, draped reclining figures." Moore commented, "This drawing done in 1942 naturally has echoes of my shelter drawings." War's oppression is suggested by this sheet. But the page also anticipates the formal figural style associated with Britain's victory. "For two years I did almost no sculpture and my drawings began to have backgrounds, they became more pictorial... Before the shelter drawings, I did not use drapery certainly not in sculpture and not very much in drawing...Since then I have often used drapery which emphasizes the projections and the forms lying underneath."

Each figure group is distinguished from others by color. Wax crayons are used as a resist so that wash lies only on the uncoated areas, creating beads of color. The reclining figures at the left clearly point to Moore's subjects when he returned to sculpture: the hollowed-out bronze of 1945 (7 editions) and the massive wood *Reclining Figure* of 1946 (Cranbrook Academy of Art). The sheet presents an amalgam of ideas for future works. L.K.

Moore's comments are taken from information he gave to the Museum of Modern Art in May of 1980.

ALEXANDER CALDER
Philadelphia 1898-New York 1976
Cat. 120
Family with Sculpture 1944
Pencil
572 x 780 mm
Signed lower right three times.
Lent by The Perls Galleries, New York. 9020.

Calder's dream-like images are in a schematic setting provided by horizon and ground lines. A nude nuclear family gazes curiously at enormous snake-like forms. The male figures recall the artist's early wire works. Twisting, almost biomorphic shapes are indicated by pencil lines with slight suggestion of three-dimensionality. Yet Calder translated the spiral form at the left into bronze, *The double Helix* of 1944. *Family with Sculptures* is one of several drawings executed in this minimal, yet evocative manner, charged with a prophetic sense of primitive beginning as well as wit echoed by the title of the corresponding sculpture. L.K.

J.J. Sweeney, *Alexander Calder*. Exhibition catalogue, Museum of Modern Art, New York 1951. Zürich, Kunsthaus. *Alexander Calder*. Exhibition catalogue, 1957. J. Lipman. *Calder's Universe*. Exhibition catalogue, Whitney Museum of American Art, New York 1976. W.S. Strachan, *Towards Sculpture, Drawings and Maquettes from Rodin to Oldenburg*, London, 1976.

THEODORE ROSZAK
Poznan, Poland 1907—
Cat. 121
Study for Raven, 1946.
Ink and wash.
126 x 176 mm
Signed lower right, r. Roszak-'46, N.Y.C.
Lent by The Whitney Museum of American Art, New York; Gift of Mrs. Theodore Roszak, 1979, 79.8.

Roszak's small preparatory drawing for *The Raven* (1947) was inspired by Poe's lines. According to Arnason, the sculptor translated his concept of the poem's character, a female symbol, into his expansive steel sculpture. The free, bold strokes of the drawing capture the passion and anguish found in Poe's lines. Roszak's affinity for the Baroque, "at its inception, where it is closest to the gothic thrust", is conveyed by his broad, sweeping pen lines presenting the proposed form. The expressive quality of the preparatory drawing is considerably reduced by transcription into agitated steel. L.K.

H.H. Arnason. *Theodore Roszak*. Exhibition catalogue. 1956. Walker Art Center, Minneapolis and Whitney Museum of American Art.

RICHARD LIPPOLD
Milwaukee 1915—
Cat. 122
Study for Juggler in the Sun, 1949
pencil on graph paper
264 x 215 mm
Dated lower right in pencil "Jan. 20 '49"
Lent by The Museum of Modern Art, New York; Gift of Miss Mildred Constantine.

Juggler in the Sun is, according to Mildred Constantine, the first conception for a sculpture of the same title, (New York, Collection William A. M. Burden) executed without the final sculpture in mind. The measurements were added later. This sheet, worked in the manner of an engineer's mechanical drawing, provides insight into Lippold's creative process. His earlier training as an industrial designer is indicated by the working grid. The juxtaposed triangles represent a circus figure, a Juggler, one of a series of three wrought by the artist. While the lines appear to be ruler-drawn, the radiating sun at the left does not rely on a compass. The linear approach parallels the technique of Lippold's final wire sculpture, which may be traced from this first drawing through several additional studies in the collection of the artist, to the final work. L.K.

MARINO MARINI
Pistoia 1901—1979
Cat. 123
Horseman, 1949.
(Not illustrated.)
Pen, brush, ink and oil.
385 x 287 mm
Inscribed: "a Jim Soby/Marino/12 -10-49"
Lent by the Museum of Modern Art, New York; The James Thrall Soby Bequest.

The Horseman presents a taut, exultant figure with arms outstretched, astride a powerful steed. The equestrian image suggests phallic energy and masculine triumph. Energy courses through the group, emphasized by the dark outlines. Thickly applied brushstrokes suggest a pale human seen against a grey ground. Austere, almost Etruscan in severity, this group is close to Marini's Small Rider (New York, Collection Mr. Alfreid R. Stern) where the arms are extended forward rather than laterally. Here, the figure seems quite literally "riding for a fall," in keeping with the sculptor's increasingly pessimistic approach.

In an interview of 1958, Marini commented on the image of horse

and rider: "I no longer have the intention of celebrating the victory of the hero. I would like to express something tragic, almost the twilight of humanity, a defeat rather than a victory. If you consider, one after another, my statues of nudes of the last twelve years, you will notice each time the rider becomes less capable of mastering his horse and the animal becomes increasingly intractable and wilder instead of yielding. Quite seriously, I believe that we are approaching the end of the world." L.K.

ALBERTO GIACOMETTI
Stampa 1901—Chur 1966
Cat. 124
The City Square, 1949
Brush and colored inks
314 x 511 mm
Signed
Lent by the Museum of Modern Art, New York; Gift of Alexander L. Liberman in honor of René d'Harnoncourt.

Giacometti was fascinated by urban life with its ceaseless flow of people, creating complex, yet accidental compositions. *The City Square* (1949) relates to the bronze sculpture of the same title of 1948. It presents an important resolution of the mature artist's concerns. Sketchy figures punctuate a square whose freely rendered architecture is in the background. Isolated from one another, the pedestrians move in a shallow space. This sense of the lonely crowd is even more pronounced in the sculpture, whose figures are reduced in size, without an architectural setting. In both works, Giacometti makes his figures "doubles of reality when living persons are confronted with them …the confrontation becomes a convincing, life-like experience (and) the viewer becomes a part of the composition." (Guggenheim, p.31)
 S.R.G.

Alberto Giacometti—A Retrospective Exhibition, Solomon R. Guggenheim Museum, 1974
Alberto Giacometti, Dessins, Gallerie Claude Bernard, Paris, 1975-76
G. Jedlicka, "Alberto Giacometti als Zeichner", *Alberto Giacometti, Einige Aufsätze von Prof. Dr. G. Jedlicka,* Zürich, 1965 J. Lord, *Alberto Giacometti, Drawings,* New York, 1971 S.R.G.

DAVID SMITH
Decatur, Indiana 1906—Albany 1965
Cat. 125
24 Greek Y's, from notebook ca. 1950
279 x 216 mm
Lent by the Archives of American Art, Smithsonian Institution, Washington, D.C.

Impressed as a child by illustrations of Greek, Egyptian, and Sumerian sculpture in a Bible, Smith's interest in ancient art was reawakened on a trip abroad and resurfaced with his series of fifteen anti-war medallions (*Medals of Dishonor,* 1937-40), which included explanations of their symbolism written in Greek.

Four sketches associated with *24 Greek Ys* appear in this notebook page. A candelabra-like configuration explores the decorative potential of the Greek "Y". Sprouting branchlike from a base, each Y dances on and dangles from horizontal supports. All the drawings vary the number of Y's, ranging from 21 to 23 as they evolve into the sculpture with 24.

24 Greek Ys presents an asymmetrical balance of communicating Greek consonants, rhythmic stick figures poised on slender beams. Related to his fascination for Greek culture, and akin to such works as *17 Hs, 36 Bird Heads,* and *The Letter, 24 Greek Ys* belongs to the "line drawing" period of Smith's work. S.R.G.

Cat. 126
Untitled (Study for Egyptian Landscape) recto
Untitled (Study for Egyptian Landscape) verso. both ca.1950-51
Tempera
504 x 665 mm
Lent by the Estate of David Smith, Courtesy of M. Knoedler & Co., New York, 73-50-37

Close to the seminal origins of Western culture, Smith combined an interest in Egyptian ritual with the style of prehistoric wall paintings and carvings, to produce works such as *Egyptian Landscape,* 1951. Sculpture in this vein appeared throughout the 50's: *Sacrifice,* 1950; *Canopic Head,* 1951; *Egyptian Barnyard,* 1954; and a series of bronze reliefs in a calligraphic manner, 1956-57.

Study for Egyptian Landscape (recto) presents a large emerald-green form

hanging above an arc secured to a base, an image Smith related to sacrifice. Rust-colored strokes accentuate the central figure. The background is in white and pale lavendar wash. Color is applied first, then thick black lines are added to increase a sense of volume by echoing the forms. Contrasts between arc and diagonal, diagonal and horizontal, are found throughout. The *verso* is also preparatory to the sculpture; like the *recto,* it contrasts the curved with the angular but diminishes the play of parallels and diagonals in favor of a strong horizontal axis.

The red painted steel and acid-treated bronze sculpture incorporates elements from both sides of the page. Combining the *recto's* composition with the *verso's* clarity, extraneous lines are omitted and color and shape are integrated to produce a sharper image. S.R.G.
G. McCoy (ed.), *David Smith,* New York, 1973, p.71.

LOUISE BOURGEOIS
Paris 1911—
Cat. 127
Untitled, 1949-50
India ink.
229 x 335 mm
Signed lower right
Lent by Jean Louis Bourgeois, New York.

These drapery-like forms follow Bourgeois's undulating landscape drawings of the same period. Pen strokes range from thick to thin, from sweeping to staccato. They describe hanging shapes which Lippard found evocative of the wool skeins used by the artist's mother. A sense of geometric precision follows Bourgeois's interest in mathematics and may be connected with her first work with tapestries. This drawing of soft folds descending from varied heights is, according to Bourgeois, the inspiration for her sculpture, *Cumul I* of 1969. The marble's draped sides, enclosing a sculpted 'nest', follow the linear sweep described by this pen drawing. Eloquent in its austerity, this page presages the new sculptural vision of the coming decades. L.K.
L. Lippard, "Louise Bourgeois: from the inside out," *ArtForum,* XIII, March 1975, pp. 26-33.

ACKNOWLEDGEMENTS

This is an extraordinary exhibition and we are very proud to be able to present it. I should like to thank the Curator, Colin Eisler, Robert Lehman Professor at the Institute of Fine Arts, New York University, for having conceived and created it. I am also very grateful to:

The Board of Directors for their constant help over four wonderful years: Edward H. Tuck, Chairman, George R. Collins, Colin Eisler, Granville Meader, Mrs. Gregor W. Medinger, Douglas Newton, and Mrs. Felix G. Rohatyn.

The National Endowment for the Arts, who made the exhibition possible. Tom Freudenheim, whose courteous attention made working on the exhibition a pleasure.

The New York Council for the Humanities, whose continuing interest once again made an exhibition important to us happen, and especially Dr. Carol Groneman for her advice and good counsel.

The Institution of Museum Services, a Federal agency in the Department of Education, whose generous grant sustains us through the years.

Exxon Corporation, who had the faith to back us; particularly Leonard Fleischer, whose encouragement, enthusiasm, and support gave everyone associated with the Center a great deal of pride.

Michael Iovenko, our lawyer and friend.

Huntington T. Block, our insurance broker and adviser on security.

Massimo Vignelli, who has donated all of our graphic design.

The Security Staff of the Metropolitan Musuem of Art, especially Allen E. Gore and John J. Barelli. Marceline McKee, Coordinator for Loans of the Metropolitan Museum of Art for her interest and care.

All of the lenders to the exhibition, to whom we are grateful and indebted.

Christa Cornell and Marie McCann, whose help was extremely valuable.

Finally, I would like to thank my colleagues: Ruth Crocker, Administrative Assistant; Rosemarie Garipoli, Director of Development; Marie Keller, Assistant Curator/Registrar; Thomas Lawson, Viewing Program Assistant; Robin Lehrer, Schools' Program Assistant; and finally to the many work/study students whose hard work is an indispensable asset to the Drawing Center.

Martha Beck
Director

The Drawing Center was established by Martha Beck in 1977, to convey the quality and diversity of drawing and to encourage new drawing talent. The eight major exhibitions which the Center has mounted to date have included the first major showing of Antonio Gaudi's drawings outside Spain (and his largest exhibition ever); *Drawings for Animated Films*, the first retrospective exhibition tracing the development of animated film; and *Musical Manuscripts*, the Center's most recent major exhibition.

The Center's Viewing Program, meanwhile, enables new artists to show their work to the Drawing Center staff and to discuss it. Since 1977, 3,500 artists have taken this opportunity. For quite a few, the occasion is a first attempt to present work professionally—a major, and often difficult, step in the career of an artist.

For an institution like the Center—which travels light, with no collection or permanent exhibitions—a catalogue and book such as this one provides, in addition to the usual benefit, a visible milestone and permanent evidence of its work. In this respect, it has been the Center's good fortune to have curators who were compelling essayists as well. We thank Colin Eisler, George Collins, Vincent Scully, and the other scholars whose work, talent, and authority has so strengthened the Drawing Center.

For the Board of Directors,
Edward H. Tuck
Chairman

Our very warmest thanks go to the many collectors and curators whose encouragement and generous loans made this exhibition possible. For their extraordinarily responsive assistance, far beyond the call of professional duty, providing invaluable help toward this gathering of sculptors' drawing, we are deeply indebted to:

Nicole Barbier, Musée des Beaux-Arts, Rennes

Harold Barkley, Victoria and Albert Museum, London

Jonathan Brown, New York University, Institute of Fine Arts

Andrew S. Ciechanowiecki, Heim Gallery, London

Janis Conner, Curator, Malvina Hoffman Estate, New York

Paul Cummings, Whitney Museum of American Art, New York

Péter J. Day, Chatsworth, Bakewell

Elaine Evans Dee, Curator of Drawings, Cooper-Hewitt Museum, Smithsonian Museum, New York

John H. Dryfhout, Saint-Gaudens National Historic Site, Cornish, New Hampshire

Albert E. Elsen, Stanford University, Standford, California

Dennis Farr, Courtauld Institute Galleries, London

Ted Feder, Scala Fine Arts Photos, New York

Peter Fusco, Los Angeles County Museum of Art, Los Angeles

Kenneth Garlick, The Ashmolean Museum, Oxford

James M. Goode, Smithsonian Institution, Washington

Julianne Griffen, The Architectural History Foundation, New York

George Gurney, National Museum of American Art, Smithsonian Institution

Ann Sutherland Harris, Metropolitan Museum of Art, New York

Egbert Haverkamp-Begemann, Institute of Fine Arts, New York University

Dyveke Helsted, Thorvaldsens Museum, Copenhagen

Hugh Honour, Villa Marchiò, Lucca

Flora Miller Irving, Whitney Museum of American Art, New York

H. W. Janson, New York University, Institute of Fine Arts

Harold Joachim, The Art Institute of Chicago

William R. Johnston, Walters Art Gallery, Baltimore

Lois Katz, Arthur M. Sackler Foundation, New York

C. M. Kauffmann, Victoria and Albert Museum, London

Beatrice Kernan, Museum of Modern Art, New York

Raymond Learsy, New York

Garnett McCoy, Archives of American Art, Smithsonian Institution, Washington

Lisa M. Messinger, Metropolitan Museum of Art, New York

Theodora Morgan, national Sculpture Society

Maria Naylor, New York

Victoria Newhouse, Architectural History Foundation, New York

Richard Oldenburg, Museum of Modern Art, New York

Ann S. Percy, Philadelphia Museum of Art, Phil.

Bernard R. Reilly, Library of Congress, Washington

Honorable Gladys Roberts, Windsor Castle

Barbara T. Ross, The Art Museum, Princeton University

Bernice Rose, Museum of Modern Art, New York

Margit Rowell, The Solomon R. Guggenheim Museum, New York

William S. Rubin, Museum of Modern Art, New York

Eleanor V. Sayre, Museum of Fine Arts, Boston

Ingrid Scheib-Rothbart, Goethe House, New York

Lewis I. Sharp, Metropolitan Museum of Art, New York

W. J. Strachan, Thames & Hudson, London
Lisa Taylor, Cooper-Hewitt Museum, Smithsonian Institutions, New York
Philip Troutman, Courtauld Institute Galleries, London
Dr. J. Kirk T. Varnedoe, New York University, Institute of Fine Arts
Jeanne L. Wasserman, Fogg Art Museum, Harvard University
Jeffrey Weidman, Indianapolis
Suzanne Wells, Philadelphia
Andrew Wilton, The British Museum, London
James B. Wood, The Art Institute of Chicago

Catalogue entries for this exhibition were prepared by:

Albert Alhadeff ..A.A.
 Associate Professor, University of Colorado at Boulder
Colin Eisler ...C.E.
Shellie Goldberg ...S.G.
Adina F. Gordon..A.F.G.
Donna J. Hassler ...D.J.H.
Lorraine Karafel...L.K.
Elizabeth McGowan ...E.M.
Roberta J. M. Olson ..R.J.M.O.
 Assistance Professor, Wheaton College, Norton, Mass.
Constance Vallis ...C.V.
Ian Wardropper ..I.W.

Students at the Institute of Fine Arts—Lawrence Becker, Ilana Dreyer, Tricia
Emison, Leslie Heiner, Holly Hotchner, Katherine Schwab, Shara Wasserman,
and John M. Wilson—contributed information to this project. The manuscript
was prepared for publication with the assistance of Suzanne Babineau-Simenauer,
Linda Bridges, Carol Learsy, Ann Hudson Niehoff, Scott Rabiet, Lisa Reilly, and
Laura Tennen.

Photographic Credits Courtesy Of:
The Art Institute of Chicago
Museum of Fine Arts, Boston
Whitney Museum of American Art, New York. Geoffrey Clements.
The Robert Schoelkopf Gallery, New York. eeva-inkeri.

Caption for Cover Illustration:
Giovanni Battista Tiepolo: Study for Statuary Group Zephyrus and Flora, c. 1750-55.
Lent by the Victoria and Albert Museum, London.